THE
# SKETCHBOOK
PROJECT

# THE SKETCHBOOK PROJECT

## *World Tour*

*by*

## STEVEN PETERMAN

*and*

## SARA ELANDS PETERMAN

PRINCETON ARCHITECTURAL PRESS · NEW YORK

# CONTENTS

**NORTH
AMERICA**

*Page 12*

**SOUTH
AMERICA**

*Page 76*

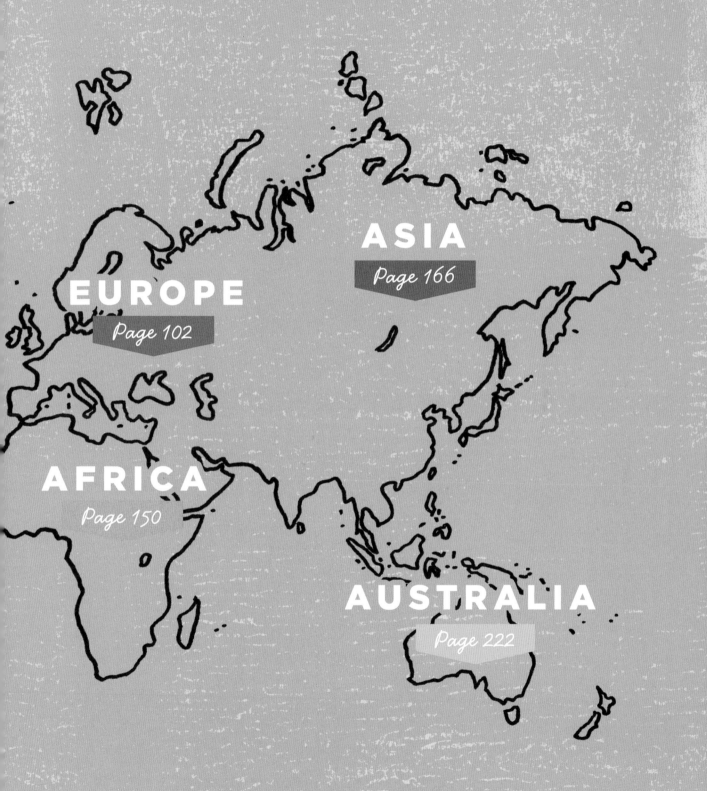

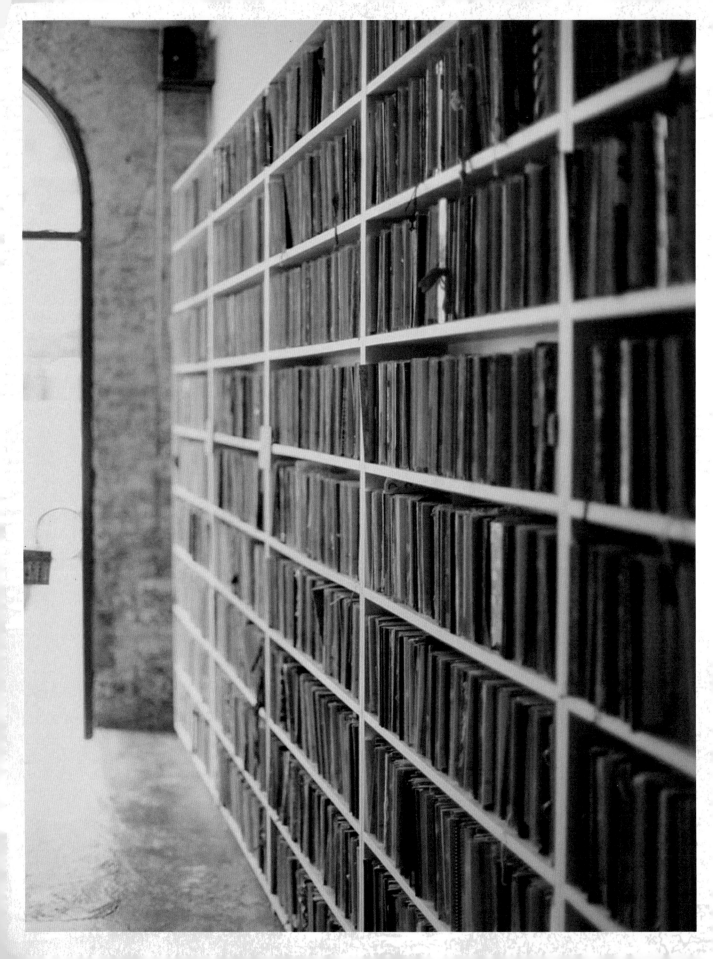

# FOREWORD

By Chris Jobson

**EDITOR IN CHIEF, COLOSSAL**

To set foot inside the Brooklyn Art Library is to be surrounded by a phalanx of floor-to-ceiling shelves containing thousands upon thousands of artists' sketchbooks. With plenty of chairs and tables for reading, discussion, and unexpected discoveries, the library is warm and welcoming. It is the bustling home of The Sketchbook Project, one of the most fantastic global art projects I have ever been involved with. There is simply no place else like it.

In 2012 I had the opportunity to curate a selection of books for The Sketchbook Project's first Mobile Library tour across the United States. I was given the option to select entire groups of sketchbooks by theme or keyword, but instead chose to do things the old-fashioned way: one by one.

Over the next three days I endured paper cuts and carpal tunnel as I flipped through nearly eight thousand individual works of art. I encountered drawings, paintings, gestural sketches, landscapes, fully illustrated comic books, collages, photorealistic portraits, pages folded like origami, and abstract geometric experiments. Pages were covered in smudges of pastel, conte, watercolor, graphite, acrylic, chalk, dirt, marker, and even blood and tears. I discovered visual stories, manifestos, admissions of guilt, declarations of love, envelopes of evidence, explosive rants, family secrets, and bitter political diatribes.

One paper artist transformed her sketchbook into a giant foldout carousel that spun like a top. One illustrator created a powerful graphic novella providing vivid details of how his family had been destroyed by violence. Another person had spent weeks transforming the front and back of their sketchbook into a thickly layered collage of paint and metal on par with the most incredible medieval tome. My fingers quivered as I peeked inside. All thirty-two pages were blank. Never judge a book by its cover.

In the age of everything digital, where words and images are shared at an increasingly frenetic pace and success is measured in clicks and likes, it is almost miraculous that a worldwide artistic endeavor like The Sketchbook Project even exists. To think that more than thirty-one thousand people of all ages, artistic abilities, and walks of life have enthusiastically committed time and energy to fill the pages of a sketchbook submitted for public consumption is to realize our collective need for something real. Something permanent. Something that speaks to our human need to take risks, to experiment, and to be understood.

# INTRODUCTION

*By Steven Peterman and Shane Zucker*

COFOUNDERS OF THE SKETCHBOOK PROJECT

When The Sketchbook Project first started, we never imagined where it would take us. We never thought that the simple idea of sending a blank sketchbook to anyone who found our humble site and waiting for it to come back could have become the international endeavor it is today. Inside each of the tens of thousands of books housed in the Brooklyn Art Library, our permanent space for The Sketchbook Project, is a legacy, a memoir, a novel, a time capsule, and, most importantly, a real life story.

When tasked with picking the spreads to be featured in this book, we were at a loss as to how we could narrow down such a huge amount of content into one book. We didn't want to favor some over others but rather hoped to showcase just a bit of the sheer talent, meaningfulness, and global reach of this project. We have never before curated the collection on this level. Sure, we've picked out scary books for Halloween, or showed off some great spreads on social media, but for us to pick and choose only a few hundred spreads to be published in a book seemed overwhelming. We decided to organize the material by regions of the world, allowing us to show a slice of the talent and stories behind the project while traveling the world page by page.

It would be unfair of us to ever say, "These books alone represent The Sketchbook Project." Given the scope of the project, no one book, no matter how big, can capture what it means to be a part of a global movement. Here, you will find a glimpse into the community. A fraction of what it is and means. Sketchbooks over the years have served as shared memoirs to cancer survivors, inspired some to return to art school, and have been a daily practice to reinspire the dormant or budding artist. You will read accounts by people you have never met.

Or you might feel compelled to reach out to someone across the globe who views the world the same way you do.

We (Steven and Shane) grew up in separate parts of the country. Shane was raised in Florida and was making websites at the age of thirteen. Steven grew up in New Jersey, taught himself guitar, and learned to take an idea and turn it into something tangible. Neither was afraid to take a leap and try something out of the ordinary; The Sketchbook Project is just that. It's the world's attempt at trying something extraordinary. Allowing your story to go out into the world and seeing what flies back can be exciting and scary.

We now have a place where anyone is accepted, and a community is created along the way. Each submission that arrives in our mailbox is treated the same, in the most democratic way. We even have a checkout system that moves through the collection, checking out books evenly across the board. We are honored to be a part of this group, and we are ecstatic to share this tiny window into the collection with you.

We hope that you will find a voice to relate to in this book. We hope that you will take it home, flip through the pages, and know that sitting in our Brooklyn library at the time of printing are more than thirty-one thousand more sketchbooks. And, on a hot summer's day (or a snowy New York night), other curious readers are also flipping through the pages of these living time capsules. We hope that you will join us (as we travel the country in our Mobile Library, or the world on our Digital Library) or create something wonderful, and share your story with us and the world.

# ABOUT

**THE SKETCHBOOK PROJECT** is a crowd-sourced library of artists' sketchbooks from around the world. It began in 2006 as a simple project open to anyone who signed up online. Starting with only five hundred submissions in that first year, it has grown into a collection of more than thirty-one thousand books from around the globe.

Since 2010, the physical collection has resided in its permanent space, the Brooklyn Art Library, growing by thousands of new submissions every year. Daily, visitors explore the stacks, whether they live around the corner or have come from far away to see a book by someone they know.

The Sketchbook Project exists in two other outlets: the Digital Library and the Mobile Library. In addition to the physical library, about half of the sketch-books can be viewed online through the Digital Library, creating a connection between viewer and artist, even if they live across the world from each other. The Mobile Library is the traveling extension of the Brooklyn Art Library: a custom bookmobile that treks all across the United States and Canada, creating pop-up libraries in small towns and large cities.

Technology has always been a catalyst for The Sketchbook Project, from the initial website allowing sign-ups from anywhere, to the eventual in-house built library search system that allows visitors to find physical books based on keywords. The project, however, always maintains ephemeral qualities through the medium of the sketchbook.

Over the years, people have casually or wholeheartedly shared their stories. Inside the millions of pages, you will find drawings, writings, collage, complex fold-outs, and the occasional interactive book.

Starting with a blank sketchbook, anyone can add his or her unique voice to the library. It's a practice in deadline, restrictions, and sending your art out into the world, even if it's not perfect.

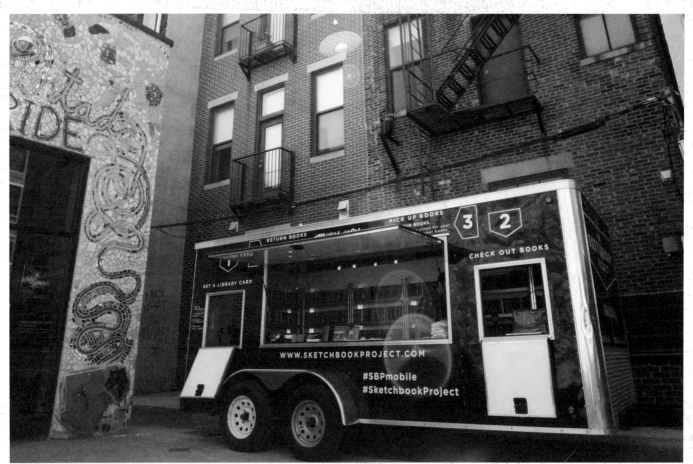

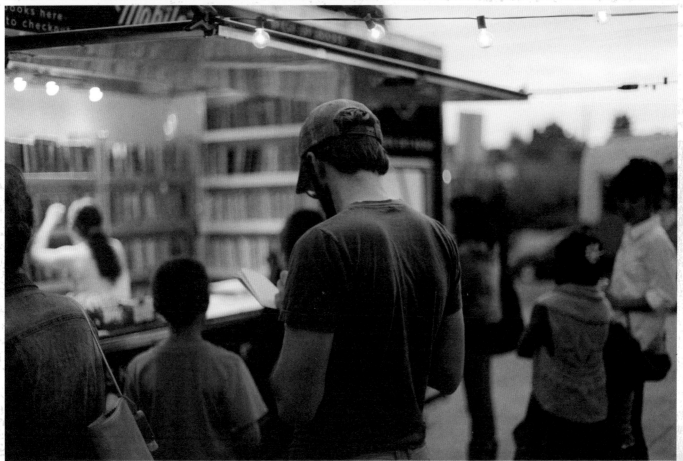

# NORTH AMERICA

Each summer, as we tour across North America in our Mobile Library, loaded with a year's worth of submissions, we find ourselves captivated by the stories and people we find along the way. There was the Atlanta couple who reunited with their nephew, who works as a designer in Seattle, by spending an afternoon flipping through one of his sketchbooks, and the marriage proposal cleverly executed through an artist's sketchbook, with help from us, at an afternoon show in Chicago. In Austin, Texas, we shared a quiet moment with Katherine Mahoney when she gave us a glimpse into the story of her late best friend, Barb, and their adventures together. In Portland, Oregon, we met an eight year old who doesn't believe in making mistakes while drawing, reminding us all a little bit about humility. The range of creativity and artistic voices available in North America are as varied as the region itself.

Each spread from the artists' sketchbooks is a glimpse into imagination and perception, perhaps conjuring a shared memory or offering an entirely new concept that sparks imagination. There is a playful lightness found in Emily Balsley's depiction of peanut butter factory workers, both anthropomorphized and human. You can almost taste the stolen treat. Wai Khan Au reminds us all from an unusual perspective of the feeling of standing in a line full of strangers, waiting to progress. Joseph R. Tomlinson's Abraham Lincoln offers us something not as familiar, and is a more modern version of the president than we remember from old textbooks.

A vast span of land extending from California to New York, Vancouver to Mexico City, North America shifts in texture and color, ideas and lifestyles, and yet is bound together by a common spirit while still maintaining beautiful, individual identity. From the graffiti-inspired illustrations by an urban designer to the layers of pressed paper from a rural artist, the artwork created across North America has a thread of inquisitive, passionate complexity. From Oaxaca, Mexico, artist Maria Luisa Santos Cuellar's haunting depiction of foliage to Toronto artist Amanda Nicole White's phases of the moon, and everywhere in between, we are given a look into the perspectives of artists all around North America.

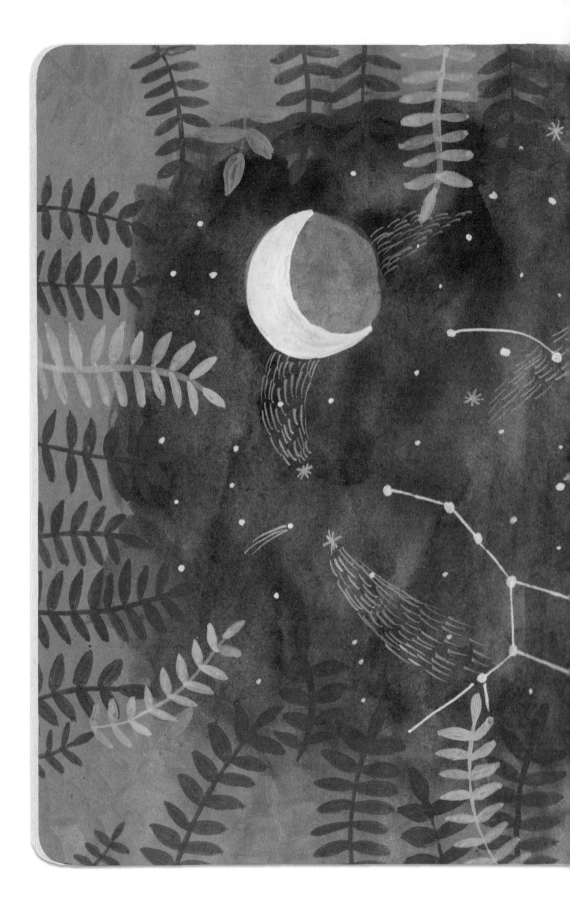

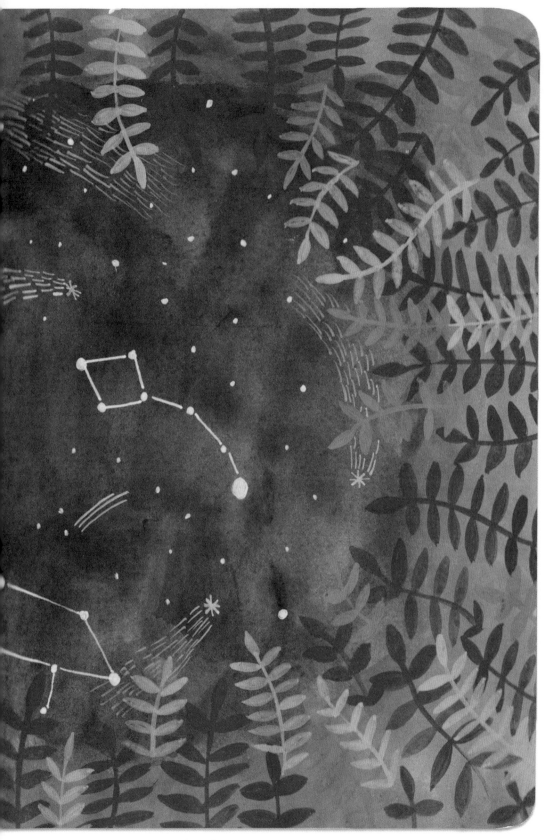

**Sara Gray** MINNEAPOLIS, MINNESOTA

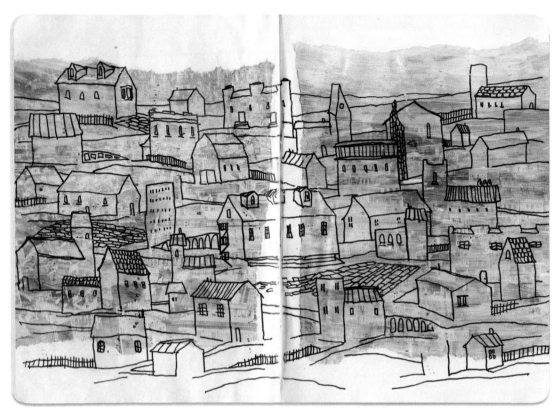

Lucie Ferguson  BALTIMORE, MARYLAND

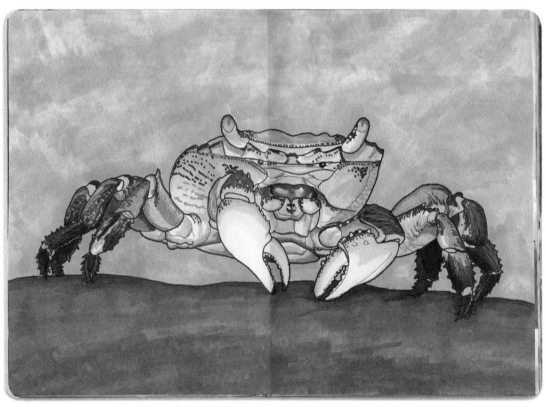

Sydnee Davidson  NORTHRIDGE, CALIFORNIA

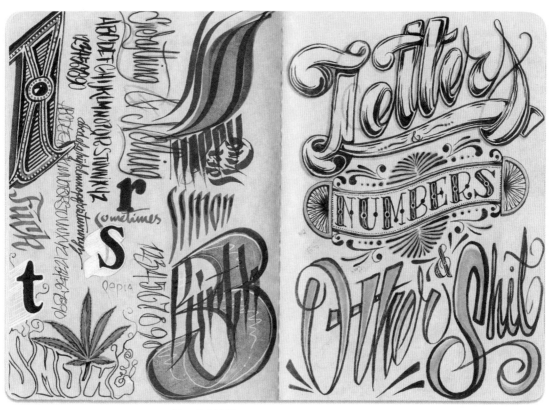

Travis W. Simon  BROOKLYN, NEW YORK

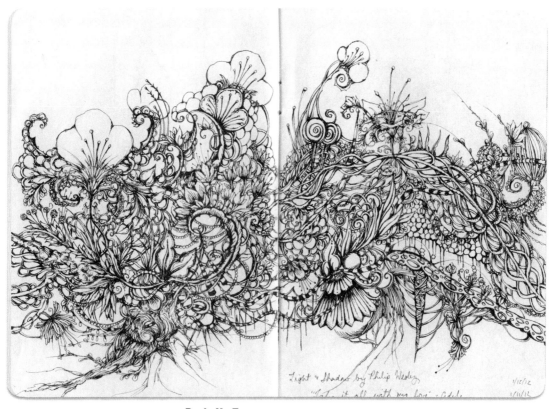

Rochelle Fox  BROOKLYN, NEW YORK

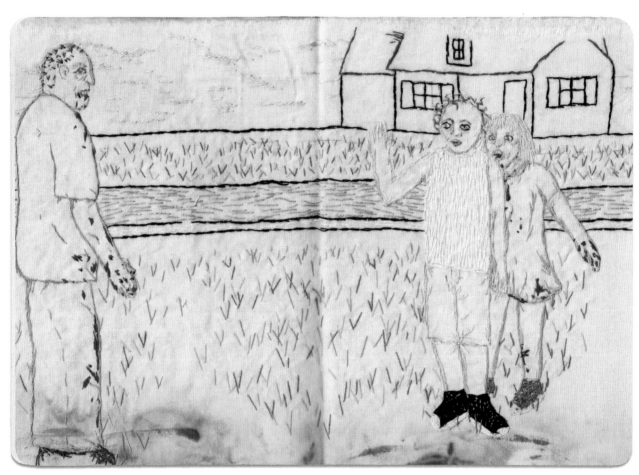

Darci Lenker   NORMAN, OKLAHOMA

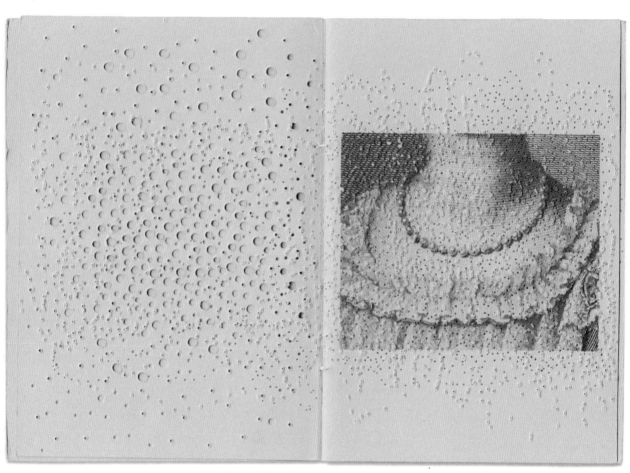

**Carson Fox** BROOKLYN, NEW YORK

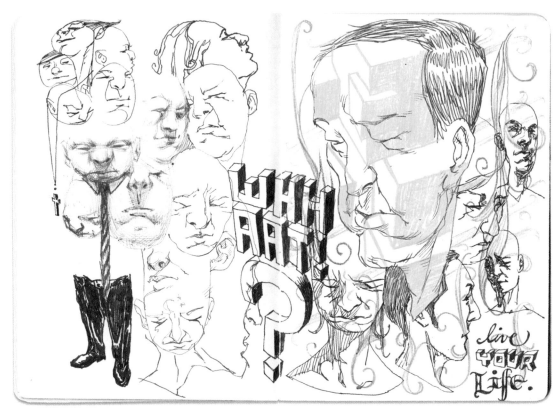

**Guno Park** BROOKLYN, NEW YORK

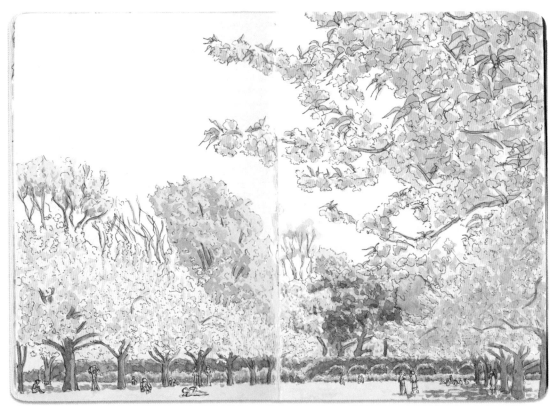

**Lee Ellen Becker** BROOKLYN, NEW YORK

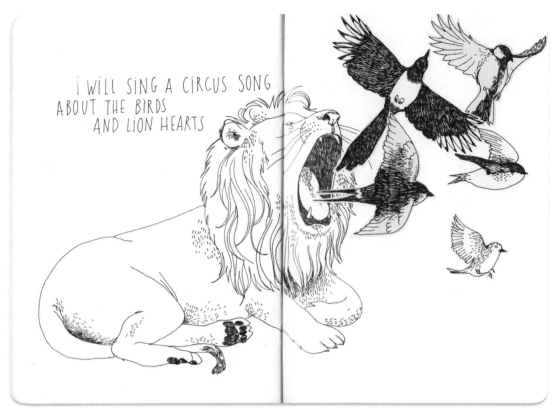

Anna Wanda Gogusey  AUSTIN, TEXAS

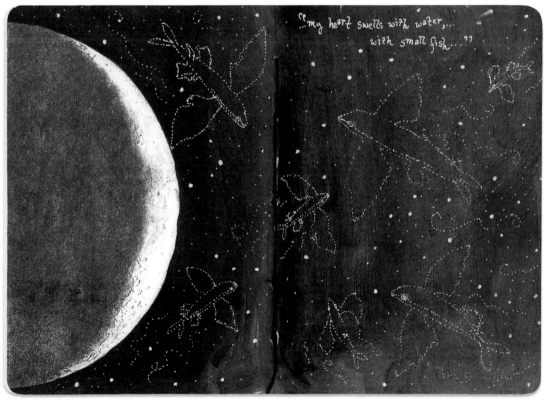

Anne M. Gagel  KANSAS CITY, MISSOURI

A PATH THROUGH THE TREES

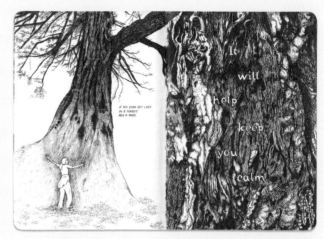

It will help keep you calm

IF YOU EVER GET LOST IN A FOREST HUG A TREE.

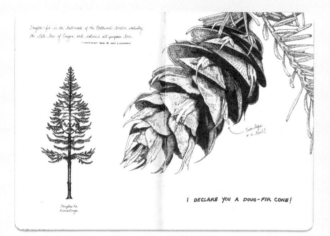

Douglas-fir is the hallmark of the Northwest timber industry, the state tree of Oregon, and nature's all-purpose tree.

Douglas Fir Pseudotsuga

Two legs + a tail!

I DECLARE YOU A DOUG-FIR CONE!

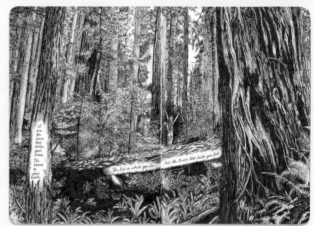

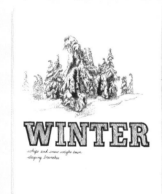

WINTER

SPRING

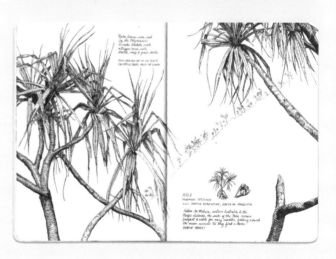

HALA

MEET THE ARTIST

# *April Donovan*

**HOOD RIVER, OREGON**

**DO YOU HAVE ANY FORMAL ARTISTIC TRAINING? IF SO, WHERE?**

I have a BFA in Communication Design from Kutztown University.

**WHAT IS YOUR FAVORITE ARTISTIC TOOL?**

Pens, pencils, and paintbrushes.

**HAVE YOU ALWAYS KEPT A SKETCHBOOK, OR WAS CREATING YOUR SKETCHBOOK A TOTALLY NEW ENDEAVOR FOR YOU? DID YOU ENTER THE SKETCHBOOK PROJECT WITH CERTAIN GOALS, OR WAS IT MORE OF AN EXPERIMENTAL EXPERIENCE?**

I always have a sketchbook going. One of the things that attracted me to The Sketchbook Project was the idea of creating a book centered around a theme. Giving the book deep meaning on many levels inspired me. I wanted to tell a story. Also, a college buddy signed up and turned me onto the project.

**WHAT DOES YOUR ARTISTIC PROCESS ENTAIL? ARE THERE CERTAIN INSPIRATIONS YOU HOLD DEAR, OR MATERIALS YOU CAN'T LIVE WITHOUT?**

Finding meaning always motivates my work. I do lots of creative research and try to create rhythm for the viewer. Mostly, I am inspired by the wilderness, where inspiration usually strikes. I love this quote by Wallace Stevens, "Perhaps the truth depends on a walk around the lake."

My process entails research, "walking around the lake," brainstorming, sketching, and creating the final piece.

**ARE THERE CERTAIN THEMES THAT RECUR THROUGHOUT YOUR WORK? DESCRIBE ANY VISUAL OR CONCEPTUAL ELEMENTS THAT YOU FIND CENTRAL TO YOUR PROCESS.**

My work usually involves words—sometimes handwriting, sometimes incorporating professional typography. I find it more enjoyable and meaningful to create work that supports an idea also expressed through words. The words can be poetry, or even just descriptive captions.

Often, I like to read in the woods and draw whatever comes to mind as I'm exploring the text.

**HOW DOES YOUR PERSONAL BACKGROUND OR GEOGRAPHIC LOCATION TIE INTO YOUR ARTISTIC PRACTICE?**

I'd say my background and location ties directly into my practice.

I'm a very curious person and love travel and adventure. I'm inspired by the woods, as mentioned, but also love to spend time soaking up the culture in proper cities. Some of my favorite cities are Philadelphia, New York, Seattle, and San Francisco.

Also, it rains a lot in Oregon in the winter, and this is always the time of year that I spend more time in the city.

My background has always involved exploring and creating. My location and travels directly tie in to my artistic practice.

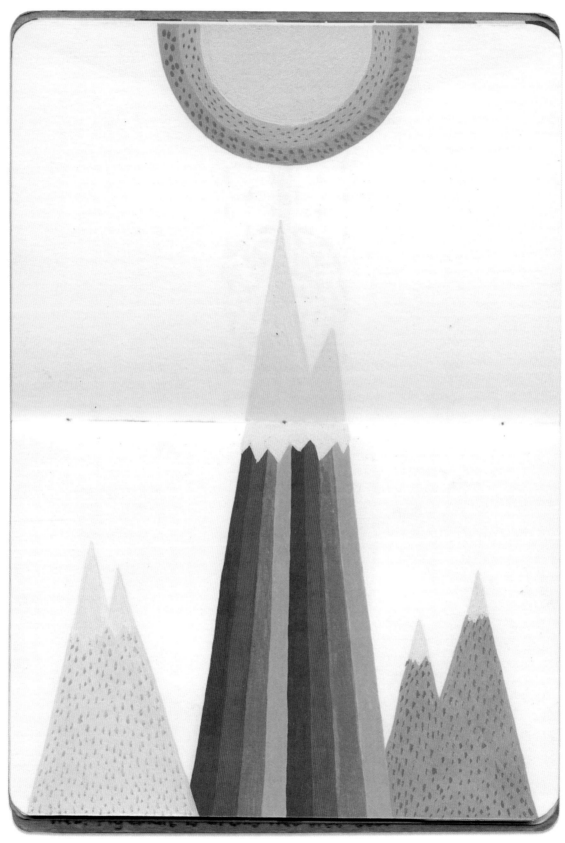

CustardMustardGustard TUXTLA GUTIÉRREZ, MEXICO

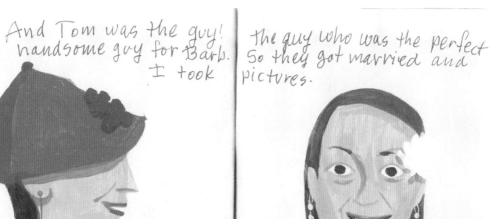

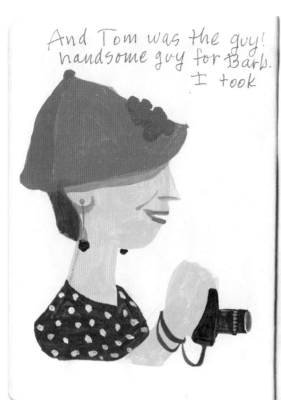

And Tom was the guy! handsome guy for Barb. I took

The guy who was the perfect So they got married and pictures.

**Katherine Mahoney** AUSTIN, TEXAS

near...

**Linda Daily** PORTLAND, OREGON

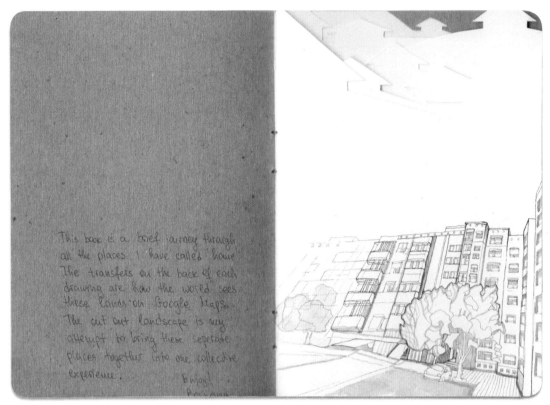

This book is a brief journey through all the places I have called "home." The transfers on the back of each drawing are how the world sees these lands on Google Maps. The cut out landscape is my attempt to bring these separate places together into one collective experience.

Enjoy!
Boryana

**Boryana Rusenova Ina**  COLUMBUS, OHIO

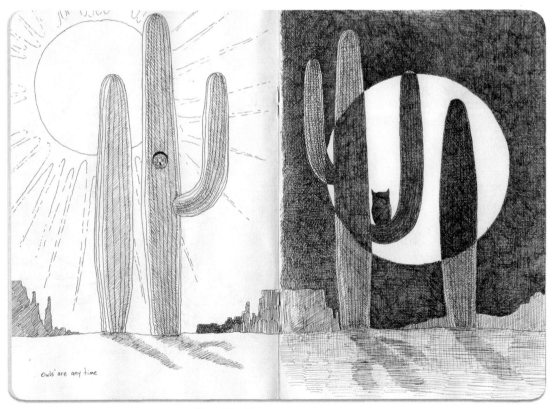

owls are any time

**Signe Nordin**  TUCSON, ARIZONA

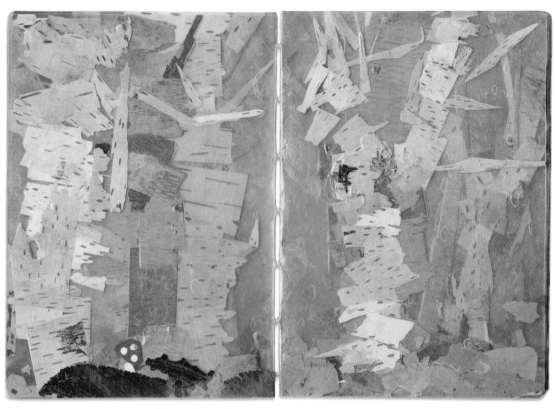

**Megan Langelier**  SOMERVILLE, MASSACHUSETTS

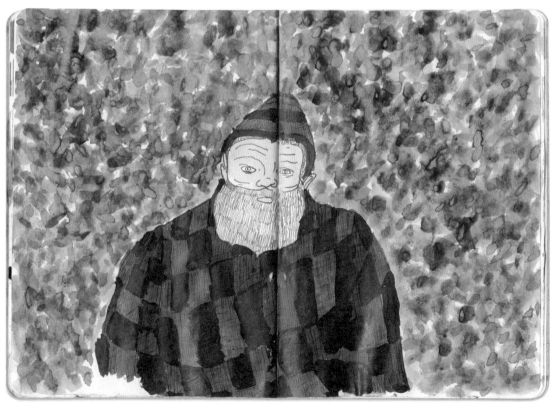

**Lara Meintjes**  LONG BEACH, CALIFORNIA

**Kip Noschese**
HENDERSON, NEVADA

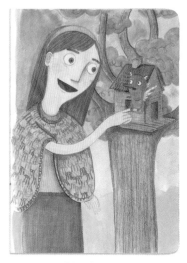

**Gina Perry**
NORTH HAMPTON, NEW HAMPSHIRE

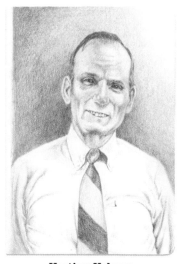

**Heather Halpern**
EUGENE, OREGON

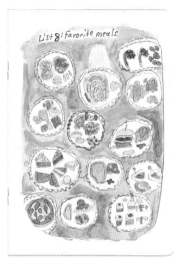

**Olivia Gresham**
NEW YORK, NEW YORK

**Janet Ames**
WENTWORTH, NEW HAMPSHIRE

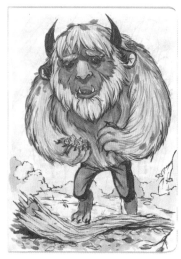

**Shelley Li Wen Chen**
TORONTO, ONTARIO

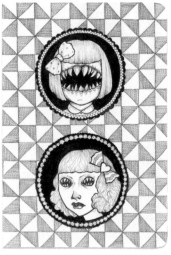

**Ally Burke**
JOHNSON CITY, TENNESSEE

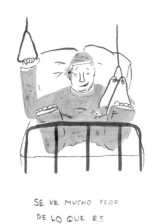

**Anna Jo Beck**
BOSTON, MASSACHUSETTS

**Jim Jobe**
HUNTSVILLE, ALABAMA

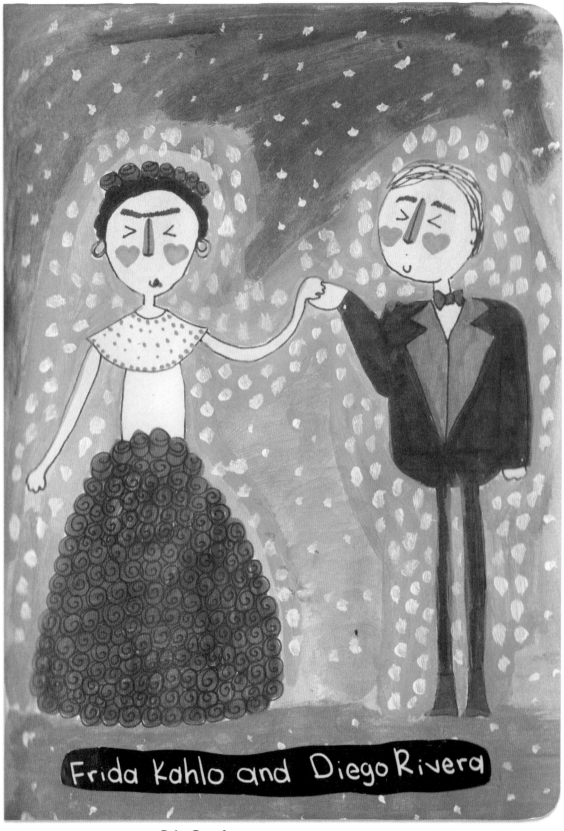

Frida Kahlo and Diego Rivera

**Reina Burrola**  VALLE DE LAS PALMAS, MEXICO

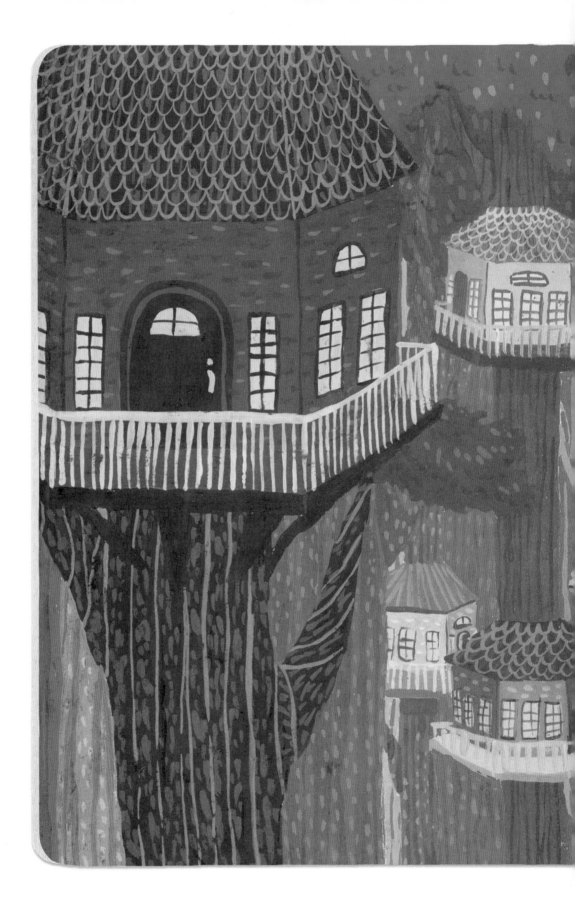

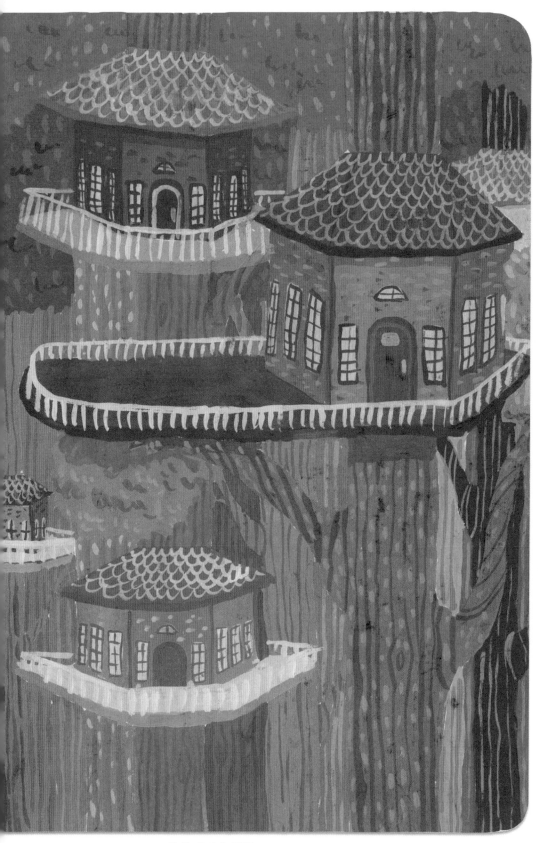

**Kelly Leigh Miller** LOUISVILLE, KENTUCKY

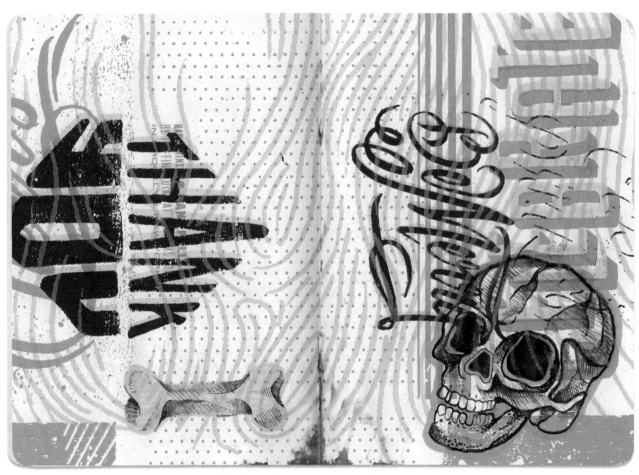

**Two Arms Inc.** BROOKLYN, NEW YORK

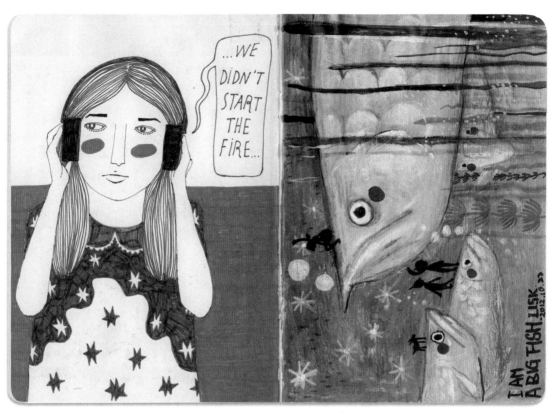

**Kevin Valente** BALTIMORE, MARYLAND

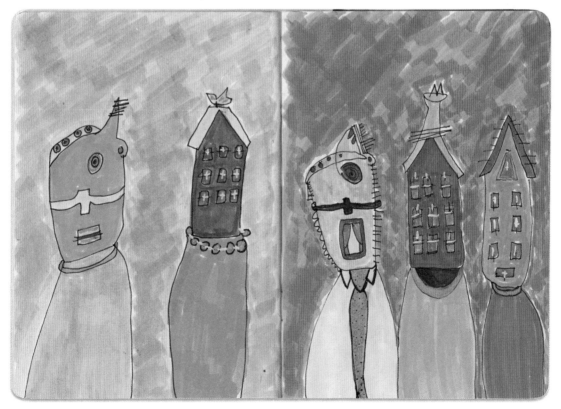

**Kathleen Farrell** ROCHESTER, NEW YORK

**Emily Taylor**  TORONTO, ONTARIO

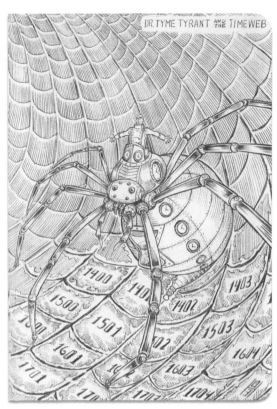

**Joe Wigfield**  DOWNINGTOWN, PENNSYLVANIA

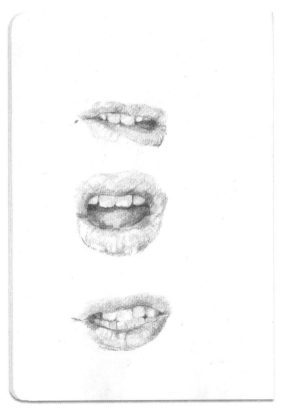

**Alexandria Pinter**  CARLSBAD, CALIFORNIA

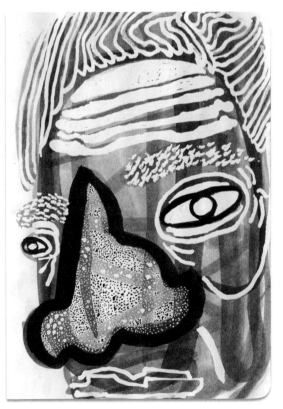

**Nathan Wade Carter**  PORTLAND, OREGON

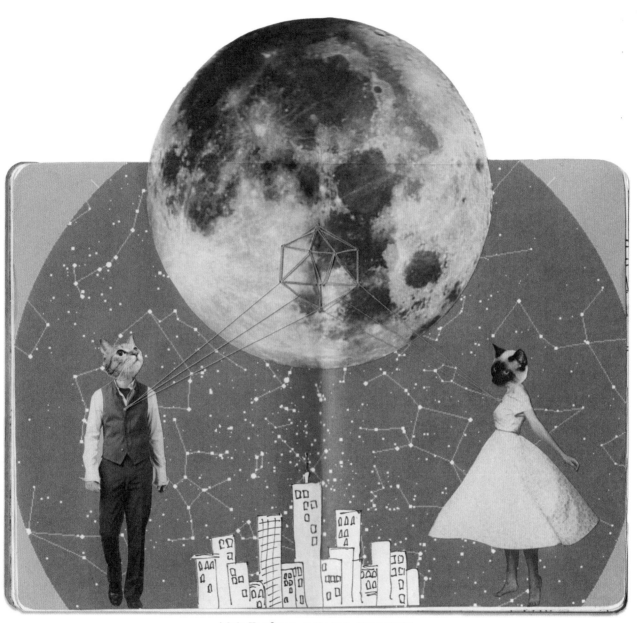

**Adria Kaufman** MADISON, WISCONSIN

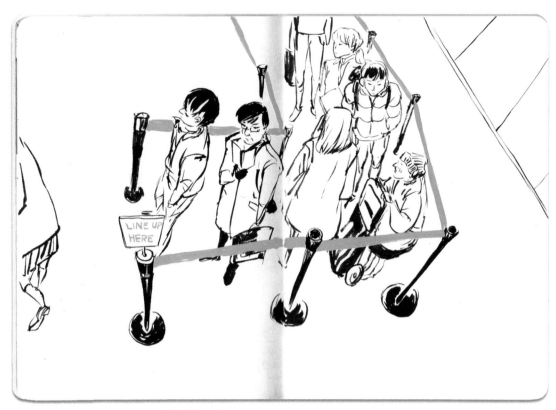

**Wai Khan Au** RICHMOND, BRITISH COLUMBIA

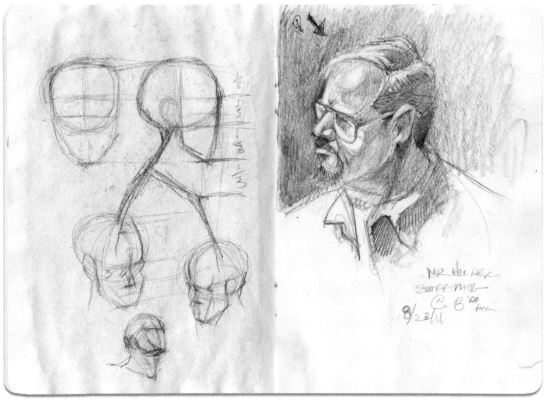

**Steven M. Cozart** GREENSBORO, NORTH CAROLINA

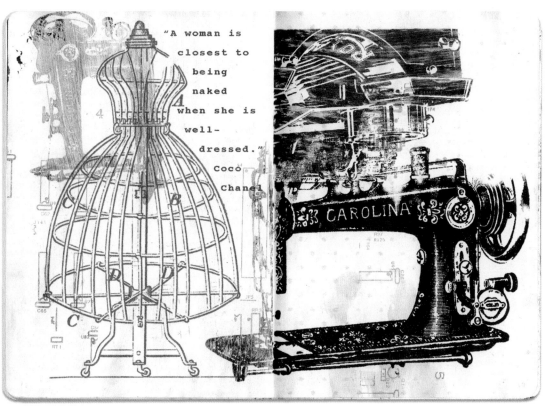

**Monica Gyulai**  BERKELEY, CALIFORNIA

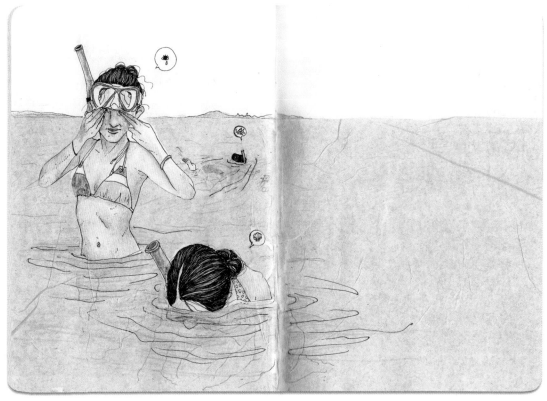

**Julia Yellow**  ASTORIA, NEW YORK

**Wendy Wolf** PHILADELPHIA, PENNSYLVANIA

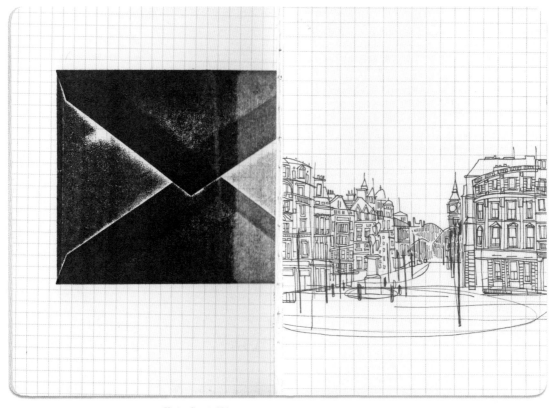

**Kate Castelli** CAMBRIDGE, MASSACHUSETTS

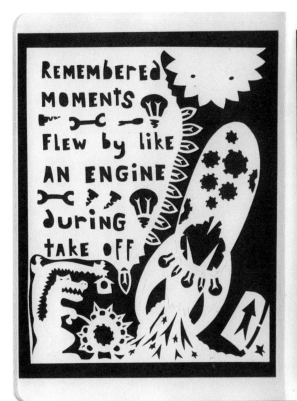

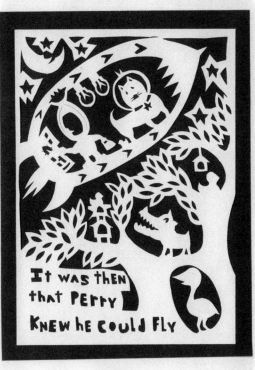

**Jeff Gunn** SANTA CLARA, CALIFORNIA

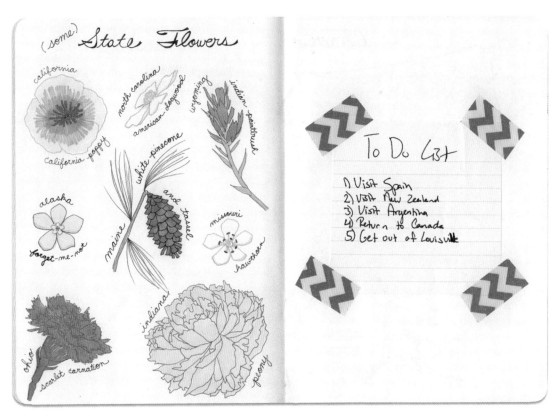

**Meg Mraz** LOUISVILLE, KENTUCKY

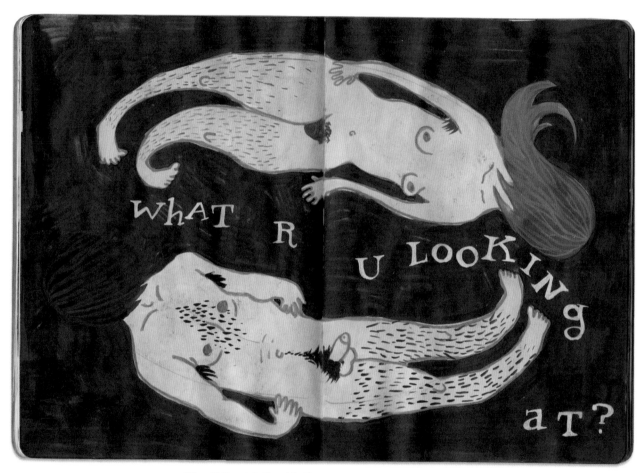

**Kjersti Faret & Cassidy Toner**  NEW YORK, NEW YORK

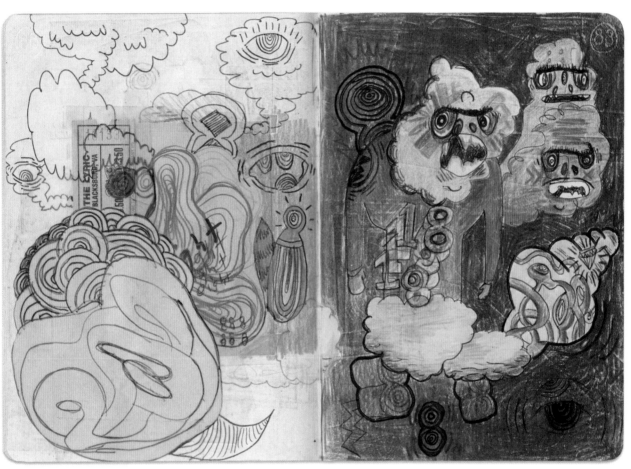

**James Chan** BLACKSBURG, VIRGINIA

**Maria Luisa Santos Cuellar** OAXACA, MEXICO

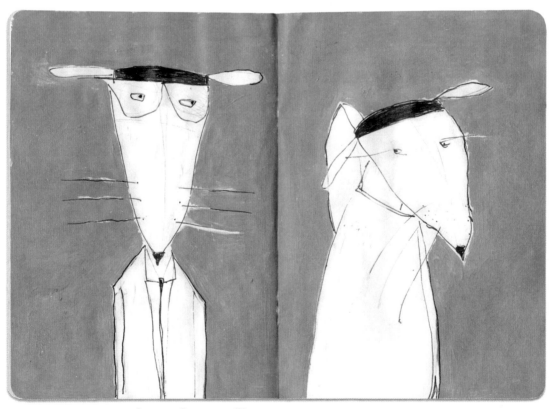

**Suzanne Summersgill** VANCOUVER, BRITISH COLUMBIA

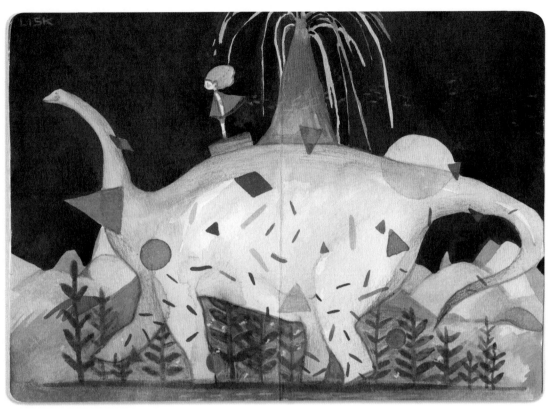

**Stacey Montebello** BALTIMORE, MARYLAND

**Galadrielle Major-Besser** MONTREAL, QUEBEC

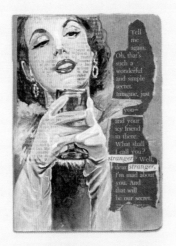

Tell me again. Oh, that's such a wonderful and simple secret. Imagine, just you—and your icy friend in there. What shall I call you? stranger? Well, dear stranger, I'm mad about you. And that will be our secret.

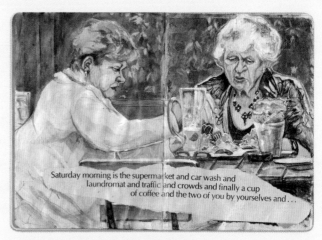

Saturday morning is the supermarket and car wash and laundromat and traffic and crowds and finally a cup of coffee and the two of you by yourselves and . . .

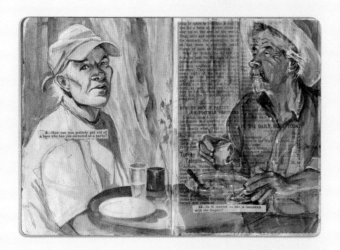

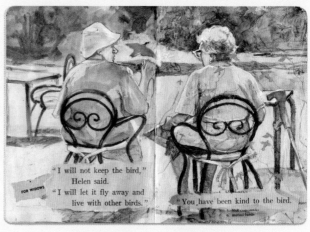

"I will not keep the bird," Helen said.
"I will let it fly away and live with other birds."

"You have been kind to the bird,

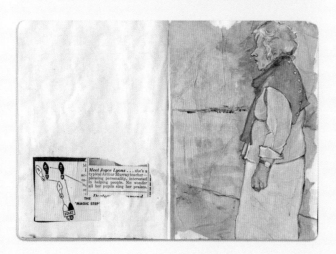

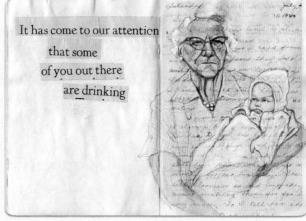

It has come to our attention that some of you out there are drinking

MEET THE ARTIST

## Loralee Vassar

**WEST CHICAGO, ILLINOIS**

**DO YOU HAVE ANY FORMAL ARTISTIC TRAINING? IF SO, WHERE?**
I studied for four years at the American Academy of Art in Chicago.

**WHAT IS YOUR FAVORITE ARTISTIC TOOL?**
Watercolors.

**HAVE YOU ALWAYS KEPT A SKETCHBOOK, OR WAS CREATING YOUR SKETCHBOOK A TOTALLY NEW ENDEAVOR FOR YOU? DID YOU ENTER THE SKETCHBOOK PROJECT WITH CERTAIN GOALS, OR WAS IT MORE OF AN EXPERIMENTAL EXPERIENCE?**
I used to keep a sketchbook for school projects. But somewhere along the way, I stopped, so when this project came along, I decided to pick up where I left off years ago. I wanted to create a sketchbook with expression and meaning to me.

**WHAT DOES YOUR ARTISTIC PROCESS ENTAIL? ARE THERE CERTAIN INSPIRATIONS YOU HOLD DEAR, OR MATERIALS YOU CAN'T LIVE WITHOUT?**
When I see something I think would make an interesting subject, I try to photograph it. Then I do a sketch, with values and composition in mind. Watercolors tend to have a mind of their own, so you go with the flow. I would, however, like to be a little looser with the rendering.

**ARE THERE CERTAIN THEMES THAT RECUR THROUGHOUT YOUR WORK? DESCRIBE ANY VISUAL OR CONCEPTUAL ELEMENTS THAT YOU FIND CENTRAL TO YOUR PROCESS.**
When I do people, I really try to get the expression across. I think the eyes are extremely important, along with the whole body gesture. With landscapes there has to be something that holds my interest, a surprise element.

**HOW DOES YOUR PERSONAL BACKGROUND OR GEOGRAPHIC LOCATION TIE INTO YOUR ARTISTIC PRACTICE?**
I live in the Midwest, so when I travel to tropical locations, it inspires me to use more color. Go outside the usual color palette comfort zone.

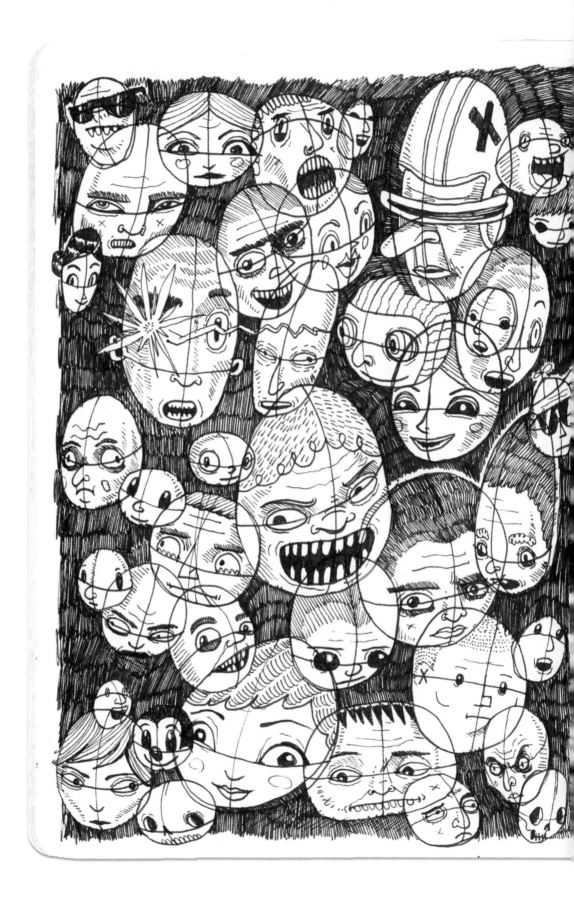

46

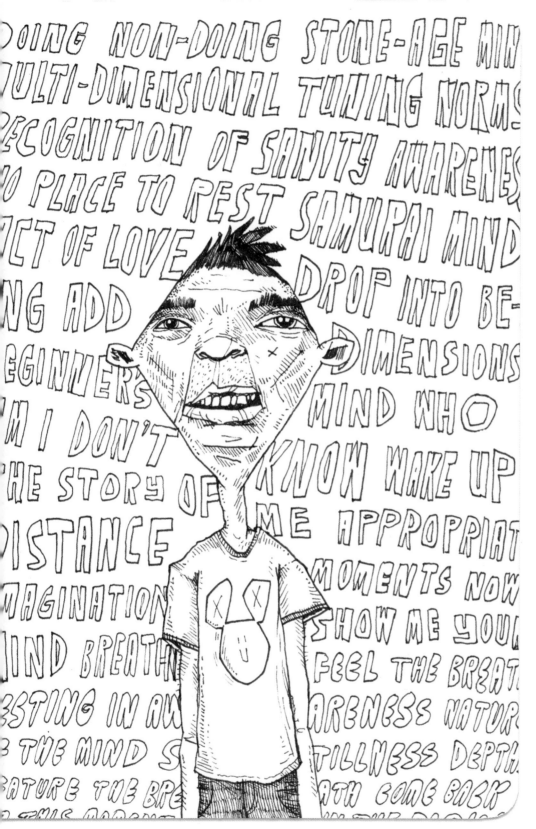

**Greg Kletsel** BROOKLYN, NEW YORK

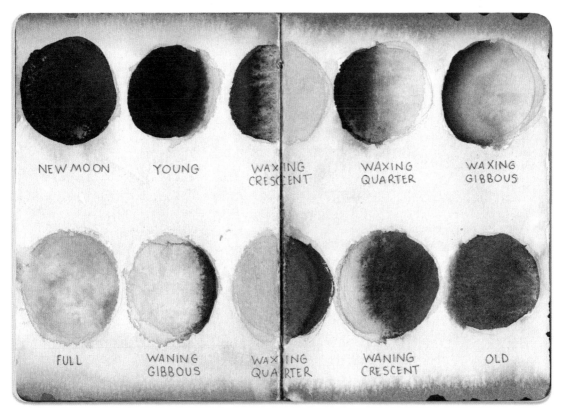

NEW MOON   YOUNG   WAXING CRESCENT   WAXING QUARTER   WAXING GIBBOUS

FULL   WANING GIBBOUS   WAXING QUARTER   WANING CRESCENT   OLD

**Amanda Nicole White**  TORONTO, ONTARIO

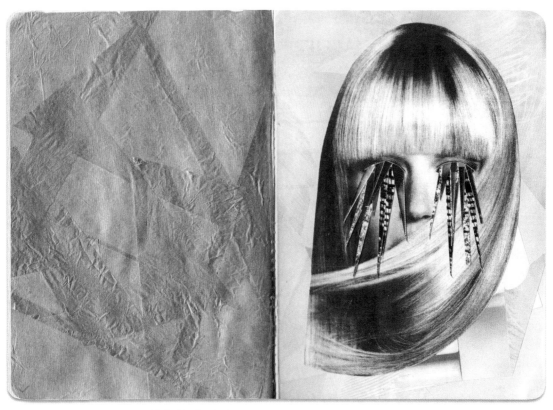

**Michelle Yee & Sol Lanzillotta**  TORONTO, ONTARIO

**David T. Miller** AMBLER, PENNSYLVANIA

**Adam Sanford** CHATSWORTH, GEORGIA

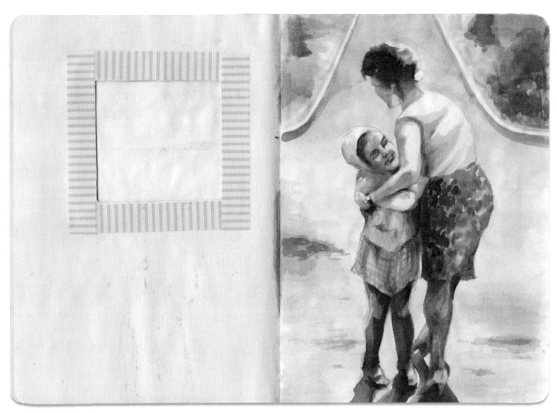

**Oleksandra Korobova** TORONTO, ONTARIO

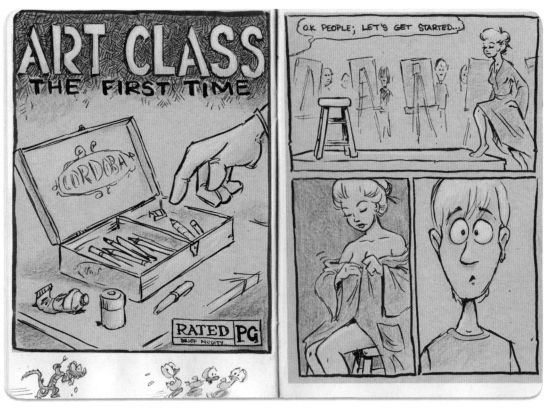

**Tim Hodge** THOMPSON'S STATION, TENNESSEE

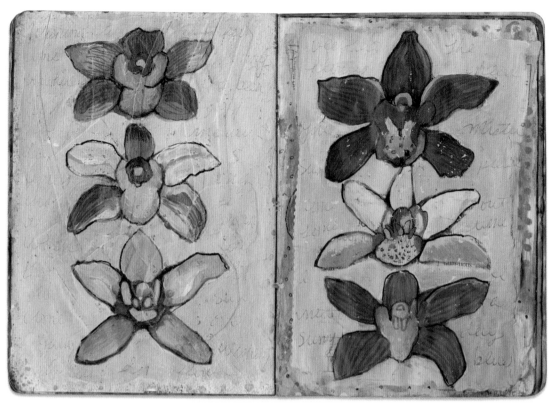

**Cate Christen Waung**  BOLTON, CONNECTICUT

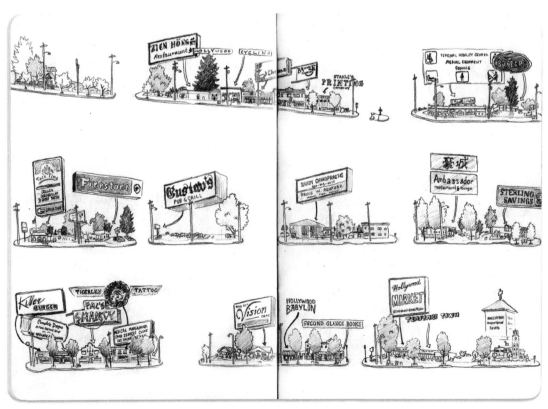

**Jill Quickenbush**  PORTLAND, OREGON

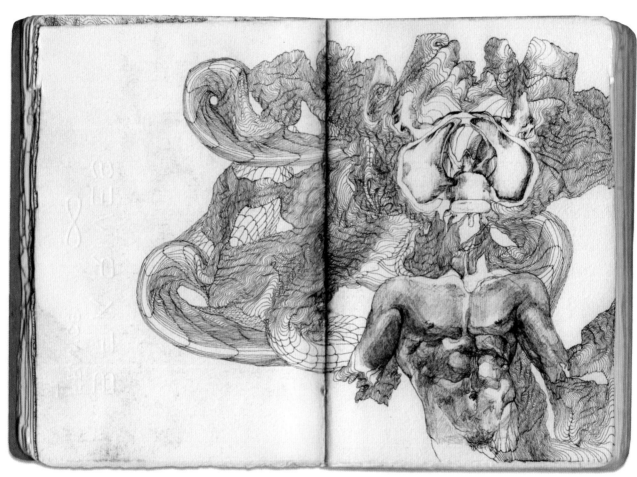

**Beth Brown** BALTIMORE, MARYLAND

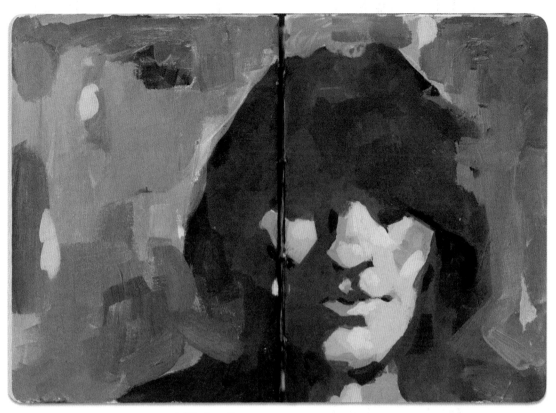

**Meghan Jean** OAKLAND, CALIFORNIA

**Jordan Kay** SEATTLE, WASHINGTON

Lauren Schroer  CHICAGO, ILLINOIS

Rob Jelinski  BLOOMFIELD, NEW JERSEY

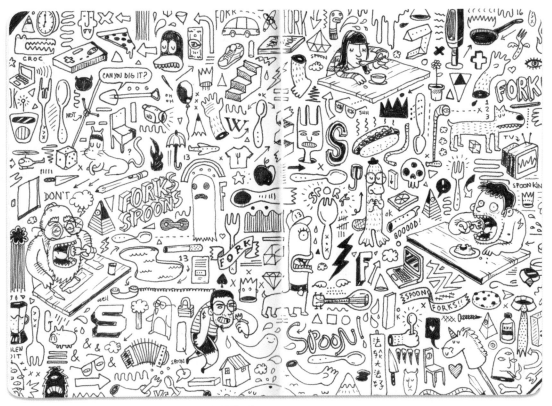

**OrlandoSOYyo!** CAGUAS, PUERTO RICO

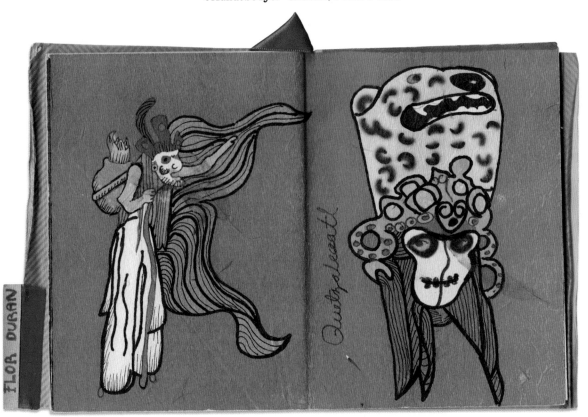

**Flor Duran** VALLE DE LAS PALMAS, MEXICO

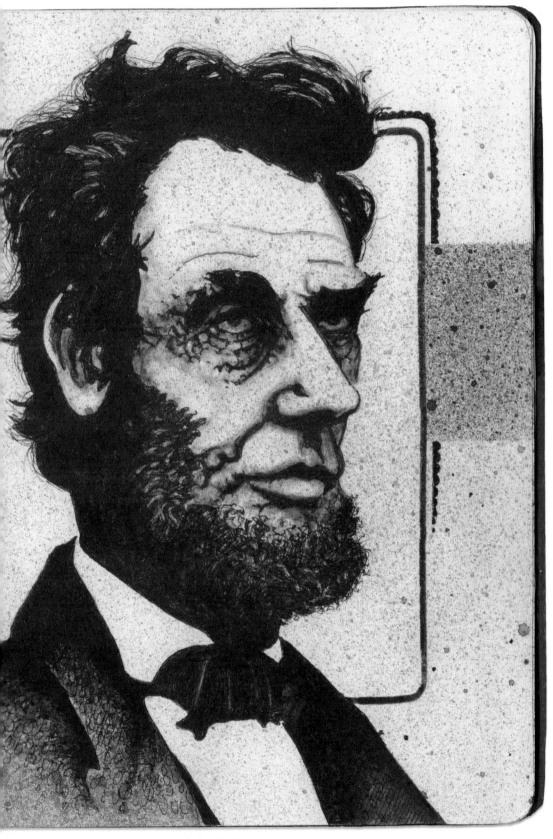

**Joseph R. Tomlinson**  SPOKANE, WASHINGTON

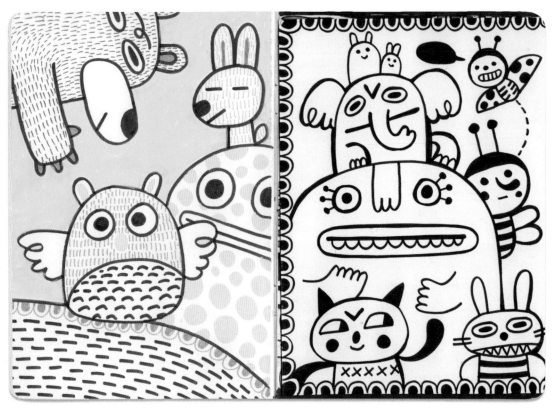

Laura Osorno  BROOKLYN, NEW YORK

Julie Pinzur  BROOKLYN, NEW YORK

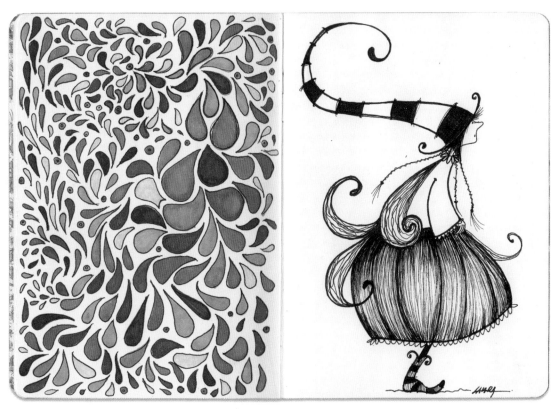

**Laura Mendoza Vela**  SANTA TECLA, EL SALVADOR

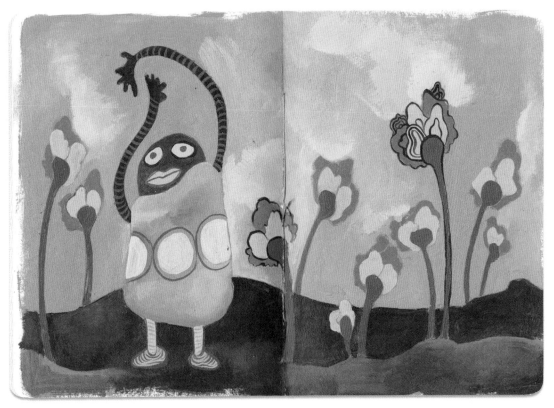

**Heather Reinhardt**  CALGARY, ALBERTA

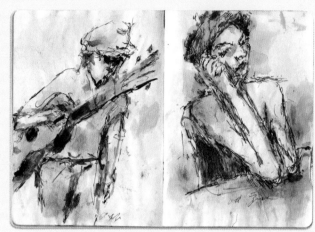
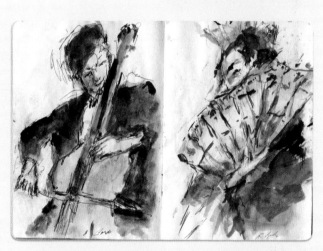
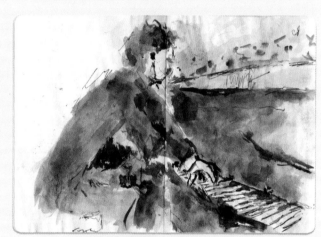
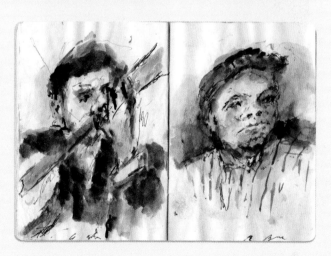
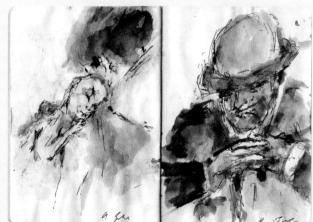

MEET THE ARTIST

# Anthony J. Zaremba

**WHITING, NEW JERSEY**

**DO YOU HAVE ANY FORMAL ARTISTIC TRAINING? IF SO, WHERE?**

I studied at the School of Visual Arts in New York City during the 1960s.

**WHAT IS YOUR FAVORITE ARTISTIC TOOL?**

A paintbrush.

**HAVE YOU ALWAYS KEPT A SKETCHBOOK, OR WAS CREATING YOUR SKETCHBOOK A TOTALLY NEW ENDEAVOR FOR YOU? DID YOU ENTER THE SKETCHBOOK PROJECT WITH CERTAIN GOALS, OR WAS IT MORE OF AN EXPERIMENTAL EXPERIENCE?**

Since childhood I've always kept a sketchbook and pen or pencil nearby. My artwork today is mainly created with watercolors, but before starting a painting, I make a preparatory sketch. The sketch allows me to gauge depth and perception in my pencil drawing before applying my watercolor wash. The finished painting does not look exactly like the sketch, but it is very helpful to use as a guide. I have entered The Sketchbook Project for three consecutive years now, and my sketchbooks have contained the types of sketches that I use in my paintings of musicians, dancers, and everyday people I see and study.

**WHAT DOES YOUR ARTISTIC PROCESS ENTAIL? ARE THERE CERTAIN INSPIRATIONS YOU HOLD DEAR, OR MATERIALS YOU CAN'T LIVE WITHOUT?**

I have multiple sclerosis, which has affected my fine coordination in my dominant right hand. Due to the MS progression, it took me three years to retrain my left hand to do what my right hand used to do. I cannot stand to paint with a floor easel, so my wooden tabletop easel is the most important tool I use to create my paintings. I am inspired by the Masters. My favorite painters are varied in their style: Picasso, Velázquez, Goya, Lautrec, Sargent, and Rembrandt.

**ARE THERE CERTAIN THEMES THAT RECUR THROUGHOUT YOUR WORK? DESCRIBE ANY VISUAL OR CONCEPTUAL ELEMENTS THAT YOU FIND CENTRAL TO YOUR PROCESS.**

I consider myself a people painter. I seldom paint landscapes and love to capture the moment in time or the expression of a person dancing, playing a musical instrument, or reading. Musicians, ballet, ballroom dancing, fishing, and sports are my favorite themes, and they often recur throughout my work. Visually, I must paint with an easel to gain correct proportion and size in my paintings.

**HOW DOES YOUR PERSONAL BACKGROUND OR GEOGRAPHIC LOCATION TIE INTO YOUR ARTISTIC PRACTICE?**

I was born and raised in New York City. Growing up in a population of diverse people and being an observant people watcher definitely impacted my painting. Depicted in many of my watercolors are memories of life experiences shared with others in New York and depictions of people I have observed at work or play.

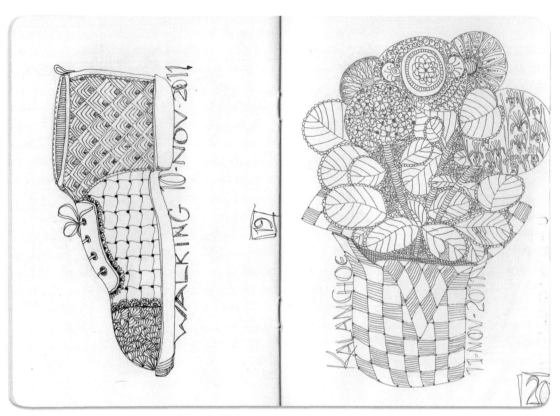

**Ruby Opaltones**  ST. MARYS, ONTARIO

**Cristina Anichini**  CHICAGO, ILLINOIS

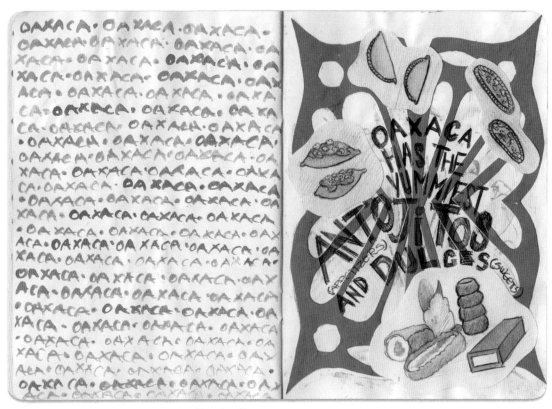

**Romina Perez** OAXACA, MEXICO

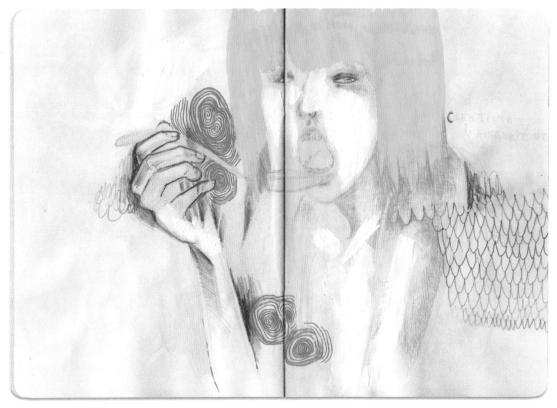

**Robyn Rognstad** COLUMBIA, SOUTH CAROLINA

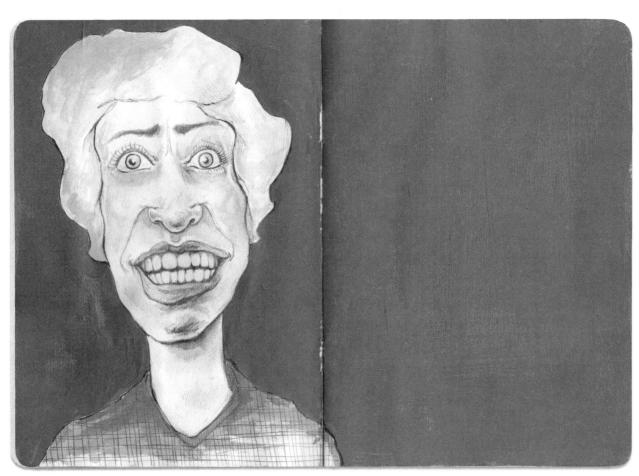

**Jessy Butts** YPSILANTI, MICHIGAN

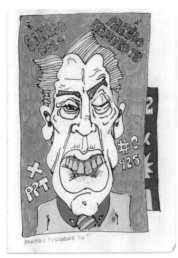

**Manuel A. Torres**
SAN JUAN, PUERTO RICO

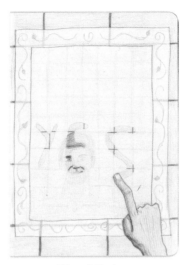

**Miguel Castro**
VALLE DE LAS PALMAS, MEXICO

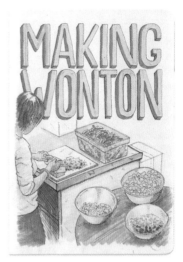

**Steven Weigh**
VANCOUVER, BRITISH COLUMBIA

**Roxanne Philipps**
BROOKLYN, NEW YORK

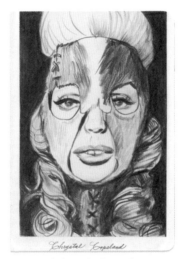

**Aristotle Rosario**
NEW YORK, NEW YORK

**Julia Prime**
TORONTO, ONTARIO

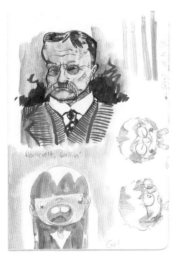

**Tony Wisneske**
SAN DIEGO, CALIFORNIA

**Brandon Schaaf**
INDIANAPOLIS, INDIANA

**Carmen Hickson**
GEORGETOWN, ONTARIO

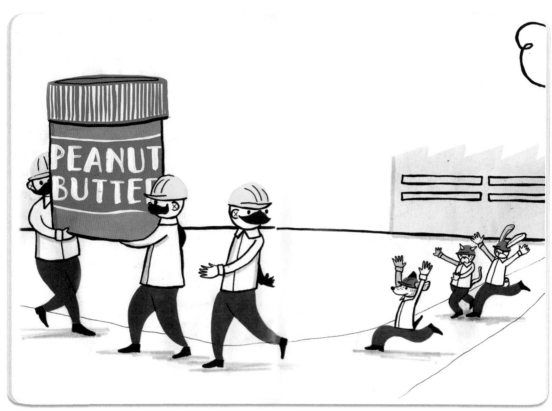

Emily Balsley MADISON, WISCONSIN

Christine Robinson NEWBURYPORT, MASSACHUSETTS

**Elizabeth Reed Smith** INDIANOLA, WASHINGTON

**Jennifer Kosharek** ST. PETERSBURG, FLORIDA

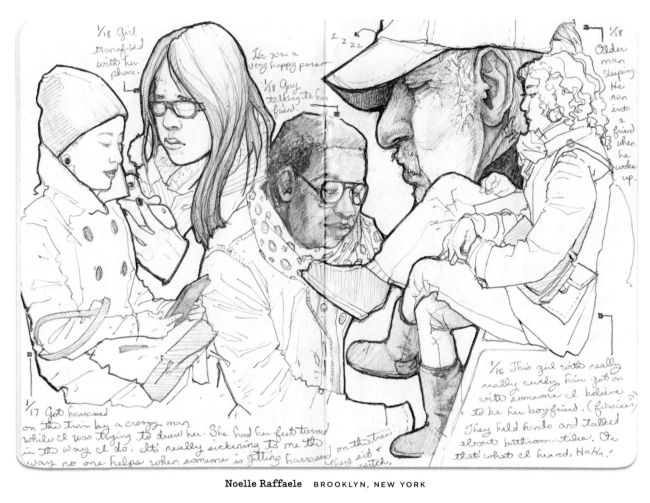

1/18 Girl transfixed with her phone.

He was a very happy person.

1/18 Guy talking to his friend.

zzzzz

1/18 Older man sleeping. He ran into a friend when he woke up.

1/17 Got harrassed on the train by a crazy man while I was trying to draw her. She had her feet turned in the way I do. It's really sickening to me the way no one helps when someone is getting harrassed on the train. They sit & watch.

1/16 This girl with really really curly hair got on with someone I believe to be her boyfriend. (furrier) They held hands and talked about bathroom tiles. Or that's what I heard. HaHa!

**Noelle Raffaele**  BROOKLYN, NEW YORK

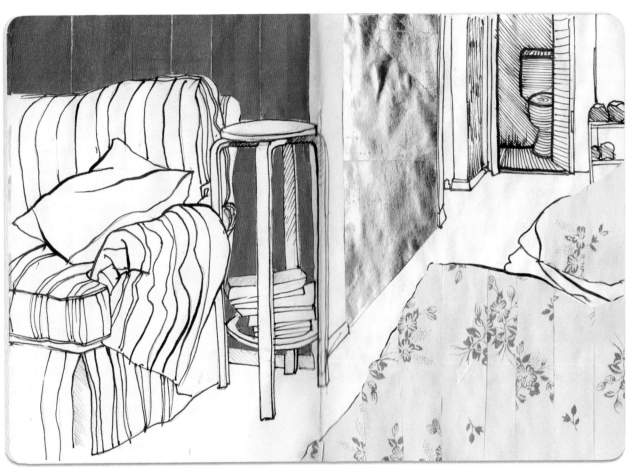

**Emily Heidel Jaderberg**  FALLS CHURCH, VIRGINIA

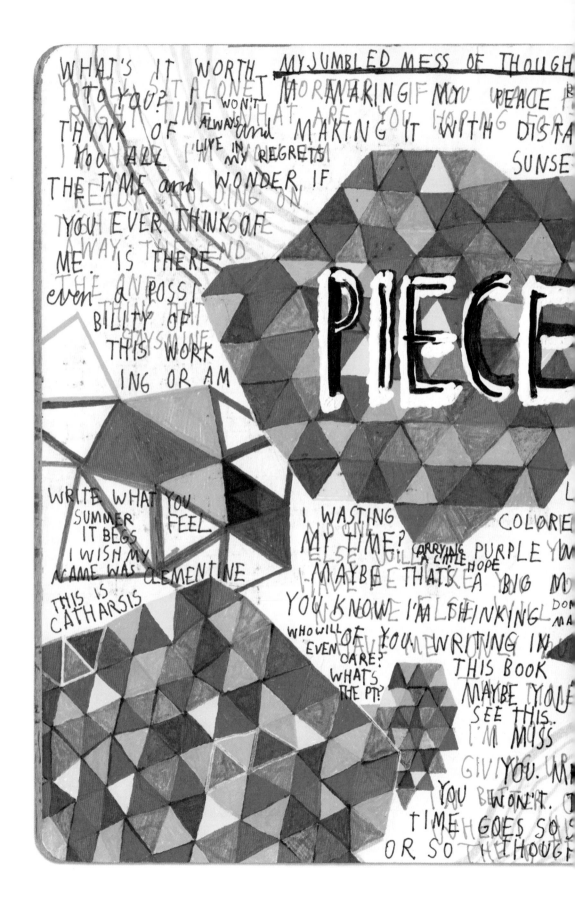

WHAT'S IT WORTH MY JUMBLED MESS OF THOUGH
TO YOU? WHY SIT ALONE I MORE MAKING IF MY PEACE
RIGHT TIME WHAT ARE YOU HOPING FOR
THINK OF ALWAYS and MAKING IT WITH DISTRA
I YOU ALL I LIVE IN MY REGRETS SUNSE
THE TIME and WONDER IF
READY HOLDING ON
YOU EVER THINK OF
ALWAYS THE END
ME. IS THERE
THE AND
even a POSSI-
TELLING THAT
BILITY OF IT
SAYS MINE
THIS WORK
ING OR AM

PIECE

WRITE WHAT YOU
SUMMER FEEL
IT BEGS
I WISH MY
NAME WAS CLEMENTINE

THIS IS
CATHARSIS

I WASTING COLORE
MY TIME? CARRYING PURPLE YO
A LITTLE HOPE
MAYBE THAT'S A BIG M
YOU KNOW I'M THINKING
WHO WILL OF YOU WRITING IN
EVEN CARE? THIS BOOK
WHAT'S MAYBE YOU
THE PT? SEE THIS..
I'M MISS
GIV YOU
YOU B WON'T.
TIME GOES SO
OR SO THE THOUG

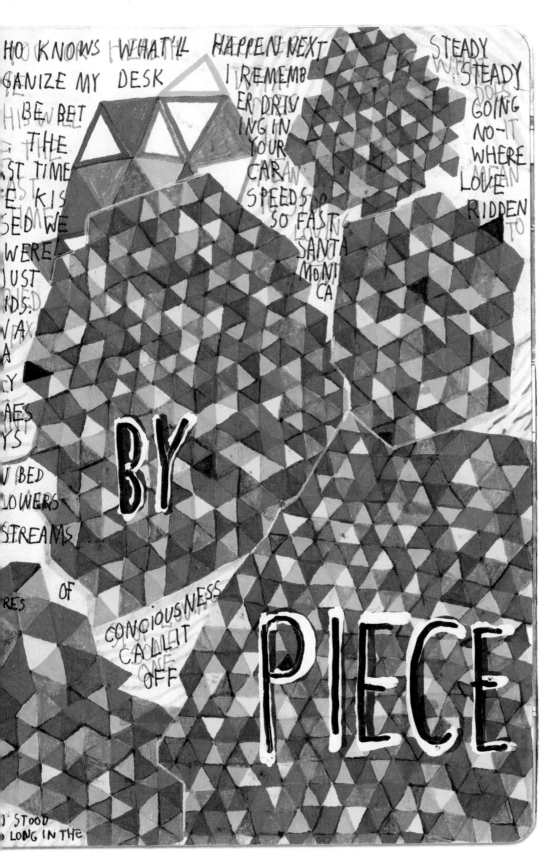

HO KNOWS WHAT'LL HAPPEN NEXT / GANIZE MY DESK / I REMEMB ER DRIVING IN YOUR CAR AN SPEEDS SO FAST SANTA MONI CA / STEADY STEADY GOING NO-IT WHERE LOVE RIDDEN

BE BET THE ST TIME ES KIS SED WE WERE JUST RDS. A Y AES YS BED LOWERS STREAMS OF

BY

CONCIOUSNESS CALL IT OFF

PIECE

I STOOD LONG IN THE

**Beverly Ealdama** CHINO, CALIFORNIA

71

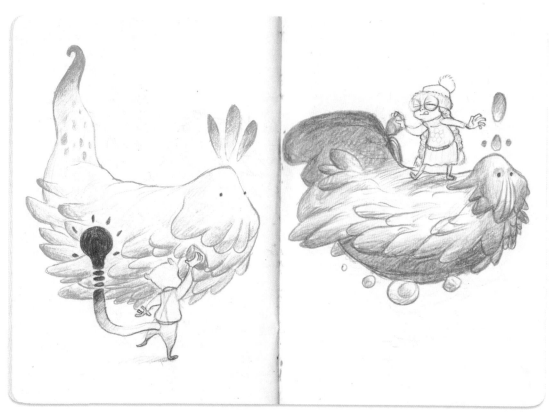

**Sho Uehara** STRATHMORE, ALBERTA

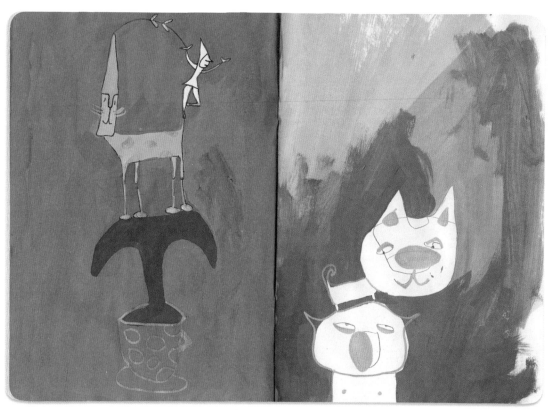

**Laia Jufresa** XALAPA, MEXICO

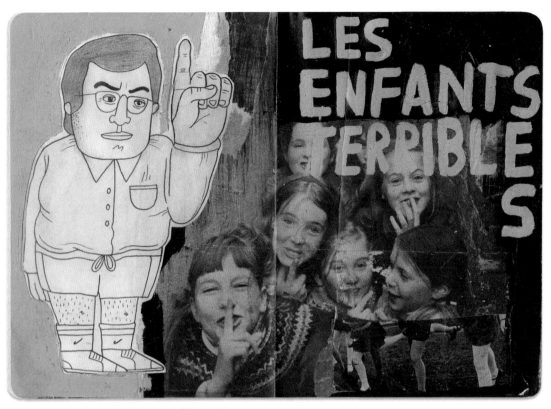

**Alberto Pazzi**  BROOKLYN, NEW YORK

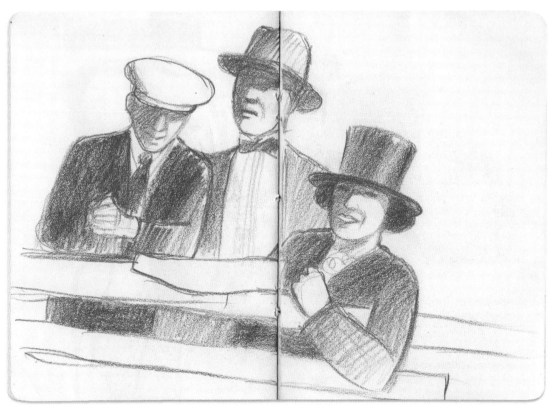

**Jamie Hogan**  PEAKS ISLAND, MAINE

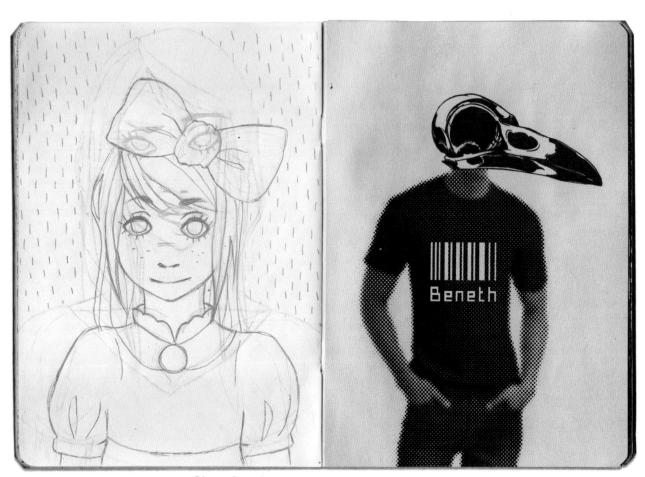

Bianca Gonzalez  VALLE DE LAS PALMAS, MEXICO

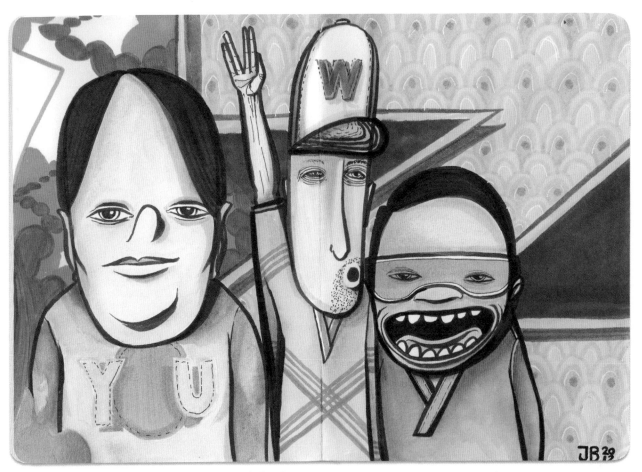

**Joseph Brooks** SEATTLE, WASHINGTON

# SOUTH AMERICA

The submissions from South America always impress us with their ingenuity and expression. Over the years, the submissions have been vibrant and imaginative, wonderfully playful, and laced with daydreams and nostalgia. The images that typify books from this region are full of stories and life, offering individuals who have the opportunity to flip through them a chance to slip away into another world altogether. With elegant attention to detail and a real sense of emotion, these books have a sincerity all their own.

One thing is certain about the artists from South America: their work asks viewers to stop and think, to analyze the beauty, colorfulness, and simplicity of everyday life. Full of interpretive possibility and potential, some of the work invites us to exercise our own freedom to imagine what *could* be occurring. The sketchbook spreads you'll see in this selection do just that.

The polished lines found in the sketchbook submitted by Yara Fukimoto from Brazil leave us wondering why, if the world can be designed with such simplicity, such beauty, don't we build it that way? Estefania Malic from Argentina inserts Peruvian imagery next to drawings of Nepal, using the familiar form of a travelogue to bring the viewer on a global journey. Victor Rissatto's sketchbook features animals that, on first glance, seem to fit perfectly within the vast landscapes of South America, yet upon further inspection, are fantastical creatures from the artist's imagination.

Cluttered, pattern-like line drawings can be compared to the sprawling city of São Paulo; floating figures in blues and purples can remind us of a delicate sea creature drifting off the coast of Argentina. The artistry found in the sketchbooks from South America adds to the collection a sense of ingenuity and vision, taking the ordinary and turning it into something completely original, challenging perceptions and representations of a continent with such variegated cultures.

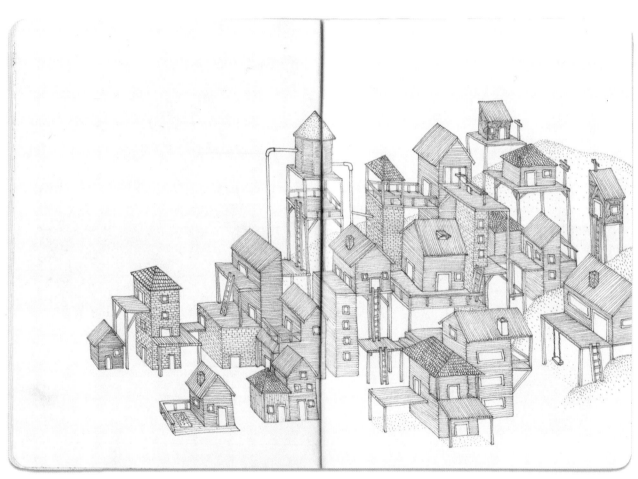

**Yara Fukimoto** SÃO PAULO, BRAZIL

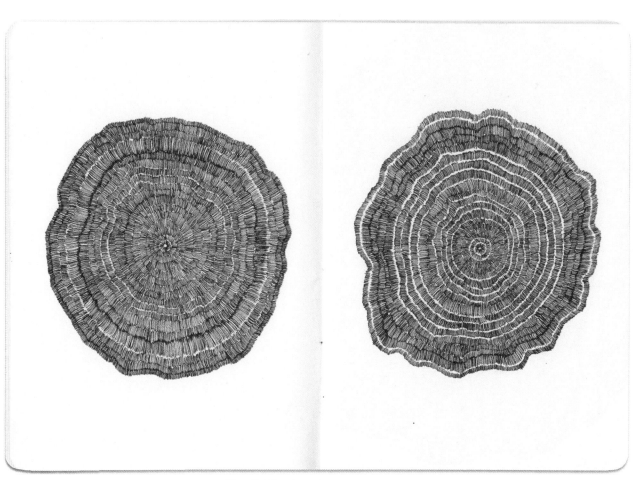

**Yara Fukimoto** SÃO PAULO, BRAZIL

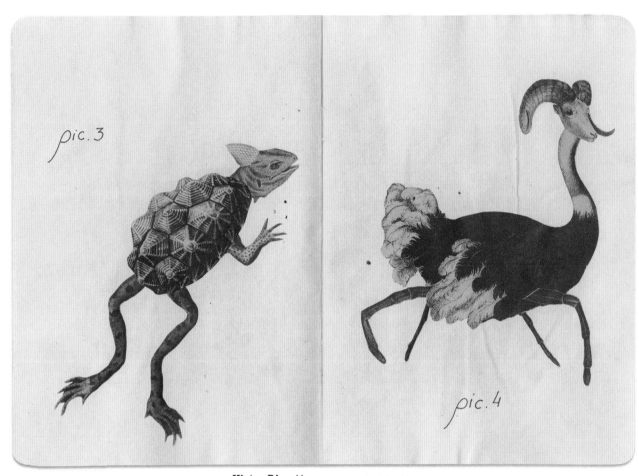

pic.3

pic.4

**Victor Rissatto** CAMPINAS, BRAZIL

**Raúl Olmo** BOGOTÁ, COLOMBIA

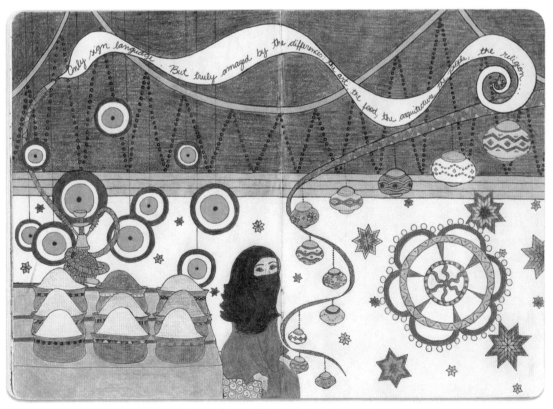

**Lorena Braun Prado** SANTOS, BRAZIL

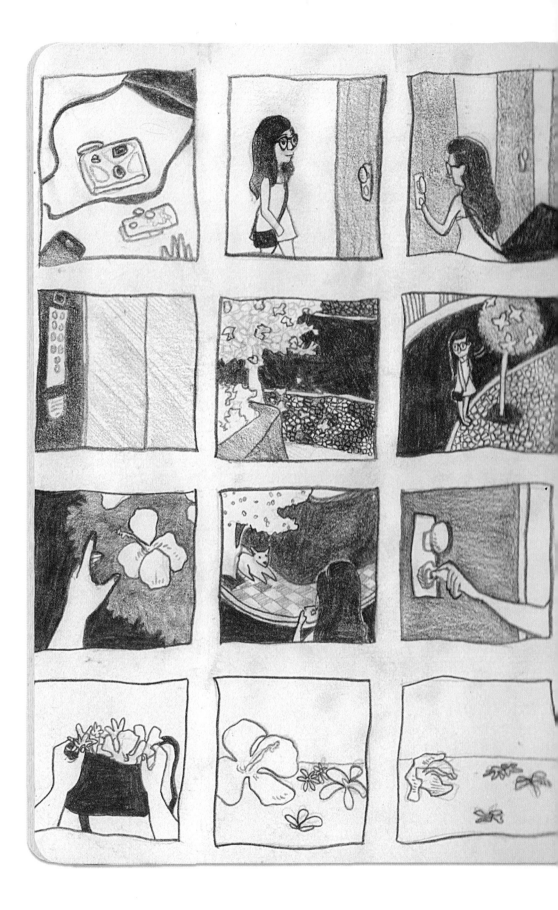

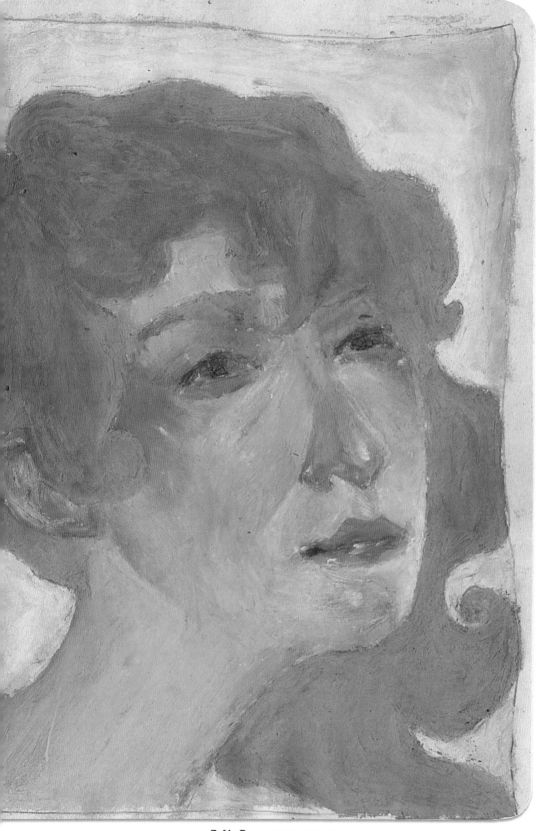

**Julia B.** SANTOS, BRAZIL

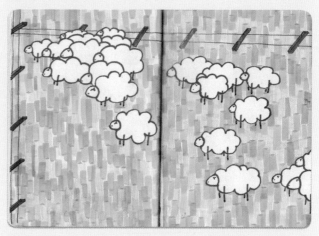

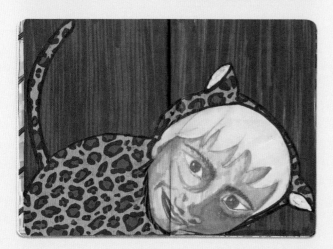

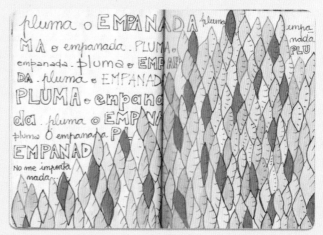

# Lulu Gueron

**BUENOS AIRES, ARGENTINA**

**DO YOU HAVE ANY FORMAL ARTISTIC TRAINING? IF SO, WHERE?**

I'm an architect and a dancer, but I have not studied drawing.

**WHAT IS YOUR FAVORITE ARTISTIC TOOL?**

I don't have a favorite; I like to try different tools.

**HAVE YOU ALWAYS KEPT A SKETCHBOOK, OR WAS CREATING YOUR SKETCHBOOK A TOTALLY NEW ENDEAVOR FOR YOU? DID YOU ENTER THE SKETCHBOOK PROJECT WITH CERTAIN GOALS, OR WAS IT MORE OF AN EXPERIMENTAL EXPERIENCE?**

I used to have sketchbooks when I was a teenager. I entered The Sketchbook Project just for an experimental experience, and it was fun.

**WHAT DOES YOUR ARTISTIC PROCESS ENTAIL? ARE THERE CERTAIN INSPIRATIONS YOU HOLD DEAR, OR MATERIALS YOU CAN'T LIVE WITHOUT?**

I just work with what I have near. For the sketchbook, I discovered markers and enjoyed the possibilities of this tool.

**ARE THERE CERTAIN THEMES THAT RECUR THROUGHOUT YOUR WORK? DESCRIBE ANY VISUAL OR CONCEPTUAL ELEMENTS THAT YOU FIND CENTRAL TO YOUR PROCESS.**

I like drawing characters; they usually are children. They express feelings of moments I have been through, or are evocative of people I know.

**HOW DOES YOUR PERSONAL BACKGROUND OR GEOGRAPHIC LOCATION TIE INTO YOUR ARTISTIC PRACTICE?**

I travel a lot and spend a lot of time in the mountains, and my artistic practice travels with me. When I have wood, I carve it; if I have wool, I knit it; if I have paper and paint, acrylic, or a pencil, I draw. I always have.

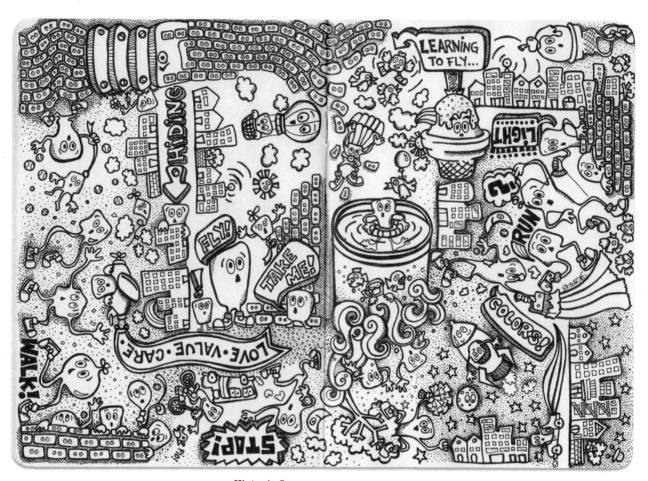

Victoria Suarez  CALI, COLOMBIA

**General Limbo** SÃO PAULO, BRAZIL

**Maria Julia Goyena**  BUENOS AIRES, ARGENTINA

**Lucas Aoki**  CÓRDOBA, ARGENTINA

**Cafundo**  FLORIANOPÓLIS, BRAZIL

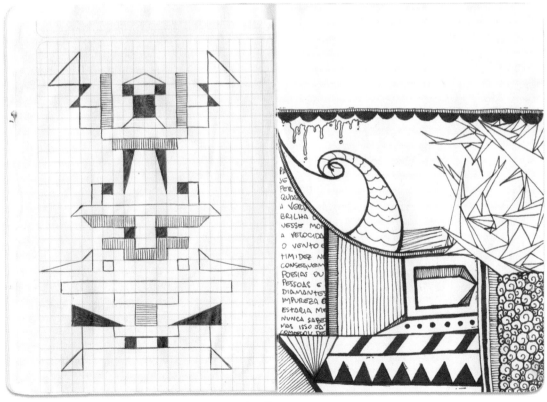

**Lucas Sousa Gondim**  GOIÂNIA, BRAZIL

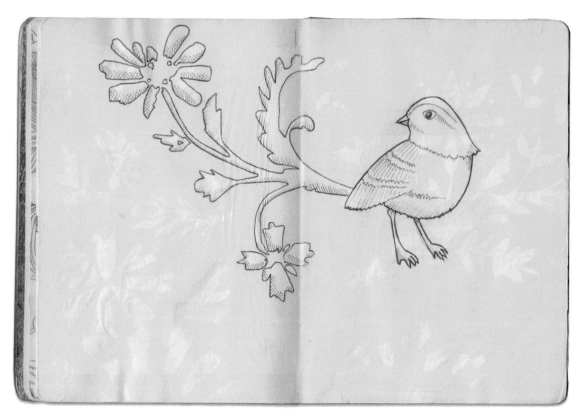

**Jorge Luis Miraldo**  BUENOS AIRES, ARGENTINA

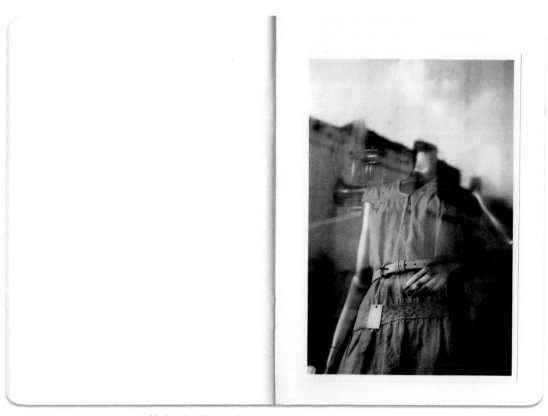

**Alejandro Alonso Estrella**  PINAR DEL RIO, CUBA

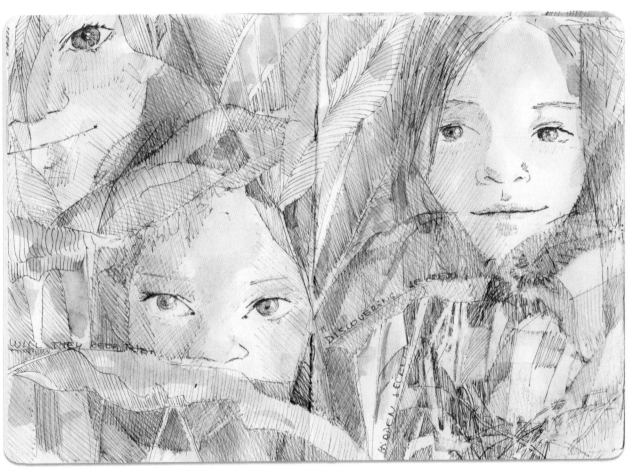

**Veronica Belcher**  BUENOS AIRES, ARGENTINA

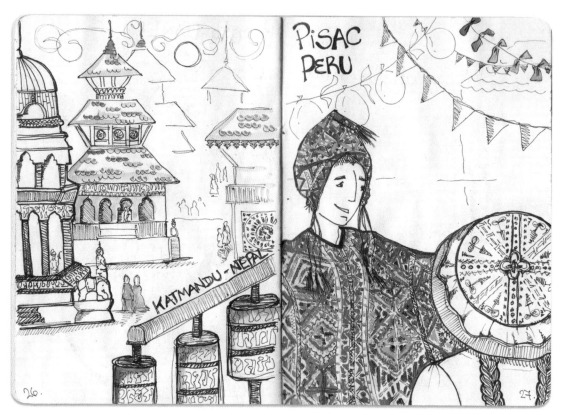

**Estefania Malic**  BUENOS AIRES, ARGENTINA

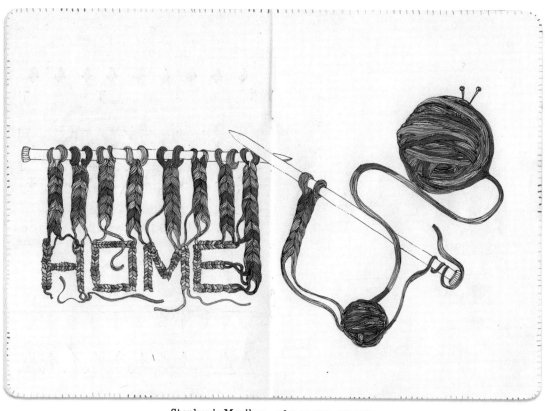

**Stephanie Marihan**  SÃO PAULO, BRAZIL

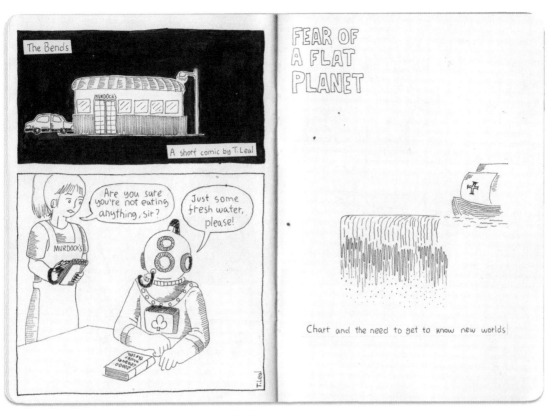

**Thiago C.A. Leal** JOÃO PESSOA, BRAZIL

**Mo Lehms** SANTIAGO, CHILE

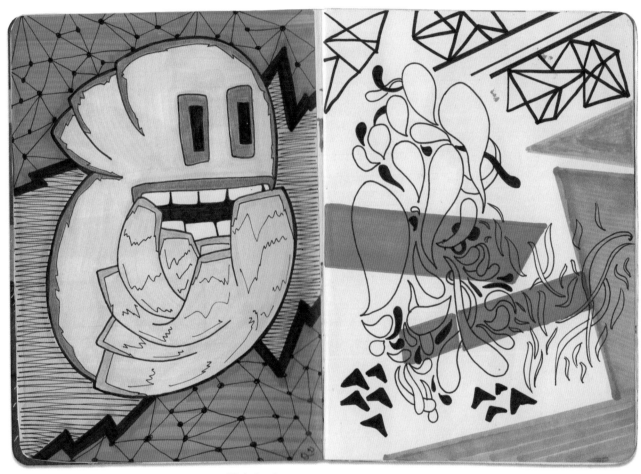

**Majo Quelas** CÓRDOBA, ARGENTINA

LUCIANO SALLES - FROM BRAZIL, ARARAQUARA SP

ABOUT.ME/LUCIANOSALLES

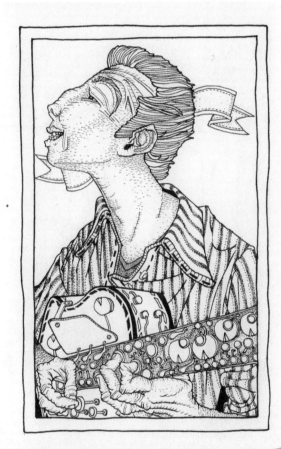

**Luciano Salles**  ARARAQUARA, BRAZIL

oject

Heroes and villains

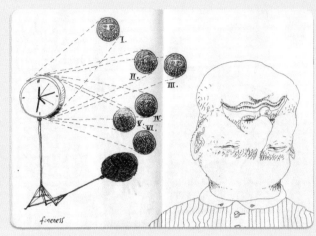

fineness

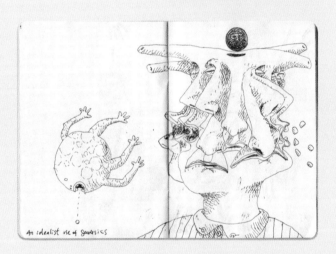

An idealist use of geodesics

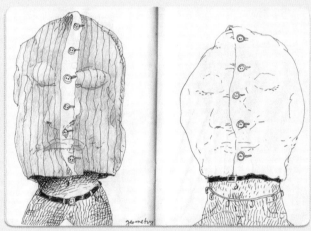

geometry

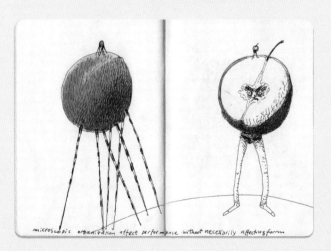

microscopic organisation affect performance without necessarily affecting form

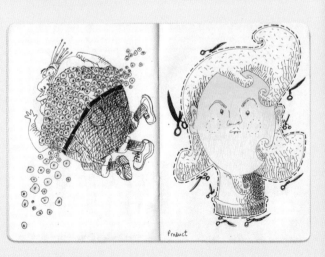

Product

# Carlos Campos

**BUENOS AIRES, ARGENTINA**

**DO YOU HAVE ANY FORMAL ARTISTIC TRAINING? IF SO, WHERE?**

I have a PhD in architecture and contemporary music. I teach design as a full professor in Buenos Aires and as a visiting professor in the United States, Italy, Germany, and Russia.

**WHAT IS YOUR FAVORITE ARTISTIC TOOL?**

Pencil and pen.

**HAVE YOU ALWAYS KEPT A SKETCHBOOK, OR WAS CREATING YOUR SKETCHBOOK A TOTALLY NEW ENDEAVOR FOR YOU? DID YOU ENTER THE SKETCHBOOK PROJECT WITH CERTAIN GOALS, OR WAS IT MORE OF AN EXPERIMENTAL EXPERIENCE?**

I have dozens of sketchbooks in my studio. I usually sketch in large format (50 x 70 cm) during my travels in Europe every year. Sketching is a cognitive experience to me. I prefer to ask my students to do sketching trips, leaving cameras at home. I use pencil, pen, charcoal, ink, water, pencil, and, often, coffee or tea.

**WHAT DOES YOUR ARTISTIC PROCESS ENTAIL? ARE THERE CERTAIN INSPIRATIONS YOU HOLD DEAR, OR MATERIALS YOU CAN'T LIVE WITHOUT?**

Usually I spend a couple of hours per 50 x 70 cm sketch in Venice. No plan, no frame, no structure. I start from one specific point, "scanning" the view, never returning to the same point once I've defined a line. I find this process fascinating, risky, and very precise. Sometimes I experiment with scribbling, or using randomness to affect my drawings. Every sketch is a challenge.

**ARE THERE CERTAIN THEMES THAT RECUR THROUGHOUT YOUR WORK? DESCRIBE ANY VISUAL OR CONCEPTUAL ELEMENTS THAT YOU FIND CENTRAL TO YOUR PROCESS.**

A sketch always "blocks" a perception. I mean, I am in front of this square, or building, or sculpture. Now, I start to replace each perception with a delicate line. And the perception is gone. Some new, weaker substitute has emerged. A sketch. Something I used to see through, something others will experience as a substitution, a beautiful waste of an achieved experience.

**HOW DOES YOUR PERSONAL BACKGROUND OR GEOGRAPHIC LOCATION TIE INTO YOUR ARTISTIC PRACTICE?**

I teach abroad all the time. I travel a lot, indeed. Geographical location is a chimera. All that counts is one's cultural approach to each site. Istanbul, full of smells and songs, remains within our drawings. Berlin, Rome, Moscow, or New York can't be defined by lines. Lines define me, as I choose them.

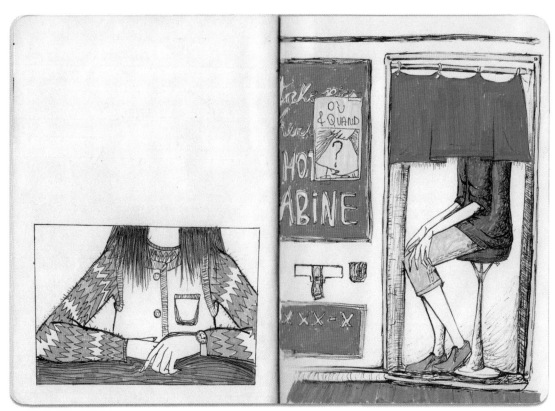

**Amanda Paschoal**  SANTA BÁRBARA D'OESTE, BRAZIL

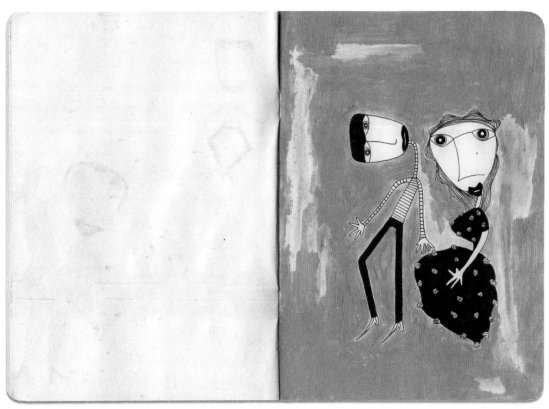

**Adriana Seiffert**  RIO DE JANEIRO, BRAZIL

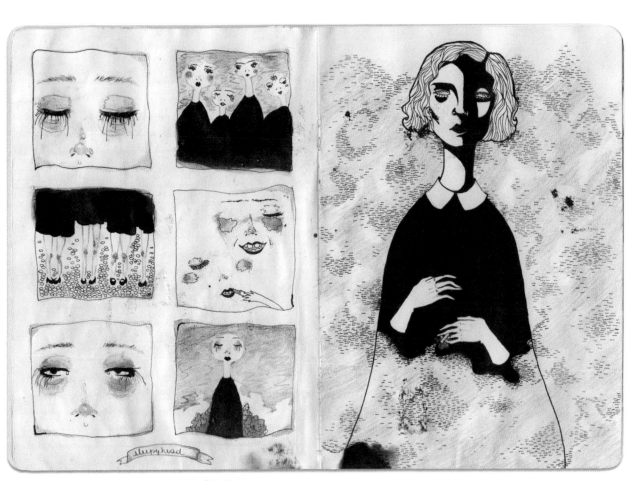

**Natália Schiavon**  SÃO JOSÉ DO RIO PRETO, BRAZIL

**Sheila Cristina (She)**  SÃO PAULO, BRAZIL

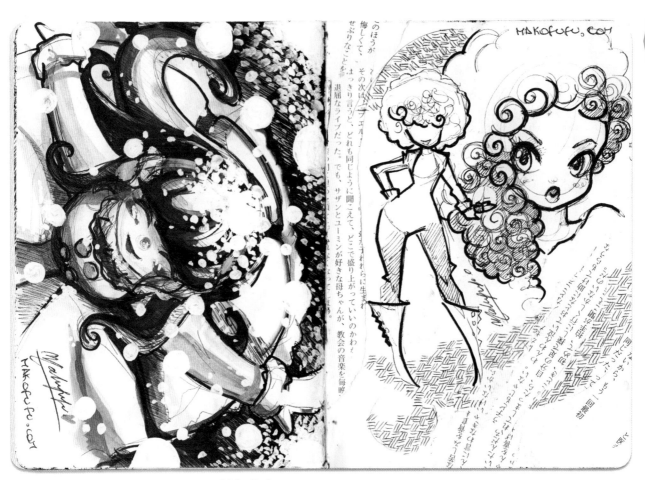

**Mako Fufu**  BUENOS AIRES, ARGENTINA

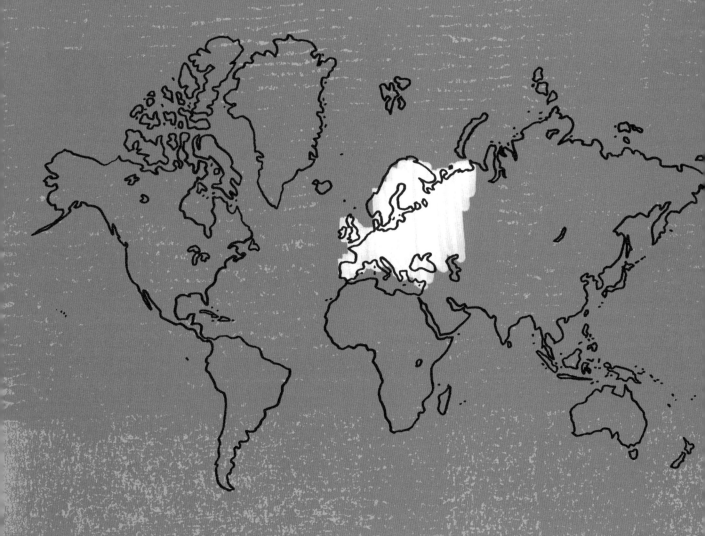

# EUROPE

At the Brooklyn Art Library, one of the most popular regions visitors search for is Europe. Sometimes, the visitor might be from Europe, curious to see work from their hometown. But just as often, we see local people more interested in books from abroad than books from their own city.

Maybe the popularity of this region stems from a love for everything Spanish or Italian or Dutch, and a desire for a glimpse into the everyday life of that culture. In many of the sketchbooks from Europe, we can see the heavy influence of architecture on the people living there. From the detailed building renderings by Francois Pensec from France to the indigo blue drawings of British artist Charlotte Vallance, the backdrop of rich historical cities proves to be a great resource for artists. These books whisk viewers into the bustling streets of France or England, without the hassle of international travel.

The sketchbooks from Europe also display a visual depth particular to this region. Maybe it comes from the layers of languages and cultures condensed into the continent. Maybe it stems from the influence of the work of the Old Masters, heavily layered in thick oil paint. Whatever the reason, something brings out a rich, and sometimes visually dark, quality in many of the sketchbooks from Europe. Romanian artist Adriana Fari-Palko depicts a dark, mysterious face staring into the eyes of the viewer.

As varied as all the flags of Europe, so too is the work submitted from the region. The apparent themes are just some of the representations of the vastly different artists from Europe in The Sketchbook Project. With a sense of wonderment and exploration, one can jump from country to country.

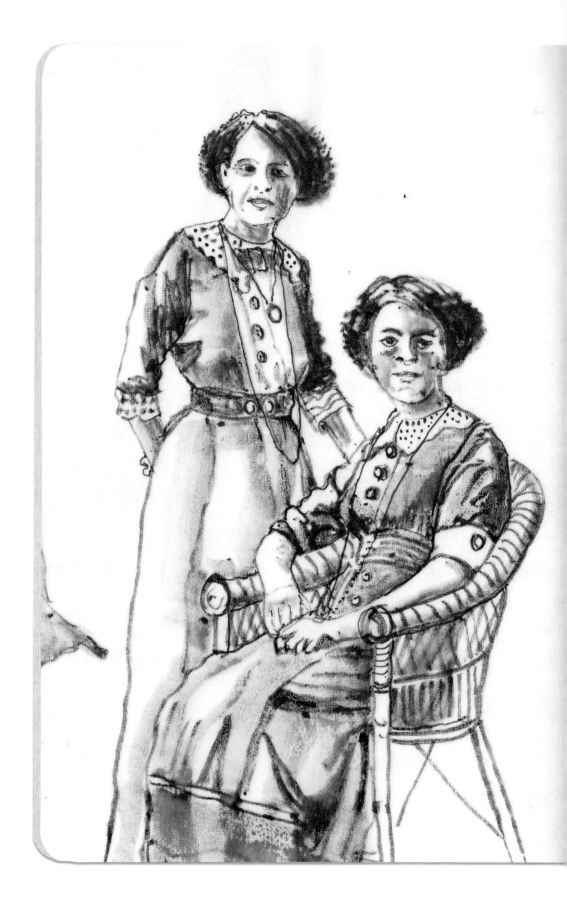

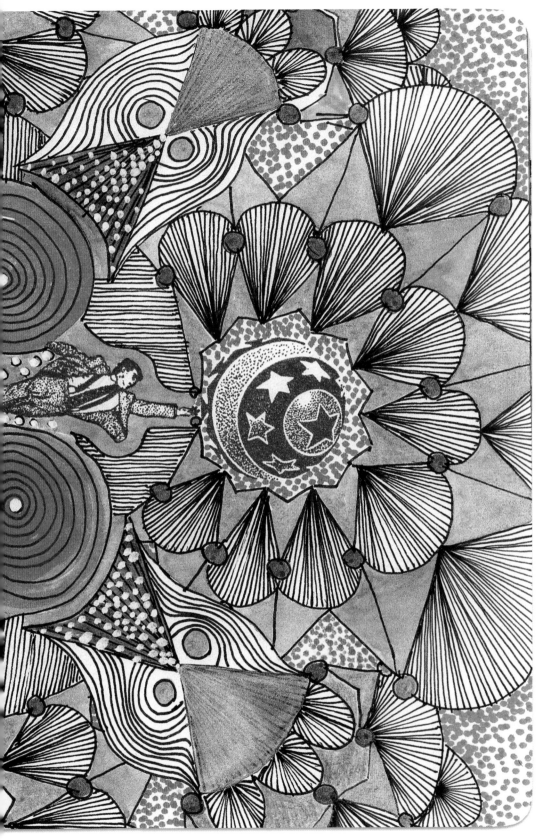

**Birgit Bruhl**  BERGEN, NORWAY

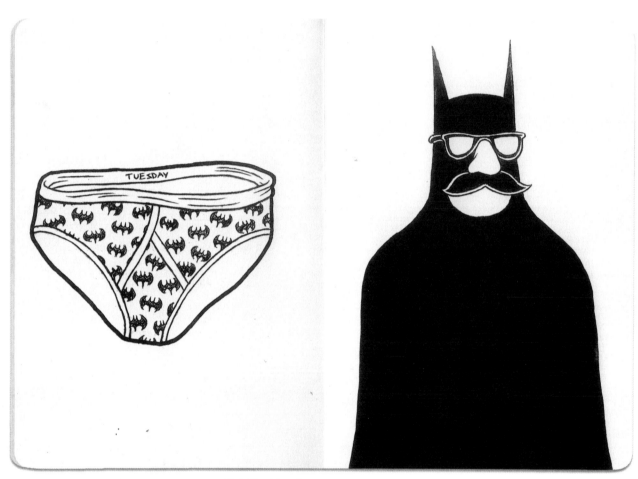

**Kristian Douglas** LONDON, ENGLAND

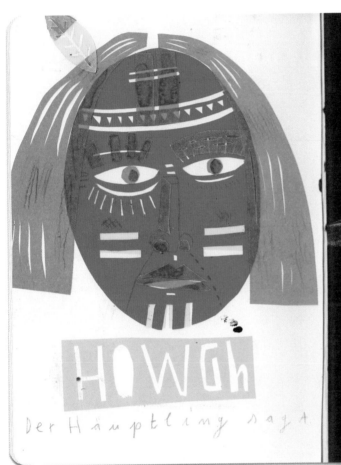

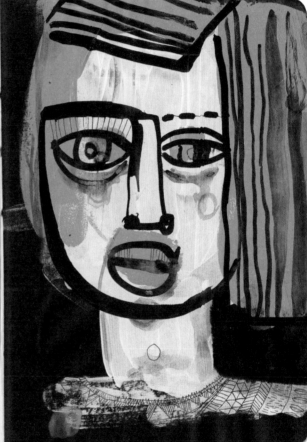

**Anne Wenkel, Ekaterina Koroleva & Ulia Benz**  BERLIN, GERMANY

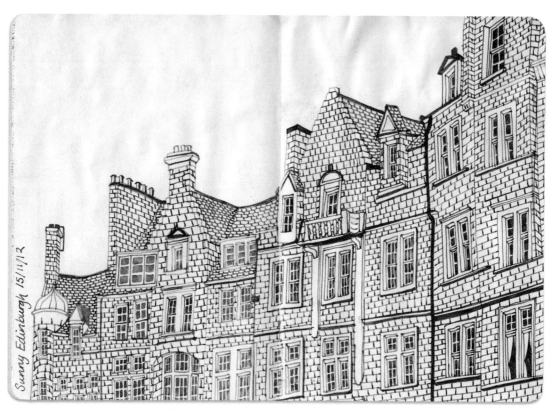

**Charlotte Vallance** AMERSHAM, ENGLAND

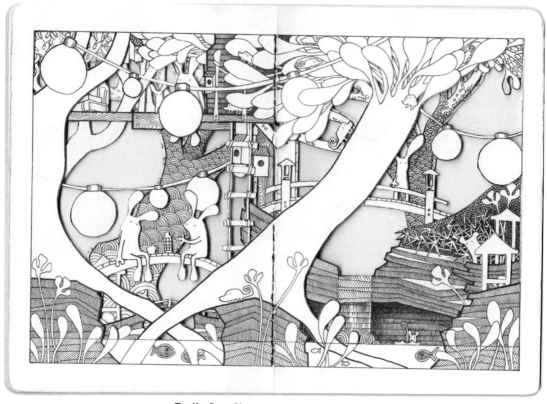

**Emily Grandin** STOCKHOLM, SWEDEN

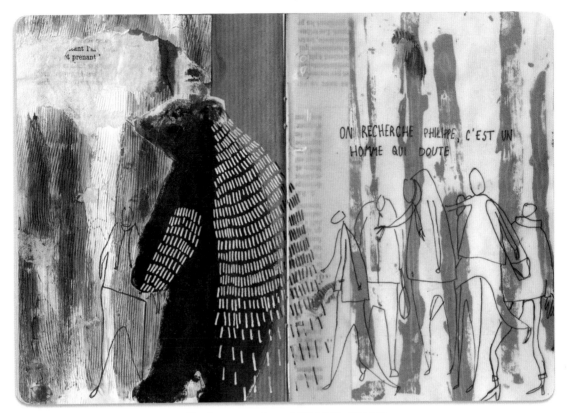

**Bonjour novembre**  TOULOUSE, FRANCE

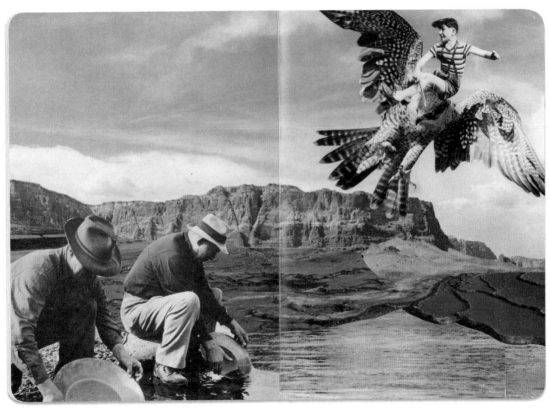

**Sabine Remy**  DÜSSELDORF, GERMANY

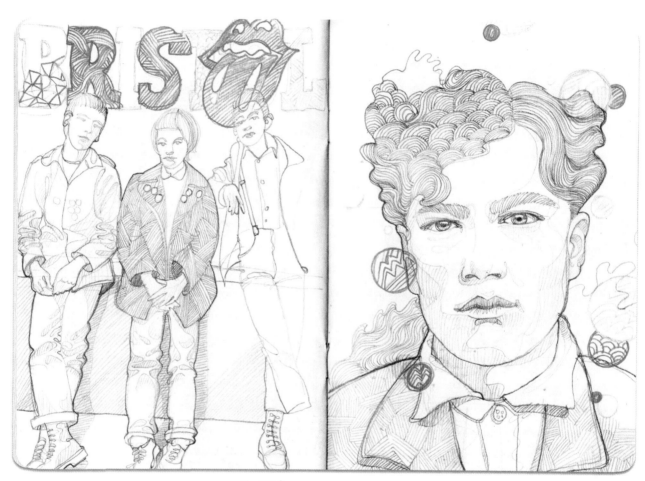

the100faces BERLIN, GERMANY

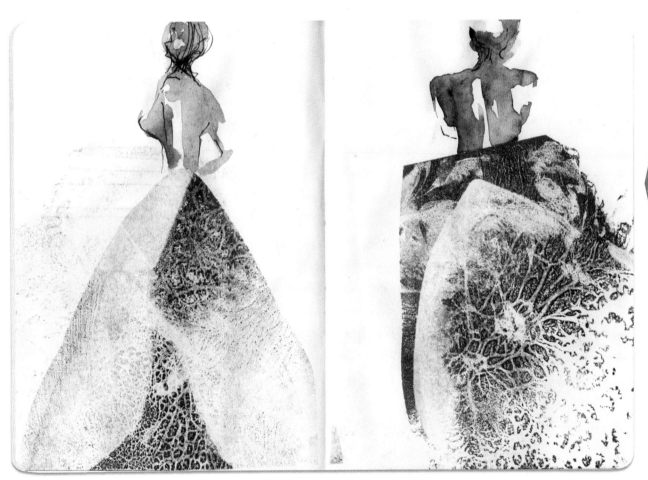

Helena Zakliczynska  GLIWICE, POLAND

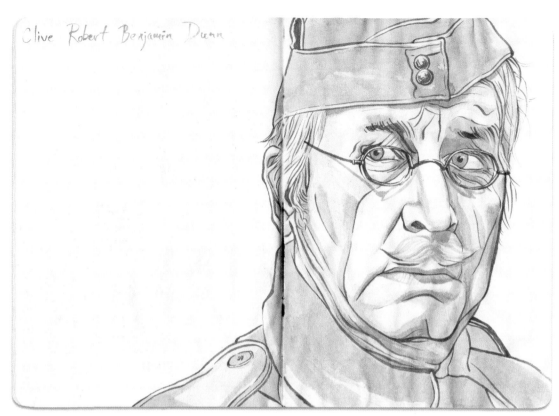

Clive Robert Benjamin Dunn

**Laura Dempsey** CAMBRIDGE, ENGLAND

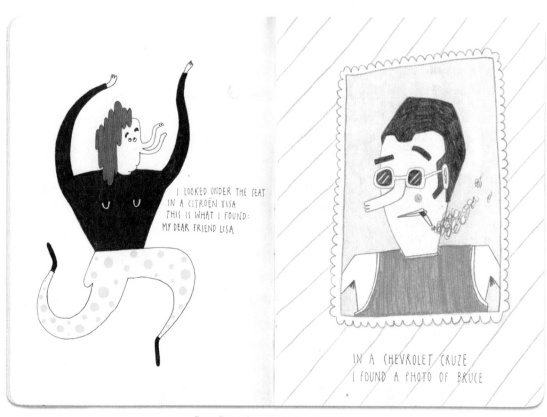

I LOOKED UNDER THE SEAT
IN A CITROËN VISA
THIS IS WHAT I FOUND:
MY DEAR FRIEND LISA

IN A CHEVROLET CRUZE
I FOUND A PHOTO OF BRUCE

**Saga Bergebo** MALMÖ, SWEDEN

Myriam G.S. Mestiaen  MOERBEKE-WAAS, BELGIUM

Karin Granstrand  MALMÖ, SWEDEN

**Raquel Agrella** LOS REALEJOS, SPAIN

**Miguel Ayesa Usechi & Sonia Ciriza Labiano** BARCELONA, SPAIN

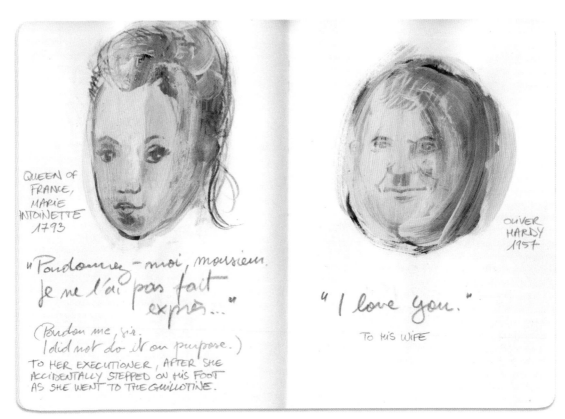

QUEEN OF
FRANCE,
MARIE
ANTOINETTE
1793

OLIVER
HARDY
1957

"Pardonnez-moi, monsieur.
Je ne l'ai pas fait
exprès..."

(Pardon me, sir.
I did not do it on purpose.)
TO HER EXECUTIONER, AFTER SHE
ACCIDENTALLY STEPPED ON HIS FOOT
AS SHE WENT TO THE GUILLOTINE.

"I love you."

TO HIS WIFE

**Alain Poncelet** WATERLOO, BELGIUM

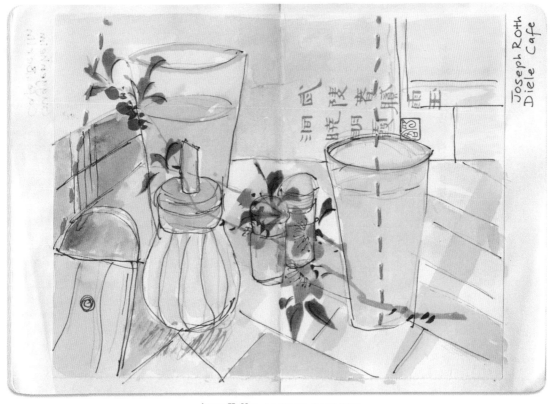

Joseph Roth
Diele Cafe

**Anne Kelly** LONDON, ENGLAND

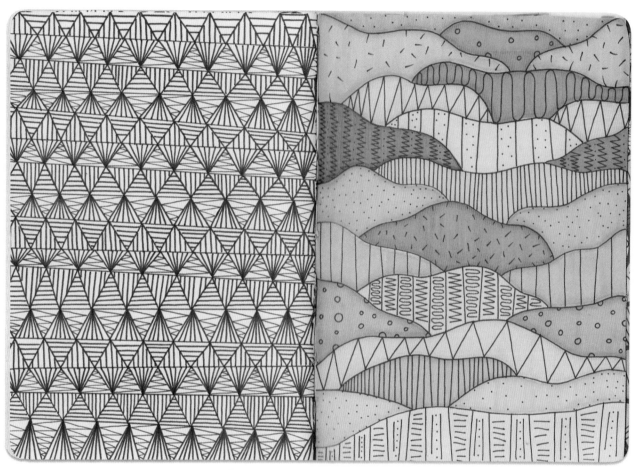

**Jamie Palmer** LONDON, ENGLAND

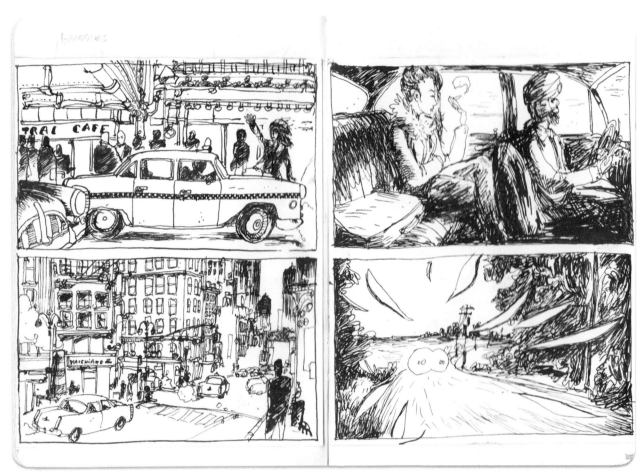

Elkar LIÈGE, BELGIUM

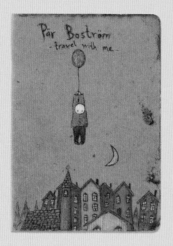

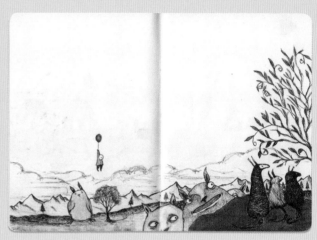

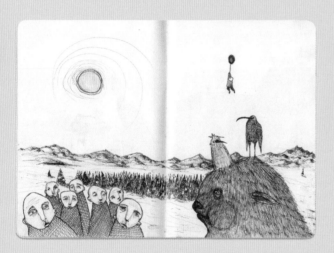

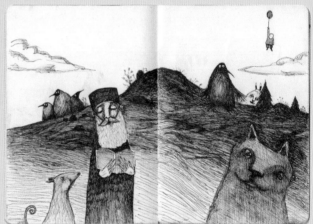

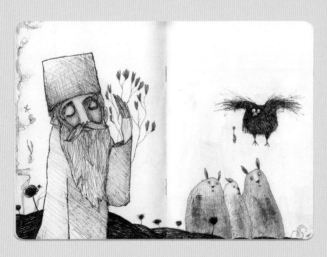

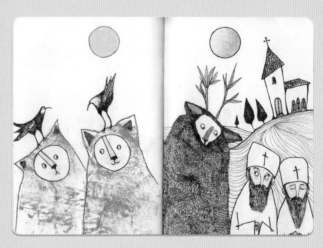

# Pär Boström

UMEÅ, SWEDEN

**DO YOU HAVE ANY FORMAL ARTISTIC TRAINING?**
No.

**WHAT IS YOUR FAVORITE ARTISTIC TOOL?**
My pencils and stamping pads.

**HAVE YOU ALWAYS KEPT A SKETCHBOOK, OR WAS CREATING YOUR SKETCHBOOK A TOTALLY NEW ENDEAVOR FOR YOU? DID YOU ENTER THE SKETCHBOOK PROJECT WITH CERTAIN GOALS, OR WAS IT MORE OF AN EXPERIMENTAL EXPERIENCE?**
I have always doodled on all sorts of paper and in sketchbooks, but with The Sketchbook Project I tried to create a story, make something more solid. A sort of journey. It was a wonderful experiment.

**WHAT DOES YOUR ARTISTIC PROCESS ENTAIL? ARE THERE CERTAIN INSPIRATIONS YOU HOLD DEAR, OR MATERIALS YOU CAN'T LIVE WITHOUT?**
I try to combine drawing with printmaking, so I really couldn't be without my stamping pads. I am also a huge fan of audio books and find them perfect to listen to while drawing. As I tend to draw strange animals, I prefer to be in the company of cats. Their personalities are the best source of inspiration.

**ARE THERE CERTAIN THEMES THAT RECUR THROUGHOUT YOUR WORK? DESCRIBE ANY VISUAL OR CONCEPTUAL ELEMENTS THAT YOU FIND CENTRAL TO YOUR PROCESS.**
My main inspiration is religious art and weird animals. Also mysticism and surrealism. A strange combination, perhaps, but it works for me. I often draw that peculiar moment when two creatures meet for the first time, and each is so surreal and strange to the other. A kind of curiosity and skepticism at the same time.

**HOW DOES YOUR PERSONAL BACKGROUND OR GEOGRAPHIC LOCATION TIE INTO YOUR ARTISTIC PRACTICE?**
I have extreme periods of insomnia, and that is what taught me how to draw. For years I only drew animals or people being asleep, and it really comforted me. As I live in northern Sweden, it is very difficult for me to sleep during the summer, due to the midnight sun, so I find nighttime to be the best time for art.

EUROPE

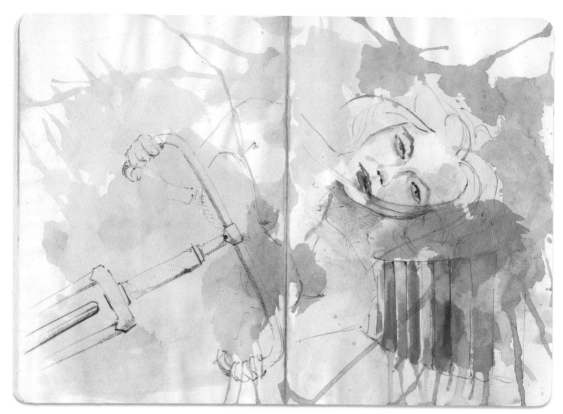

**Grigorovici Andreas** CLUJ-NAPOCA, ROMANIA

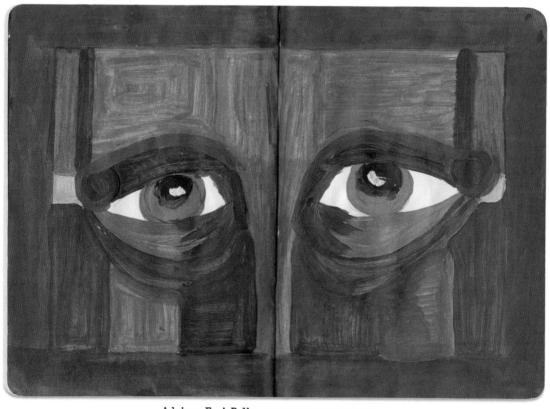

**Adriana Fari-Palko** BUCHAREST, ROMANIA

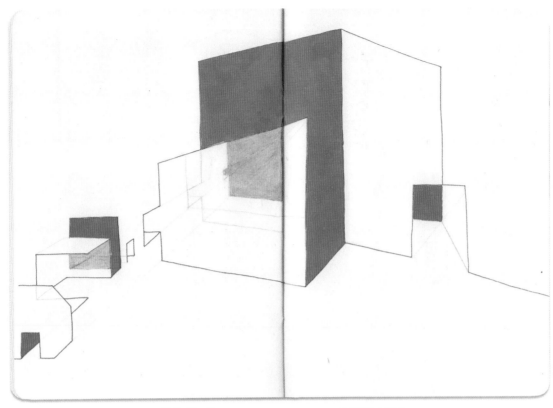

**M.G. Van Loon** AMSTERDAM, THE NETHERLANDS

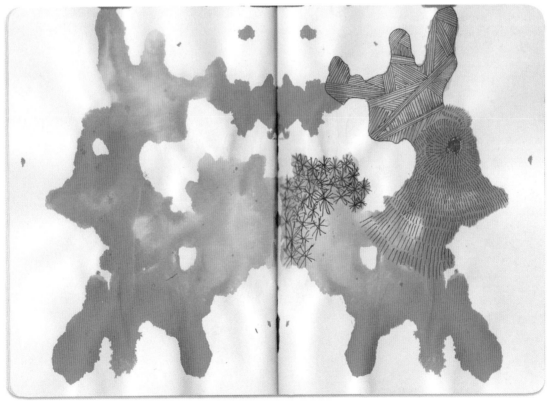

**CiDiE** VICENZA, ITALY

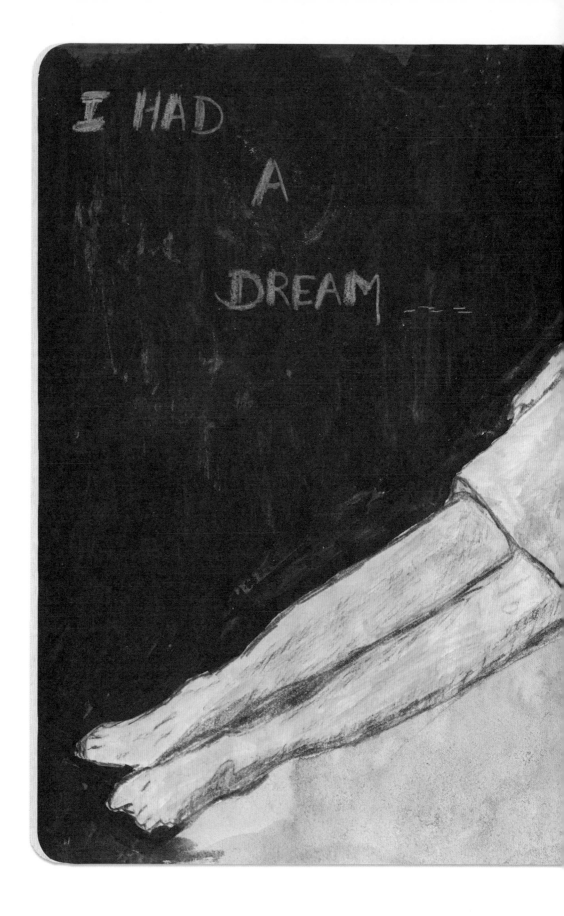

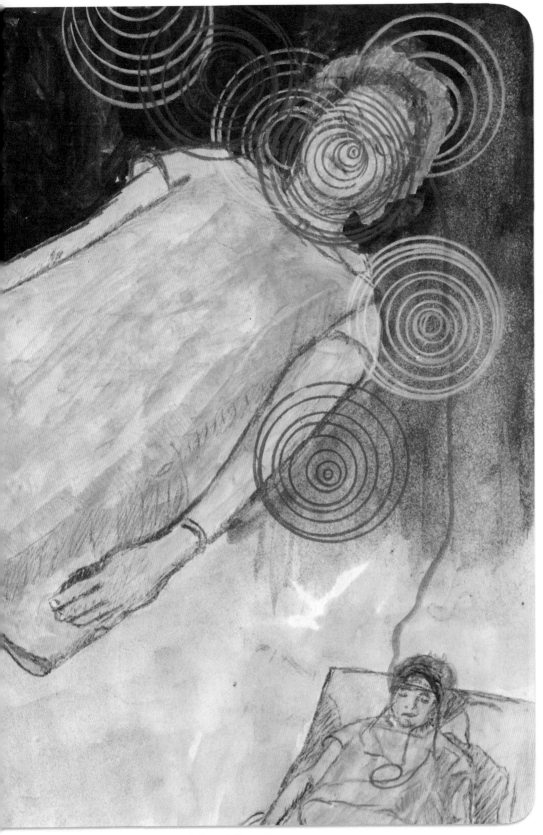

Debora Missoorten REET, BELGIUM

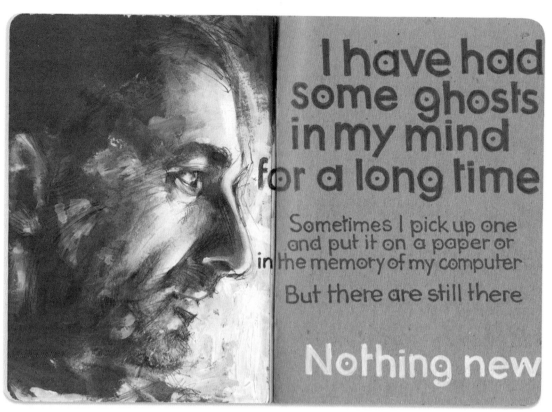

I have had
some ghosts
in my mind
for a long time

Sometimes I pick up one
and put it on a paper or
in the memory of my computer

But there are still there

Nothing new

**DOL** BRUSSELS, BELGIUM

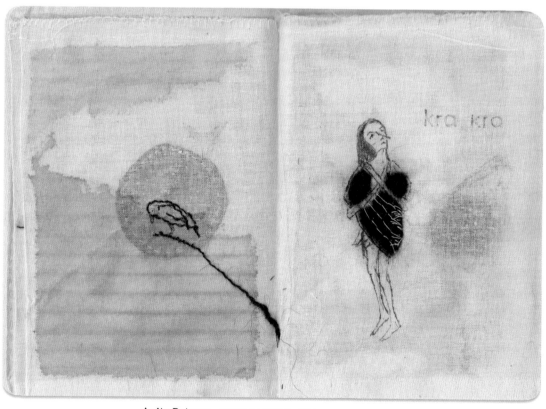

kra kra

Anita Botman HOOGKARSPEL, THE NETHERLANDS

124

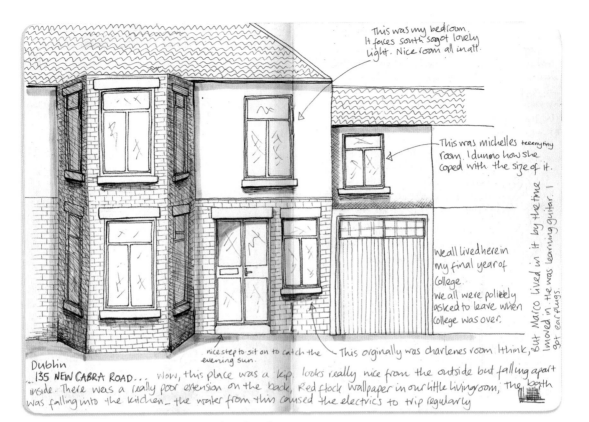

This was my bedroom. It faces south so got lovely light. Nice room all in all.

This was michelles teeeny tiny room. I dunno how she coped with the size of it.

We all lived here in my final year of College.
We all were politely asked to leave when College was over.

nice step to sit on to catch the evening sun.

This orginally was charlenes room I think.

But Marco lived in it by the time I moved in. He was learning guitar. I got ear plugs.

Dublin
135 NEW CABRA ROAD... Wow, this place was a kip. looks really nice from the outside but falling apart inside. There was a really poor extension on the back. Red flock wallpaper in our little livingroom, the bath was falling into the kitchen_ the water from this caused the electrics to trip regularly

**Amy Lynch**  DUBLIN, IRELAND

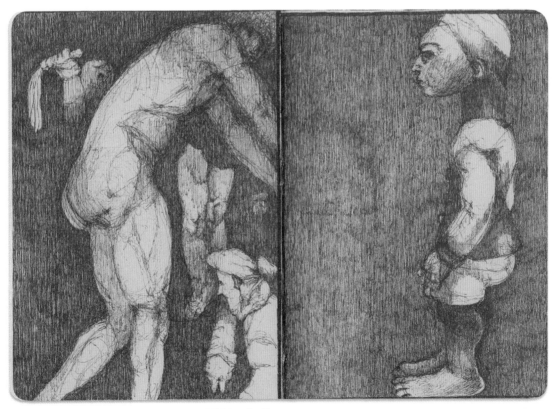

**Frances Middendorf**  MASSA MARTANA, ITALY

**Magaret Cooter**  LONDON, ENGLAND

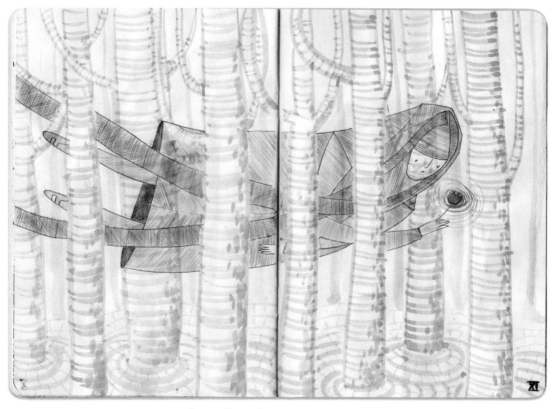

**Serena Ferrari**  TAVERNELLE, ITALY

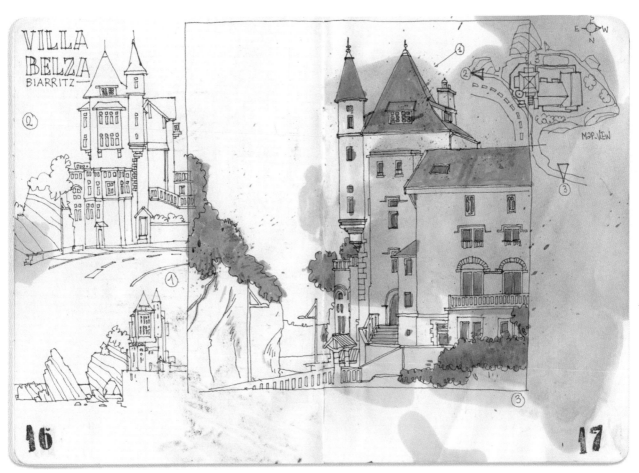

**Francois Pensec** BIARRITZ, FRANCE

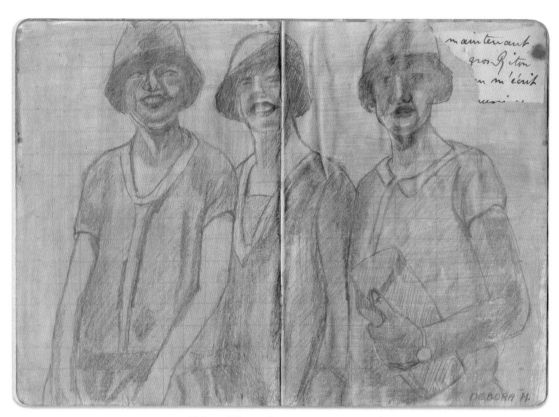

**Debora Missoorten** REET, BELGIUM

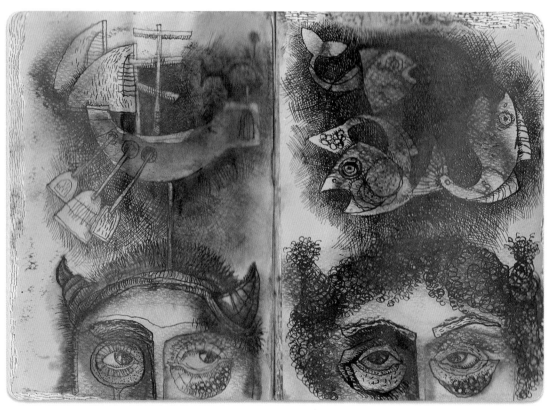

**Boriana Doncheva** SOFIA, BULGARIA

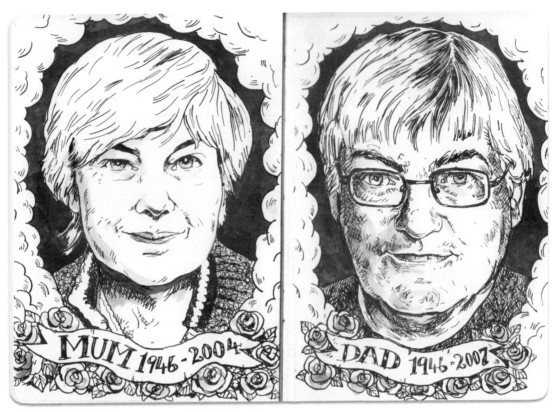

**Mark Satchwill**   WATFORD, ENGLAND

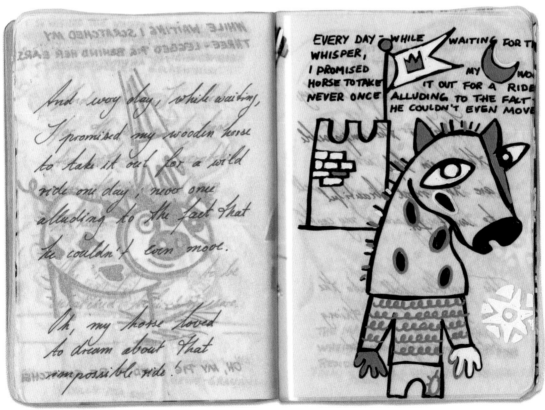

**Inger-Kristina Wegener**   BÜDELSDORF, GERMANY

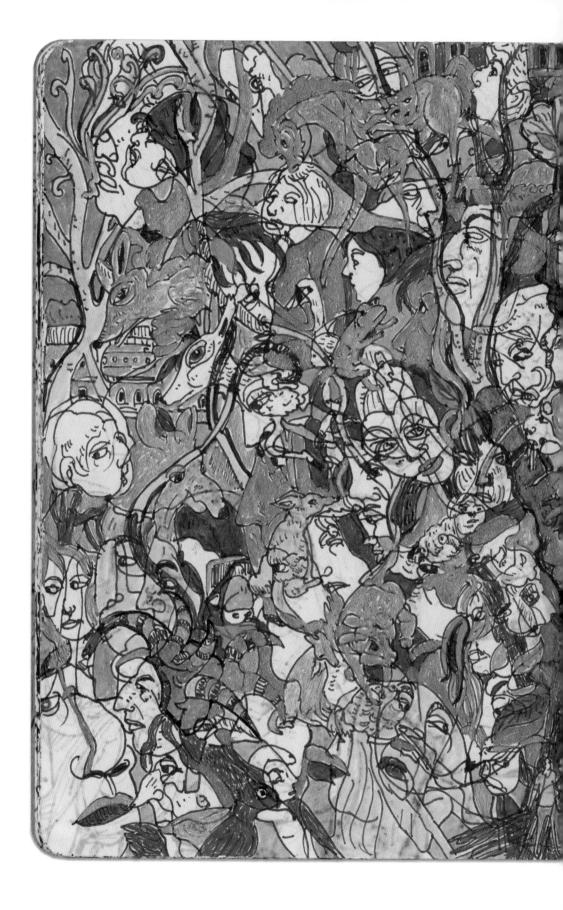

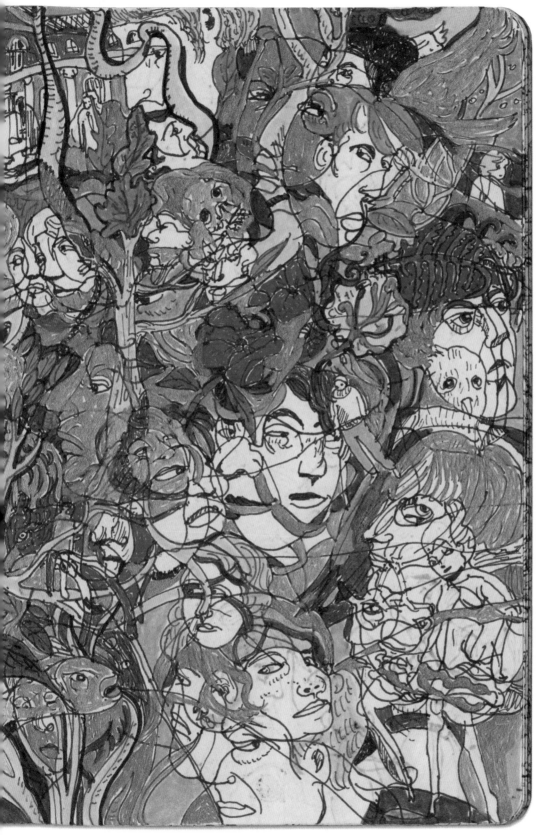

Heather Sinclair BERLIN, GERMANY

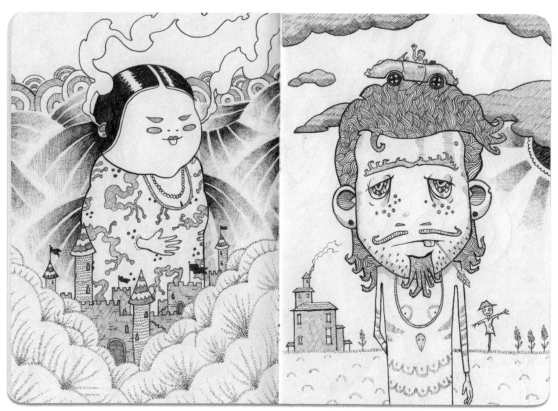

**Gareth Barnes**  LONDON, ENGLAND

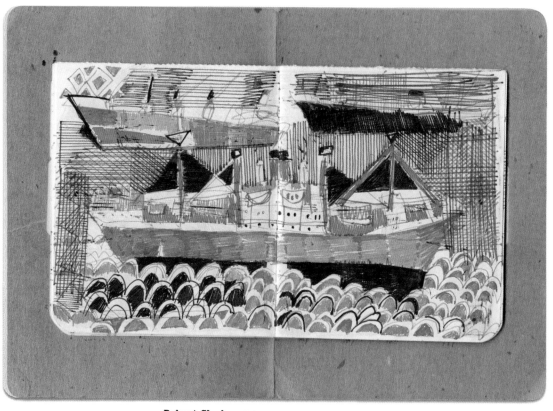

**Robert Clarke**  KIRKBY LONSDALE, ENGLAND

**Clare Shepherd**  BLANDFORD, ENGLAND

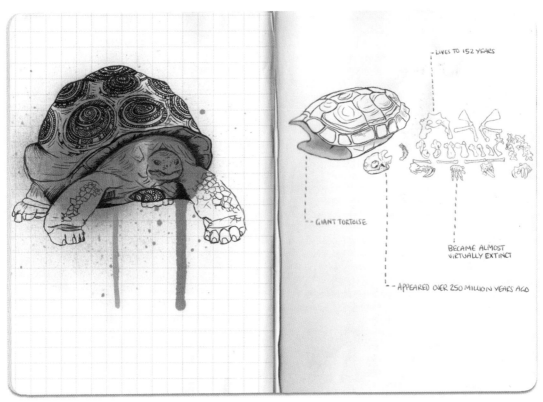

- LIVES TO 152 YEARS

- GIANT TORTOISE

BECAME ALMOST
VIRTUALLY EXTINCT

- APPEARED OVER 250 MILLION YEARS AGO

**Gx2**  HUDDERSFIELD, ENGLAND

For me:I had to stand a reason
to find a peace of mind.

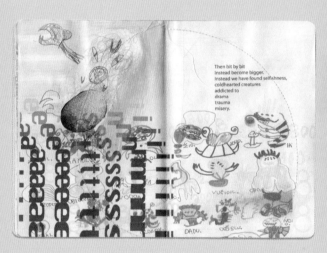

Then bit by bit
Instead become bigger.
Instead we have found selfishness,
coldhearted creatures
addicted to
drama
trauma
misery.

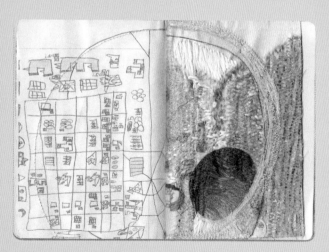

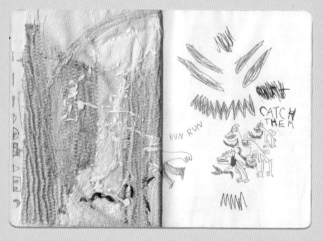

# Irena Hodzic

ZAGREB, CROATIA

**DO YOU HAVE ANY FORMAL ARTISTIC TRAINING? IF SO, WHERE?**
I received a master's degree from the Academy of Fine Arts, Croatia.

**WHAT IS YOUR FAVORITE ARTISTIC TOOL?**
Fibers.

**HAVE YOU ALWAYS KEPT A SKETCHBOOK, OR WAS CREATING YOUR SKETCHBOOK A TOTALLY NEW ENDEAVOR FOR YOU? DID YOU ENTER THE SKETCHBOOK PROJECT WITH CERTAIN GOALS, OR WAS IT MORE OF AN EXPERIMENTAL EXPERIENCE?**
I have, but The Sketchbook Project was a different affair. I had to imagine my potential readers and ways to entertain and gently educate them into my own world with the hope that one day, some of them would share a sequel with me of some sort. I looked at it as a generous and unbelievably potent source of communication, and today I see it as a precious testimony of my emotional and mental states.

**WHAT DOES YOUR ARTISTIC PROCESS ENTAIL? ARE THERE CERTAIN INSPIRATIONS YOU HOLD DEAR, OR MATERIALS YOU CAN'T LIVE WITHOUT?**
I love stories. I often go for a story I overheard on the street, or an old comic book plot, or something that happened to me when I was a child but I never had a sense of closure; deep emotions provoke pictures in me that I tend to release in some medium ASAP. I cannot live without color in all forms and shapes and materials—from just looking at nature for hours and hours to mixing threads and paint—I adore color.

**ARE THERE CERTAIN THEMES THAT RECUR THROUGHOUT YOUR WORK? DESCRIBE ANY VISUAL OR CONCEPTUAL ELEMENTS THAT YOU FIND CENTRAL TO YOUR PROCESS.**
Human nature and human relationships are, I think, my ever-turning pages. I often first listen, hoping that people will not even notice I am present, but after I come back with my work dedicated to them, that is the point when we start intense conversations, relations, even, and my subjects help me deepen my thoughts and my art and elevate my self as a human being. Visual elegance and a clever, educated mix of contemporary living and contemporary essence is my visual goal in everything I do, from photography and video to fibers, books, writing, and painting.

**HOW DOES YOUR PERSONAL BACKGROUND OR GEOGRAPHIC LOCATION TIE INTO YOUR ARTISTIC PRACTICE?**
The older I get, the more I see local embroidery coming into the picture; other than that, I am a black sheep.

EUROPE

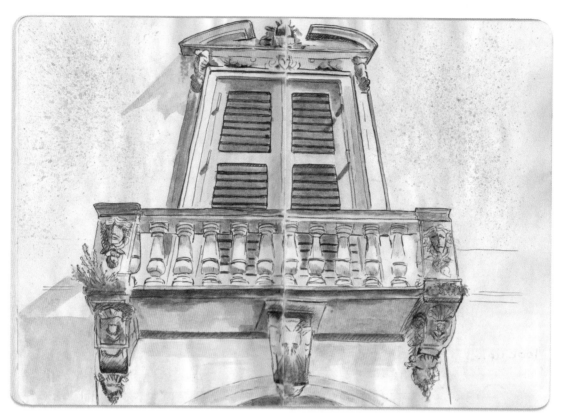

**Cathy Holtom** CASTELDACCIA, ITALY

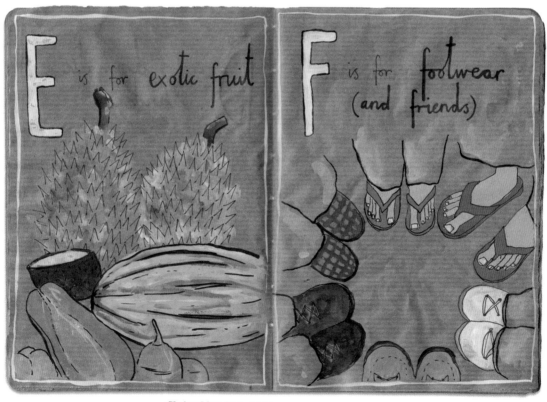

**Claire Munday** EAST SUSSEX, ENGLAND

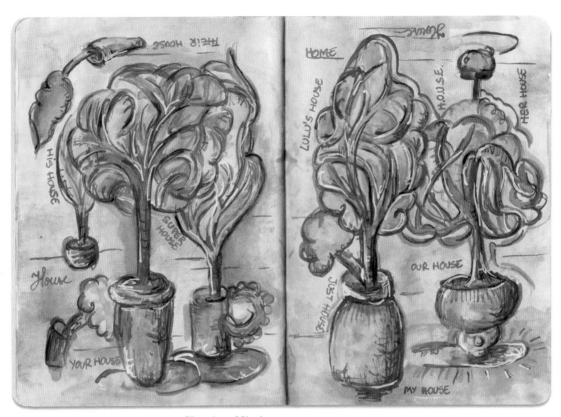

**PlesoianuMimi** CONSTANȚA, ROMANIA

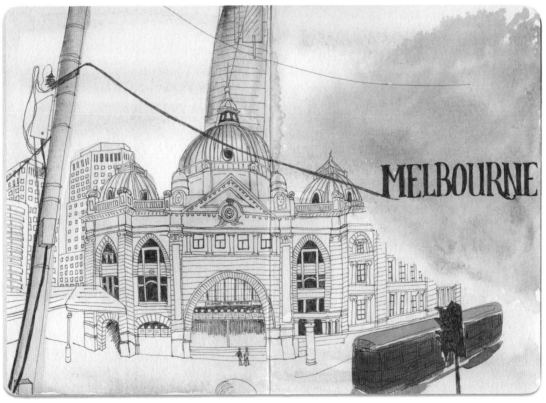

**Charlotte Vallance** AMERSHAM, ENGLAND

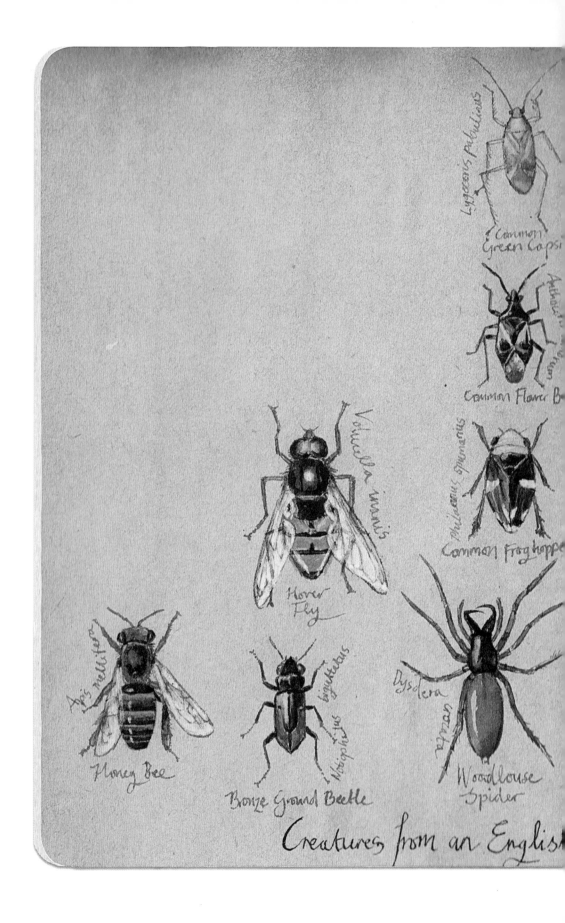

Lygaeus Pabulinus

Common
Green Capsi

Anthocoris nemorum

Common Flower B

Philaenus spumarius

Common Froghopper

Volucella inanis

Hover
Fly

Apis mellifera

Honey Bee

Notiophilus biguttatus

Bronze Ground Beetle

Dysdera crocata

Woodlouse
Spider

Creatures from an Englis

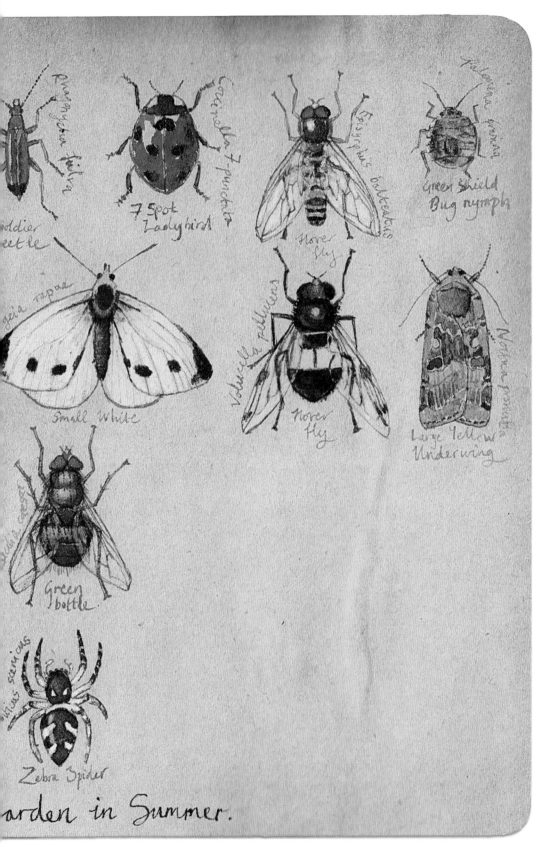

Rhagonycha fulva

Soldier
Beetle

Coccinella 7-punctata

7 Spot
Ladybird

Episyrphus balteatus

Hover
fly

Palomena prasina

Green Shield
Bug nymph

Pieris rapae

Small White

Volucella pellucens

Hover
Fly

Noctua pronuba

Large Yellow
Underwing

Lucilia caesar

Green
bottle

Salticus scenicus

Zebra Spider

arden in Summer.

Emma Coletti  FAVERSHAM, ENGLAND

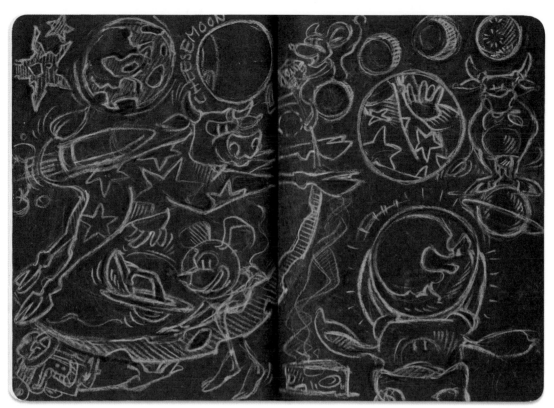

**Katrin Eberhard** MUNICH, GERMANY

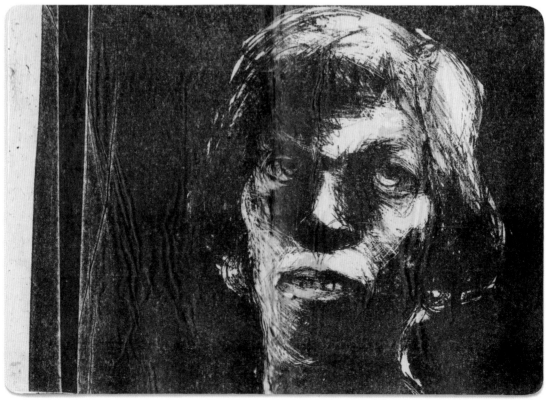

**Marcelle Hanselaar** LONDON, ENGLAND

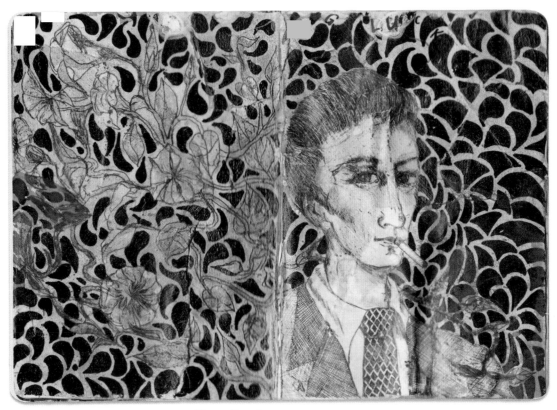

**Megan Beard** BRUSSELS, BELGIUM

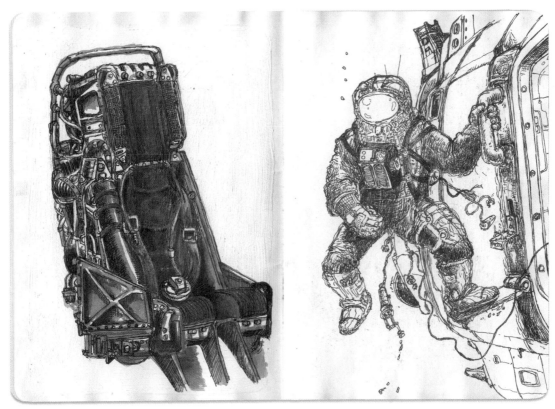

**Stephane Mercier** MONT-DEVANT-SASSEY, FRANCE

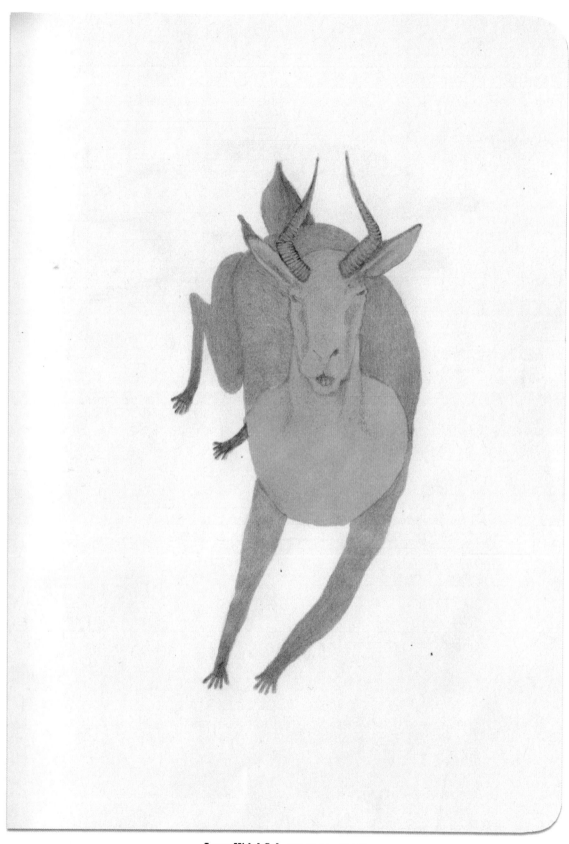

**Irene Vidal Cal**  VILALBA, SPAIN

**Christin Poler**
MÜNSTER, GERMANY

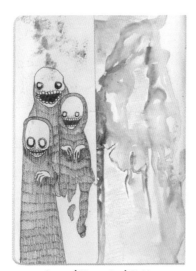

**Gugu (Cimpoies) Iulia**
CLUJ, ROMANIA

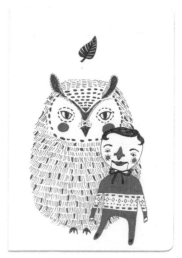

**Halah El-Kholy**
FOLKESTONE, ENGLAND

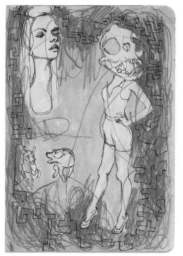

**Karolina Kawa**
EASTBOURNE, ENGLAND

Achillobator

**Lucy Irving**
BRIGHTON, ENGLAND

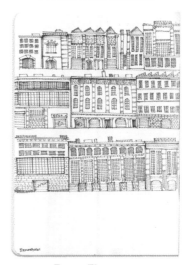

**Emma Thompson**
BIRMINGHAM, ENGLAND

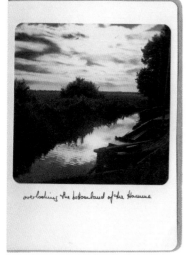

**Sabine Freienstein**
HILDESHEIM, GERMANY

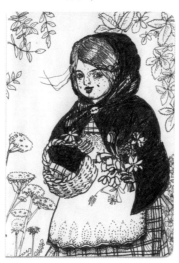

**Cecile Parcillie**
REYKJAVIK, ICELAND

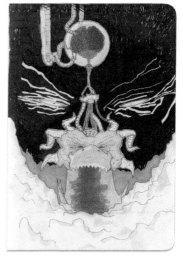

**Bizau Adrian Danut**
BAIA MARE, ROMANIA

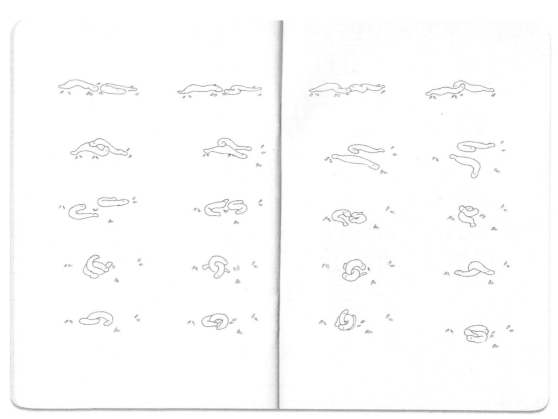

**Dita Vizoso**  BASEL, SWITZERLAND

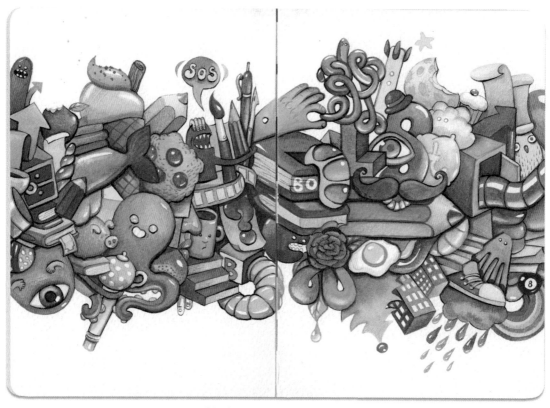

**Maria**  LONDON, ENGLAND

144

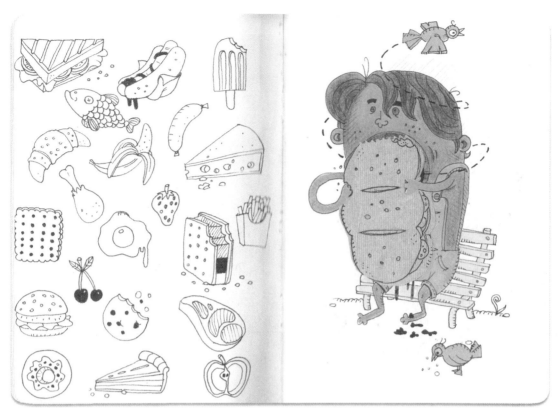

**Fausto Montanari** GENOA, ITALY

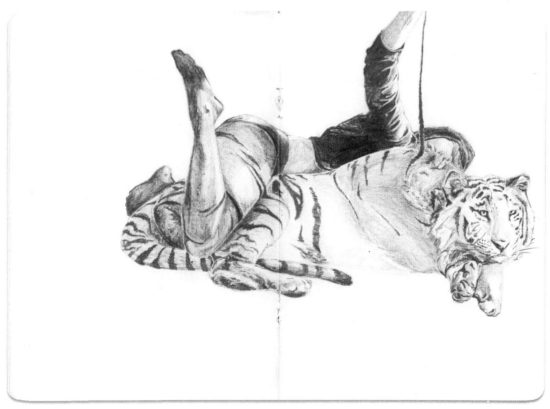

**Tsjimk Scarse** KAMPEN, THE NETHERLANDS

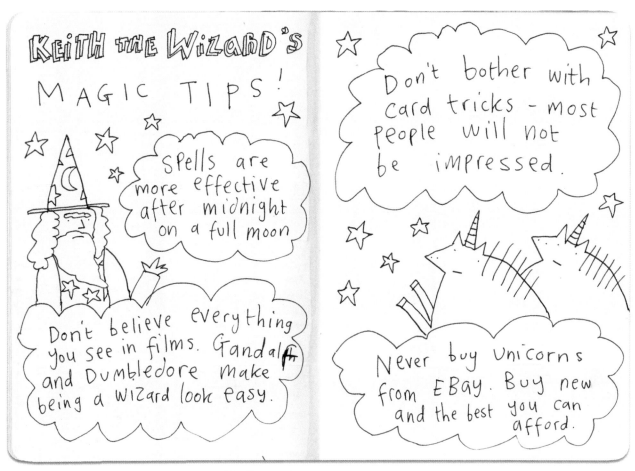

KEITH THE WIZARD'S MAGIC TIPS!

Spells are more effective after midnight on a full moon

Don't believe everything you see in films. Gandalf and Dumbledore make being a wizard look easy.

Don't bother with card tricks - most people will not be impressed.

Never buy unicorns from EBay. Buy new and the best you can afford.

**Lizz Lunney** BIRMINGHAM, ENGLAND

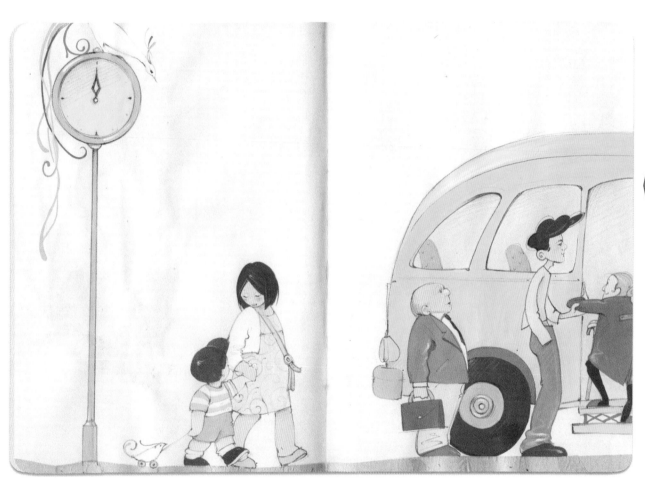

Manfroi Patrizia  MILAN, ITALY

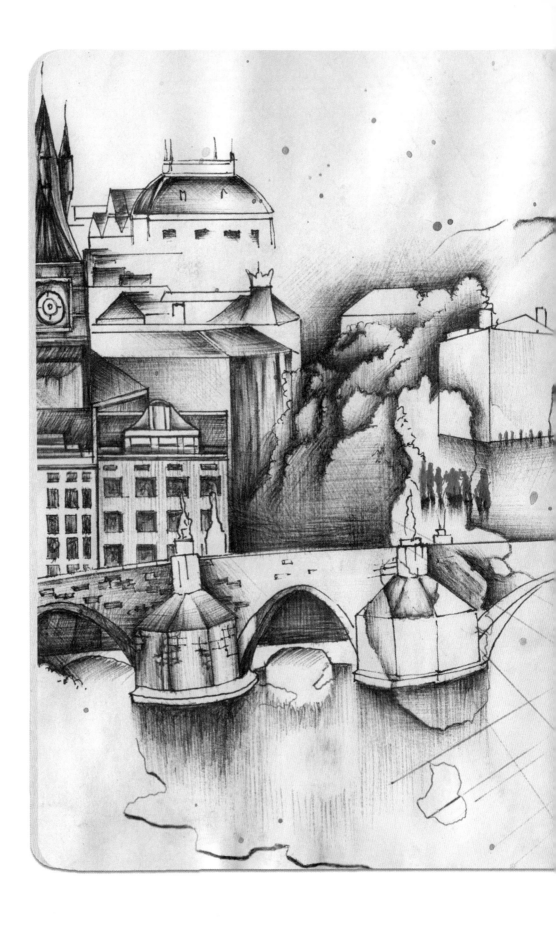

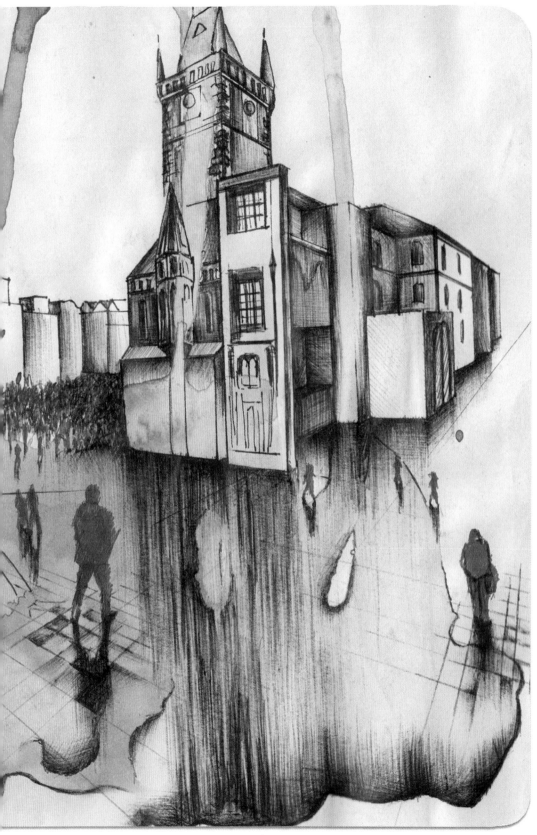

**Javier Población** CÁCERES, SPAIN

# AFRICA

Though it's our least populated region (in terms of sketchbooks), the high quality of the work from Africa makes up for the lower quantity. With a range of artwork that is reflective of the cultural vitality buzzing from this part of the world, the depictions of music and family and nature coming from the sketchbooks of Africa tell a story unique and sincere. While viewing these books, we are reminded of the specific and individual artistic expressions present within such a vast continent.

Janette Wright, an artist from South Africa, creates a charming story full of original characters, including yoga-mat-carrying Igor, whose dream is to learn to surf and own an eco-friendly surfboard. Also from South Africa, Scott Milton Brazee reveals his own brand of personalities, though his characters appear to tell a story more focused on strength than anything else. Two such characters, Rida and Alyssa, give us rare and colorful insight into the world of two students living in Sudan.

Being so far removed from the continent, we are honored to have the stories of the participants from Africa incorporated into The Sketchbook Project. The fact that they have chosen to send their books to be part of the collection, and likely never see them again in person, is truly special. With the accessibility of the glimpses into the lives of these African artists, we are able to bridge the gap that much further.

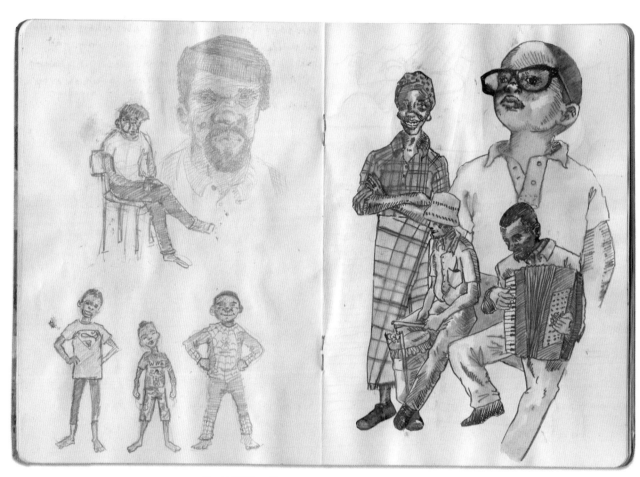

**Scott Milton Brazee** DURBAN, SOUTH AFRICA

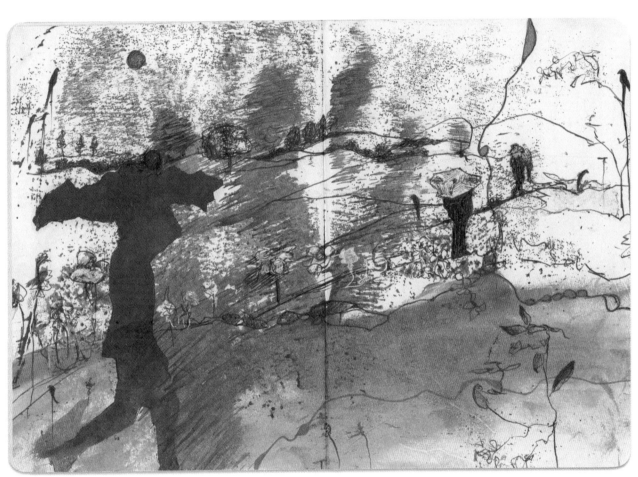

**Lara Mellon**  DURBAN, SOUTH AFRICA

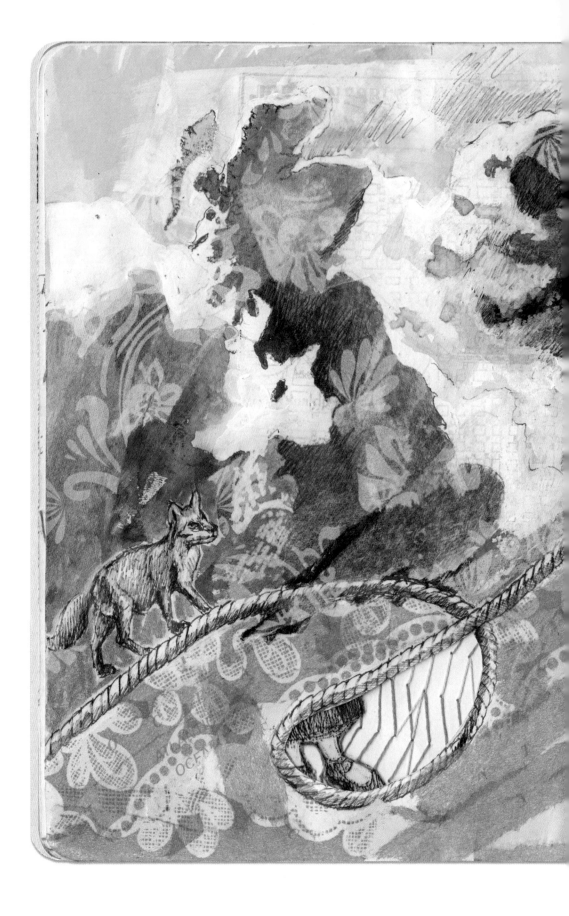

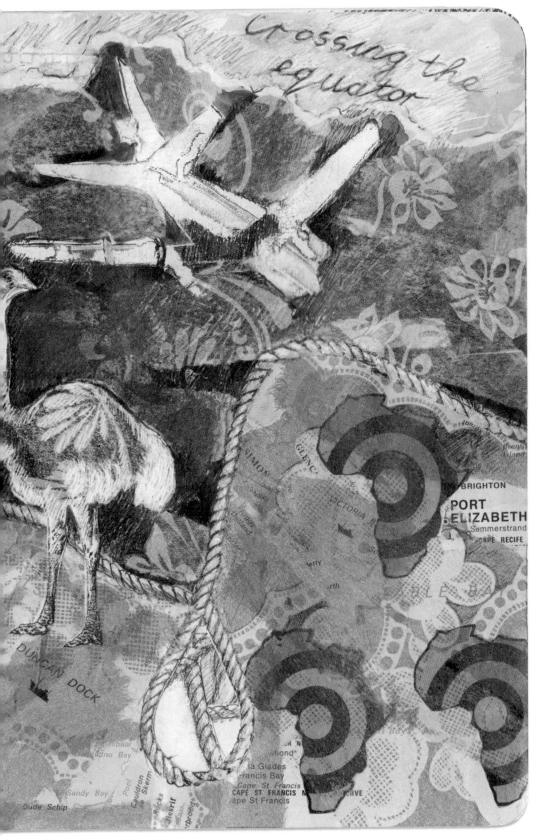

**Joan Martin**  DURBAN, SOUTH AFRICA

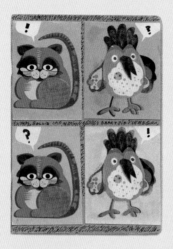

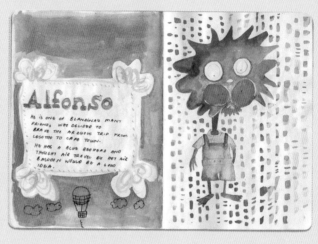

### Alfonso

He is one of Blandina's many friends who decided to brave the arduous trip from Lesotho to Cape Town.

He has a blue bighead and thought air travel by hot air balloon would be a good idea.

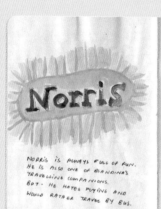

### Norris

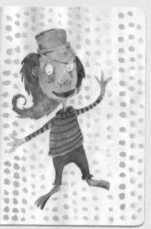

Norris is always full of fun. He is also one of Blandina's travelling companions. But he hates flying and would rather travel by bus.

### Philippe

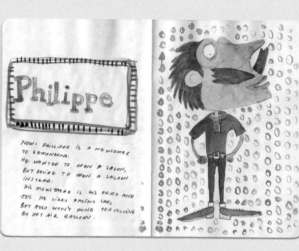

Now - Philippe is a newcomer to Lemonland. He wanted to open a salon, but decide to open a saloon instead. His moustache is his pride and joy. He likes racing cars, but also won't mind travelling by hot air balloon.

### Deborah

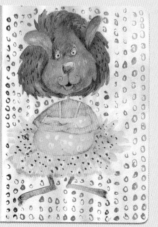

Poor girl!

She is a lion-donkey who will never be a prima ballerina. She is genetically plump and every day is a bad-hair day. She has a lovely personality though!

### André

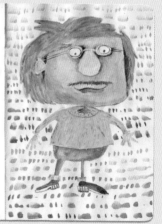

His travelling companion has a big head and a big heart. There is nothing he won't do for his friends. His hair was always blue.

156

# Janette Wright

**CAPE TOWN, SOUTH AFRICA**

**DO YOU HAVE ANY FORMAL ARTISTIC TRAINING? IF SO, WHERE?**
I attended the University of Cape Town, Michaelis School of Fine Arts.

**WHAT IS YOUR FAVORITE ARTISTIC TOOL?**
A pencil.

**HAVE YOU ALWAYS KEPT A SKETCHBOOK, OR WAS CREATING YOUR SKETCHBOOK A TOTALLY NEW ENDEAVOR FOR YOU? DID YOU ENTER THE SKETCHBOOK PROJECT WITH CERTAIN GOALS, OR WAS IT MORE OF AN EXPERIMENTAL EXPERIENCE?**
At times in the past I have kept a sketchbook, especially while studying painting. The first time I joined The Sketchbook Project, it was to encourage myself to get back into drawing and painting after a very long period of not creating anything. It was a project with a deadline, which forced me to get going. It worked! I now paint and sketch and teach art again.

**WHAT DOES YOUR ARTISTIC PROCESS ENTAIL? ARE THERE CERTAIN INSPIRATIONS YOU HOLD DEAR, OR MATERIALS YOU CAN'T LIVE WITHOUT?**
I draw and paint landscapes in watercolors and pencil. I rework them in oils or acrylic paint on canvas. Sometimes the paintings evolve into something more abstract. I also illustrate. I create imaginary characters by just letting a pencil drawing develop as my intuition leads me. These illustrations are fun, colorful, and usually in watercolor and gouache.

**ARE THERE CERTAIN THEMES THAT RECUR THROUGHOUT YOUR WORK? DESCRIBE ANY VISUAL OR CONCEPTUAL ELEMENTS THAT YOU FIND CENTRAL TO YOUR PROCESS.**
I enjoy painting and drawing landscapes with some form of structure in them. In the past I have been inspired by drawings made in Cape Town's working harbor, wintertime vineyards on our west coast, and other places where I have been on camping and road trips.

**HOW DOES YOUR PERSONAL BACKGROUND OR GEOGRAPHIC LOCATION TIE INTO YOUR ARTISTIC PRACTICE?**
Because I get out of the city often to interesting rural areas, these landscapes feature in my work. I have been fortunate to always have space and materials available. I was encouraged to experiment and mix media at school and at university. That playing and experimenting is still part of how I work.

AFRICA

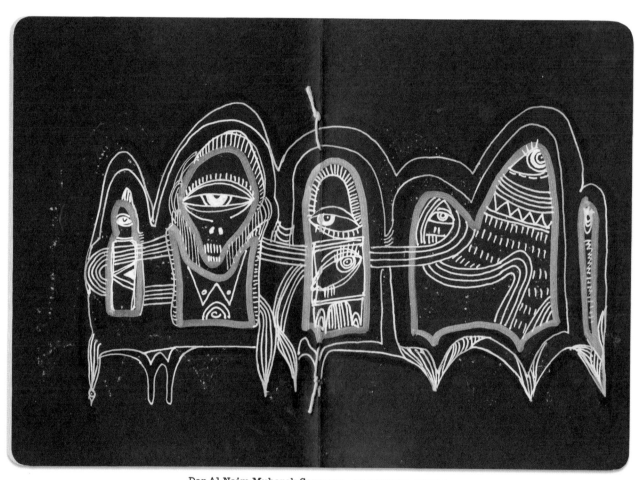

**Dar Al Naim Mubarak Carmona** KHARTOUM, SUDAN

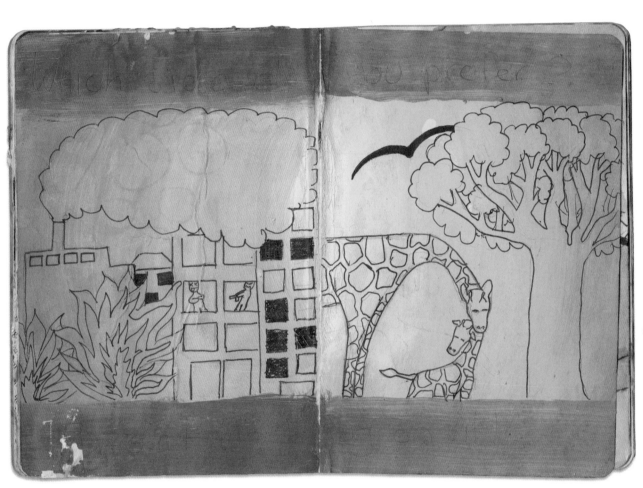

**Unnamed** KHARTOUM, SUDAN

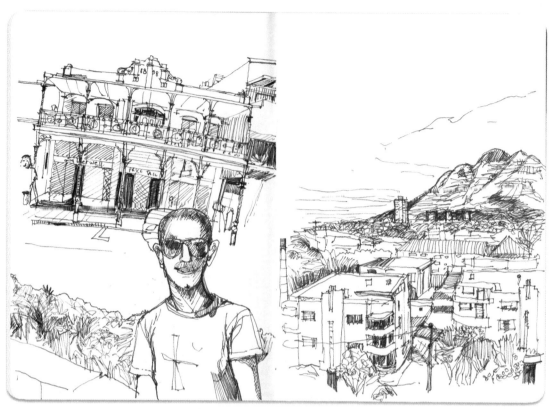

**Yusuf Vahed**  CAPE TOWN, SOUTH AFRICA

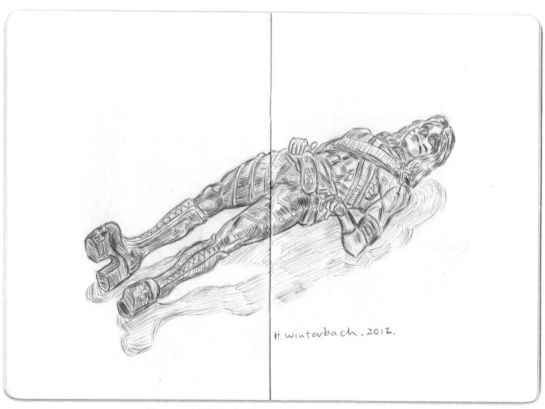

H.Winterbach.2012.

**Hougaard Winterbach**  PRETORIA, SOUTH AFRICA

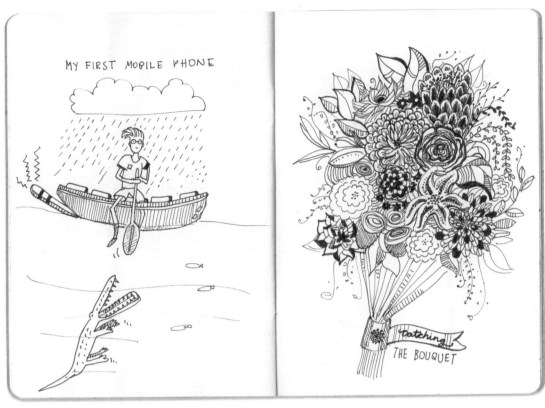

**Kyra Antrobus** JOHANNESBURG, SOUTH AFRICA

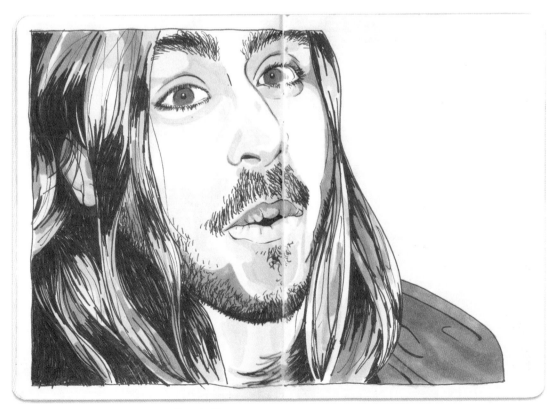

**Janzia Fiet** CAPE TOWN, SOUTH AFRICA

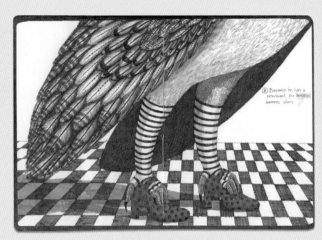

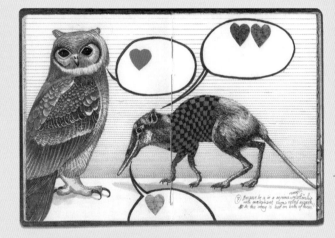

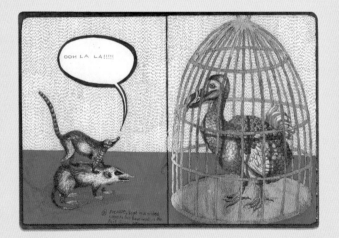

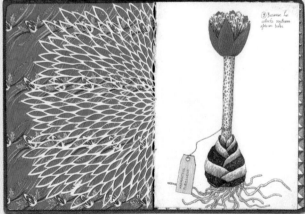

# Sarah Pratt

**CAPE TOWN, SOUTH AFRICA**

**DO YOU HAVE ANY FORMAL ARTISTIC TRAINING? IF SO, WHERE?**

Yes, I have a master's degree in fine arts from the University of Cape Town, Michaelis School of Fine Art.

**WHAT IS YOUR FAVORITE ARTISTIC TOOL?**

An etching needle.

**HAVE YOU ALWAYS KEPT A SKETCHBOOK, OR WAS CREATING YOUR SKETCHBOOK A TOTALLY NEW ENDEAVOR FOR YOU? DID YOU ENTER THE SKETCHBOOK PROJECT WITH CERTAIN GOALS, OR WAS IT MORE OF AN EXPERIMENTAL EXPERIENCE?**

I haven't always kept a sketchbook, no. I am a printmaker, and one of the things that I adore is book binding, so my attraction to The Sketchbook Project came from the direction of binding my own little book and illustrating it. I was also attracted to The Sketchbook Project because I love children's books, and the titles that you gave us made me desperate to create a little story.

**WHAT DOES YOUR ARTISTIC PROCESS ENTAIL? ARE THERE CERTAIN INSPIRATIONS YOU HOLD DEAR, OR MATERIALS YOU CAN'T LIVE WITHOUT?**

My artistic process entails a lot of printmaking— mostly etching and linocut, but also a lot of hand-cut papers. Because I am trained as an etcher, I love to draw with pen and ink in a similar, crosshatching way, creating depth through layers of line. I could not do without good paper and my Rotring pens.

**ARE THERE CERTAIN THEMES THAT RECUR THROUGHOUT YOUR WORK? DESCRIBE ANY VISUAL OR CONCEPTUAL ELEMENTS THAT YOU FIND CENTRAL TO YOUR PROCESS.**

Humor and whimsy are central to my process. Surreal juxtapositions of animals, people, and objects are also a recurring theme in my work.

**HOW DOES YOUR PERSONAL BACKGROUND OR GEOGRAPHIC LOCATION TIE INTO YOUR ARTISTIC PRACTICE?**

Cape Town can be a very busy place to be an artist. I have a great studio here and am actively showing my work in both group and solo shows as often as I can. It is hard, however, to get your work seen in other countries, which is one of the reasons that I made a little book for The Sketchbook Project.

AFRICA

**Rida & Alyssa** KHARTOUM, SUDAN

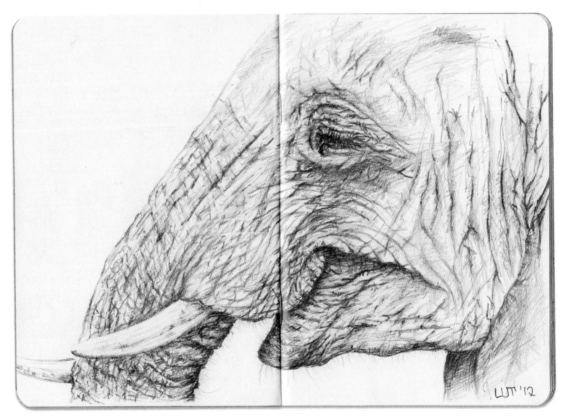

**Warren Thompson** JOHANNESBURG, SOUTH AFRICA

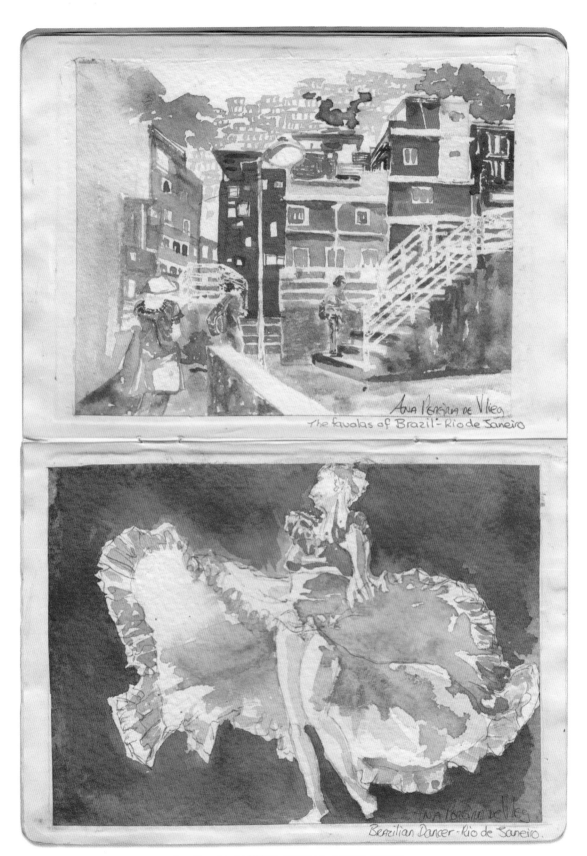

The favalas of Brazil - Rio de Saneiro
Ana Pereira de Vlieg

Brazilian Dancer - Rio de Saneiro.
Ana Pereira de Vlieg

**Ana Pereira de Vlieg** DURBAN, SOUTH AFRICA

# ASIA

Artists can get delightfully creative with all of the ways they endeavor to make the sketchbooks their own. One of the few rules of the project states that the book can consist of any format, as long as the contents fit back down to the same footprint when the book is closed. Some artists choose to redo the bindings, expanding the number of pages on which they can design. Others remove pages from the book to create a space better suited for expressing a simplified statement. The artists from Asia constantly amaze us with their inventiveness in regards to how to handle the sketchbook. Rather than augmenting its form, Japanese artist Masaco Kuroda uses fabric pages in place of paper, stained and colorfully stitched to resemble topographic maps, which could easily be islands in the South Pacific.

Structural craftsmanship and invention aside, you will find a certain delicacy and thoughtfulness in the sketchbook spreads from this region of the world. The hint to what seems to be Alice in Wonderland in Pei Shiuan Lin's sketchbook opens our eyes to a spectacular reimagining of a favorite British childhood story set against a background of pagodas and scrolls. We see several drawings of subway trains: in the whimsical travel book by Indonesian artist Clara Oktarina, the monochromatic and stylized illustration by The N2A from Isreal, and the work of Sachin Karle from India. Somehow, a single theme unintentionally runs through sketchbooks from three separate countries and cultures.

When the time came for Syed Mohammad Bakar to start a sketchbook, most of his painting supplies were packed away because of a recent move, so he used the ends of chopsticks to create the detailed images in his sketchbook. Without reading the note on the inside cover, you would never know that the artist had been constrained in any way. It is that kind of ingenuity and intention, that kind of passion and commitment, that makes these books truly special.

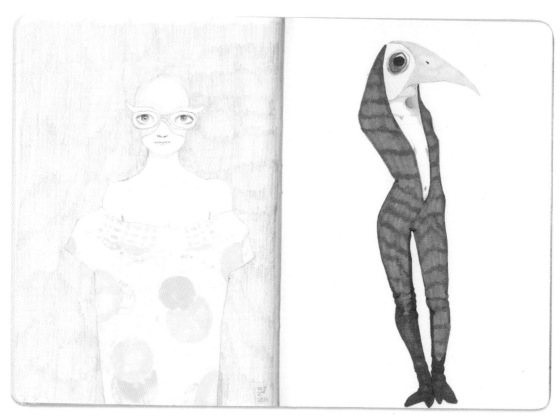

**Fatma Al-Remaihi**  DOHA, QATAR

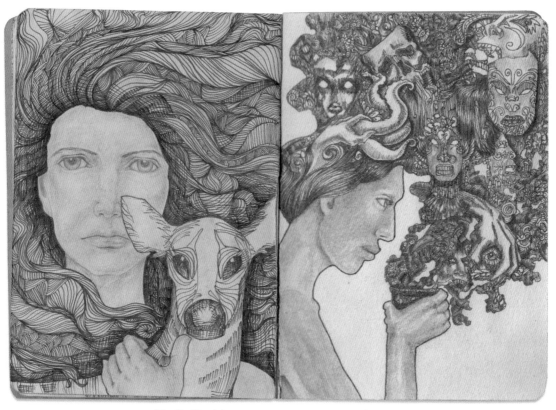

**Kavita Nambissan Ganguli**  NEW DELHI, INDIA

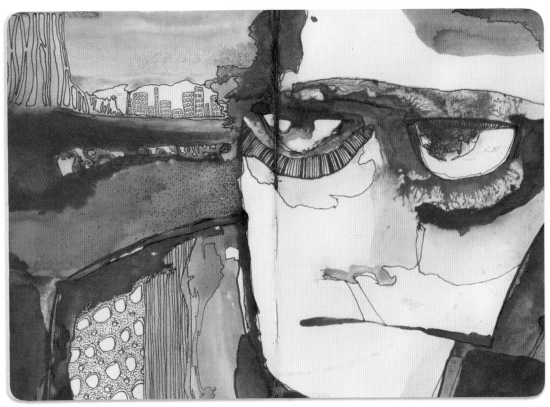

**Katia Hinic**  LJUBLJANA, SLOVENIA

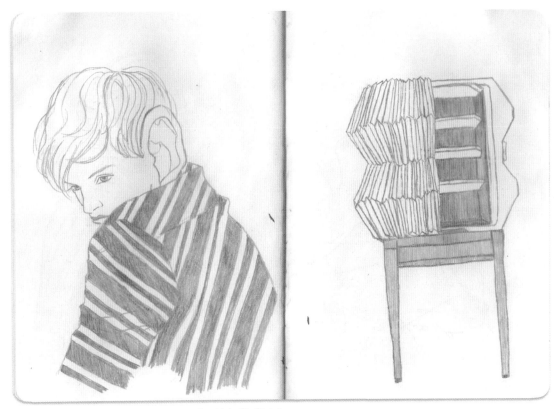

**Cynthia H. Hsieh**  TAIPEI, TAIWAN

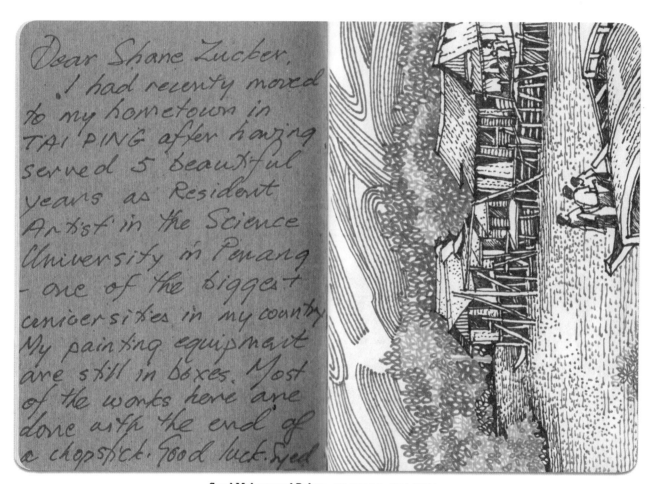

Dear Shane Zucker,
    I had recently moved to my hometown in TAIPING after having served 5 beautiful years as Resident Artist in the Science University in Penang — one of the biggest universities in my country. My painting equipment are still in boxes. Most of the works here are done with the end of a chopstick. Good luck. Syed

**Syed Mohammad Bakar**  PUCHONG, MALAYSIA

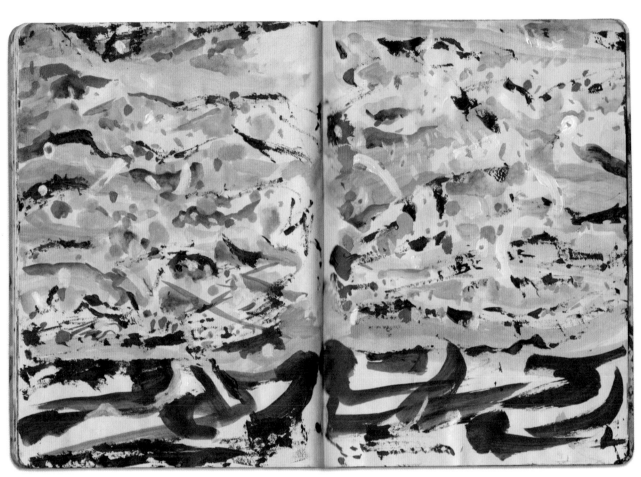

**Syed Mohammad Bakar** PUCHONG, MALAYSIA

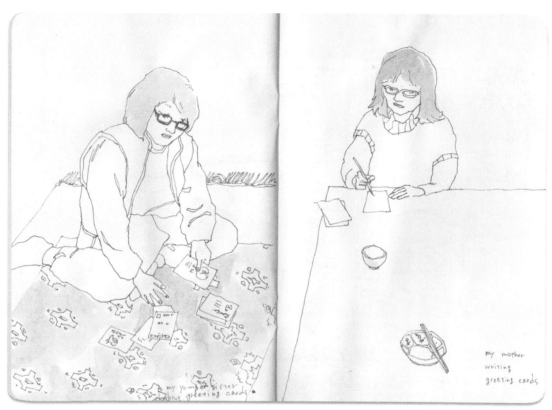

**Juriko Kosaka**  TOKYO, JAPAN

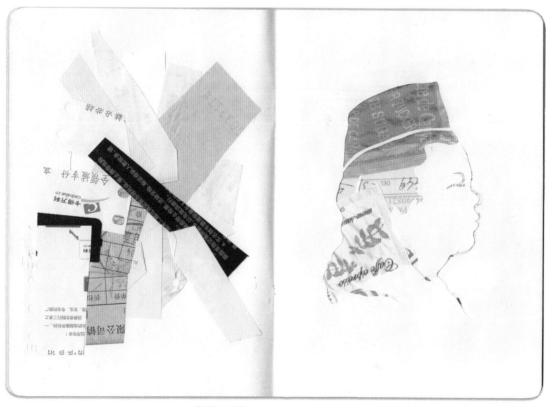

**Odding Wang**  BEIJING, CHINA

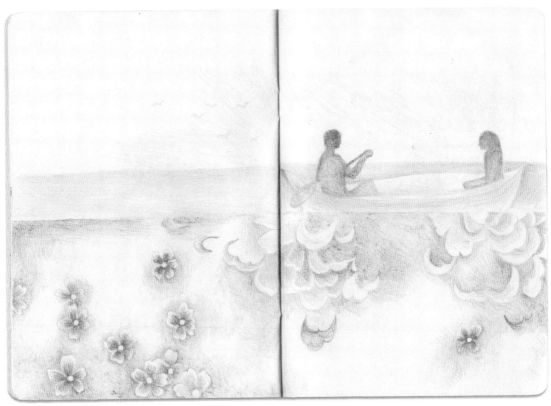

**Hsi-Tan Cheng** PINGTUNG, TAIWAN

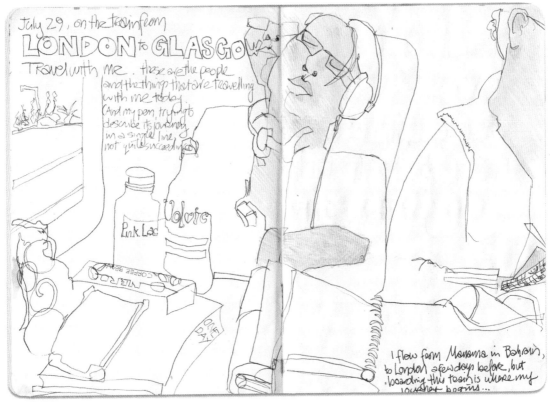

July 29, on the train from
**LONDON to GLASGOW**
Travel with me. these are the people
and the things that are travelling
with me today
(And my pen, trying to
describe its journey
in a single line,
not quite succeeding)

Pink Lac

Volvic

I flew from Manama in Bahrain,
to London a few days before, but
boarding this train is where my
journey begins...

**Seana Mallen** AWALI, BAHRAIN

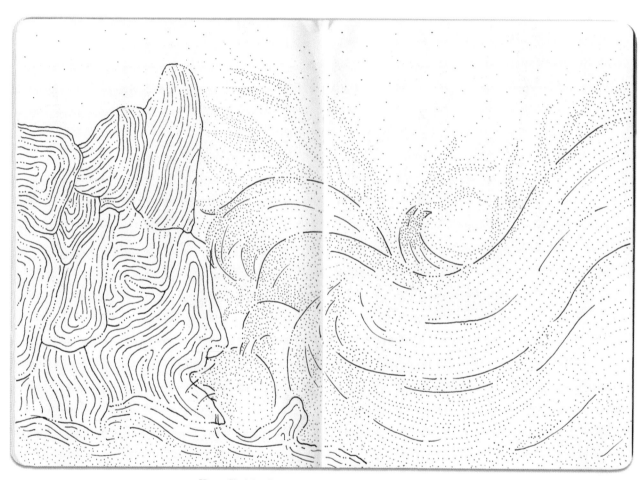

**Hana Shabira Laraswati** BANDUNG, INDONESIA

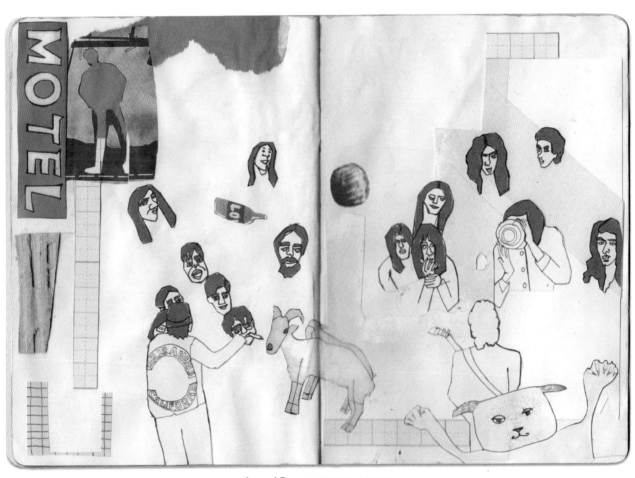

**Ayumi Inoue** TOKYO, JAPAN

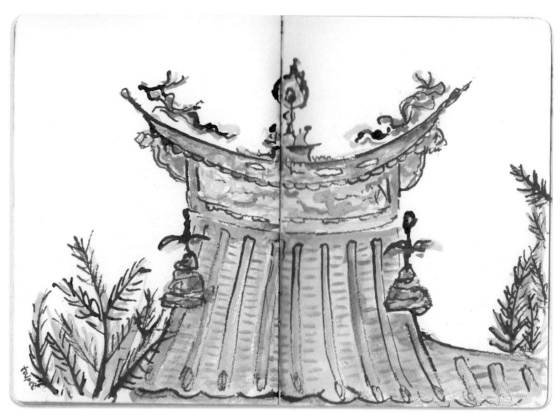

**Salome Tam** SHA TIN, HONG KONG

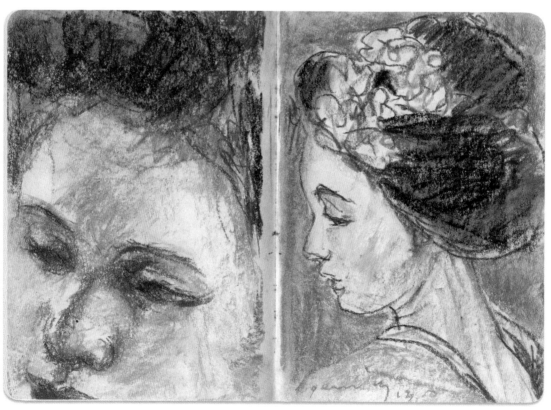

**Shigemi Yamamoto** ASHIYA, JAPAN

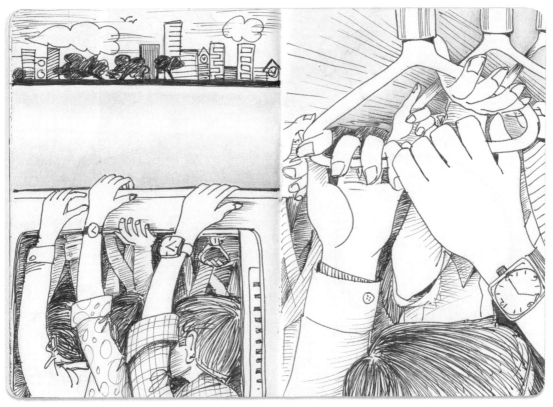

**Sachin Karle** MUMBAI, INDIA

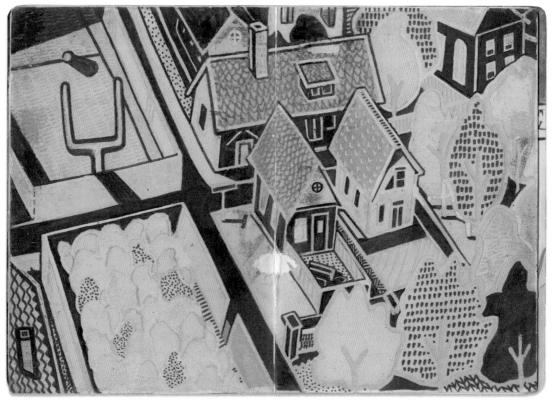

**Feng Feng** HAINING CITY, CHINA

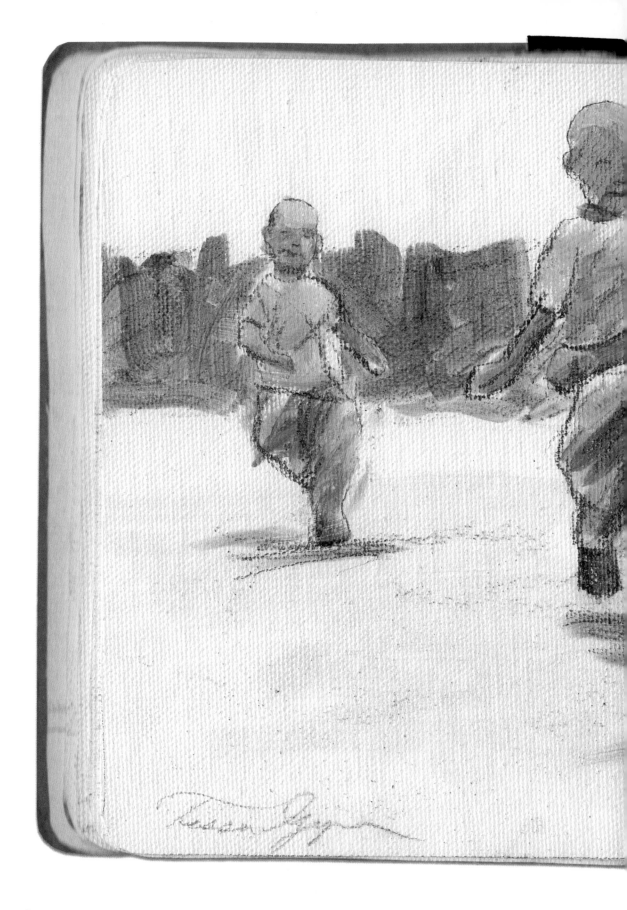

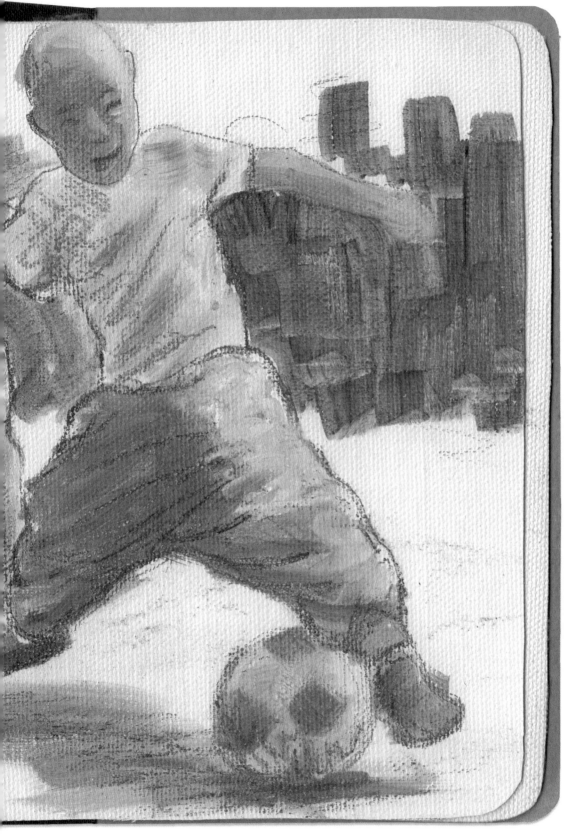

**Tessa Guze**  GWANGJU, SOUTH KOREA

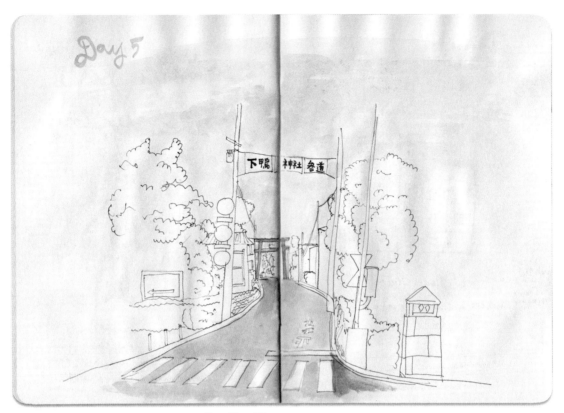

**Szu-Ying Wu** TAIPEI, TAIWAN

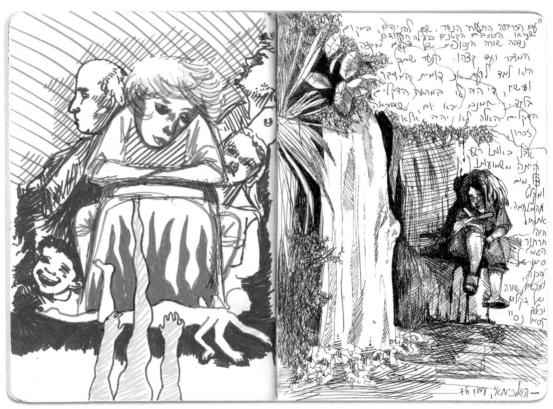

**Rozlyn Wolberger** JERUSALEM, ISRAEL

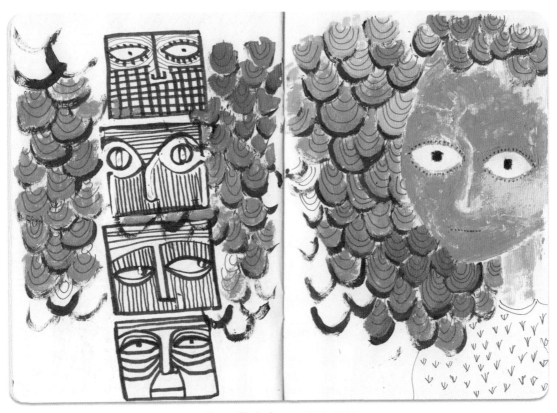

**Pooya Shahsia** TEHRAN, IRAN

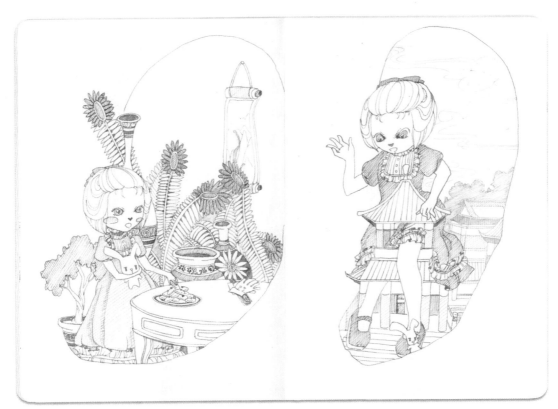

**Pei Shiuan Lin** ILAN, TAIWAN

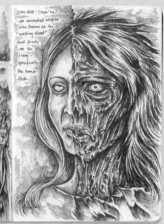

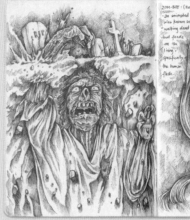

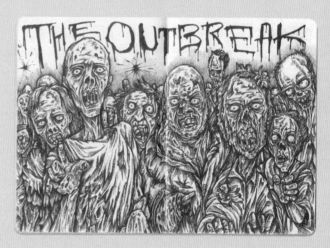

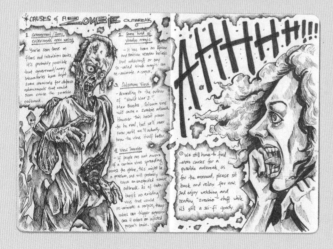

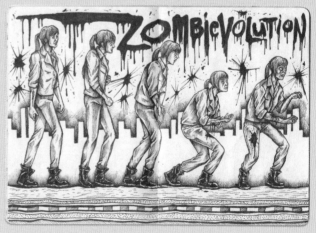

# Kristy Anne Ligones

**DUBAI, UNITED ARAB EMIRATES**

**DO YOU HAVE ANY FORMAL ARTISTIC TRAINING? IF SO, WHERE?**

I took summer art workshops during high school and studied fine arts in college.

**WHAT IS YOUR FAVORITE ARTISTIC TOOL?**

A pen.

**HAVE YOU ALWAYS KEPT A SKETCHBOOK, OR WAS CREATING YOUR SKETCHBOOK A TOTALLY NEW ENDEAVOR FOR YOU? DID YOU ENTER THE SKETCHBOOK PROJECT WITH CERTAIN GOALS, OR WAS IT MORE OF AN EXPERIMENTAL EXPERIENCE?**

I've kept some sketchbooks, but the Sketchbook Project experience was something different. It was like I was trying to complete a whole picture book, filling it up with drawings on one theme. It was fun and challenging, and knowing that a stranger would be looking at my sketchbook, I really had to make each page look interesting and fun.

**WHAT DOES YOUR ARTISTIC PROCESS ENTAIL? ARE THERE CERTAIN INSPIRATIONS YOU HOLD DEAR, OR MATERIALS YOU CAN'T LIVE WITHOUT?**

It's easy for me to get inspired by random things I see and experience every day. Dreaming is another thing I couldn't live without; I get some of my ideas from dreams. Daydreaming also helps me create stories inside my head and put them on a blank sheet. I usually do this while walking or commuting, like my brain is having a different kind of joyride.

**ARE THERE CERTAIN THEMES THAT RECUR THROUGHOUT YOUR WORK? DESCRIBE ANY VISUAL OR CONCEPTUAL ELEMENTS THAT YOU FIND CENTRAL TO YOUR PROCESS.**

The weird stuff, zombies, and strange creatures can be seen in most of my work. I feel like it's more fun and easy to create these if you only have pens and a sketchbook with you, playing with details, creating your own weird patterns for your zombie or weird skin for your creatures. It's pretty rad experimenting with your skills and style with these subjects.

**HOW DOES YOUR PERSONAL BACKGROUND OR GEOGRAPHIC LOCATION TIE INTO YOUR ARTISTIC PRACTICE?**

I think my personal background has more to do with my artistic practice than my geographic location. I can live in different places and still do the same thing over and over again. Maybe there will be a few changes, but not that many. I'm an expat. I've been doing this since before I came here to Dubai. I just love to create and see my imagination come to life through drawing. There are times when I'm out and I can't wait to go home and sketch what my head just popped out. I love to draw.

ASIA

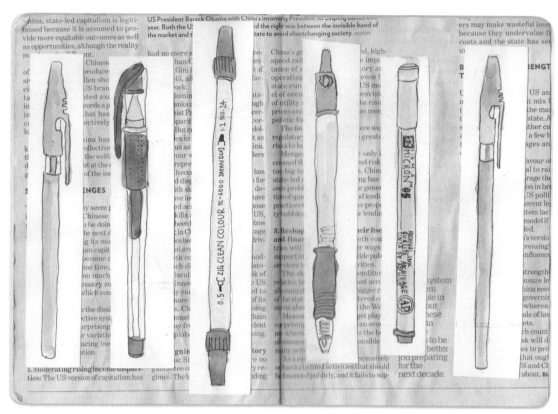

**Megan Lim En** SINGAPORE

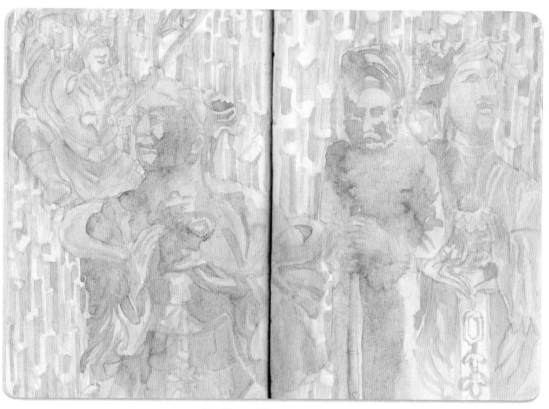

**Yap Kheng Kin** SINGAPORE

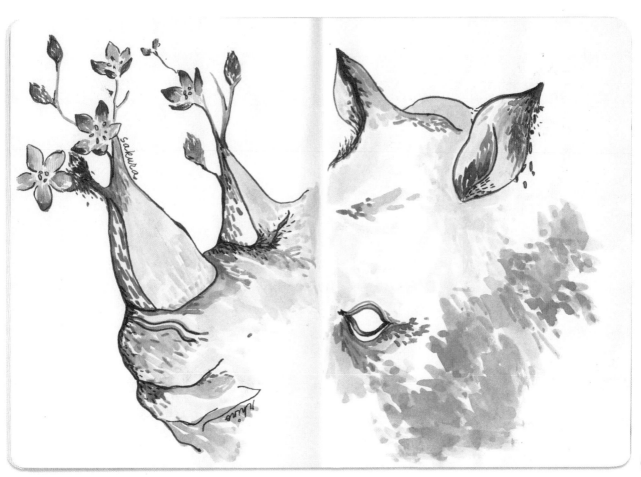

Yizu  TAIPEI, TAIWAN

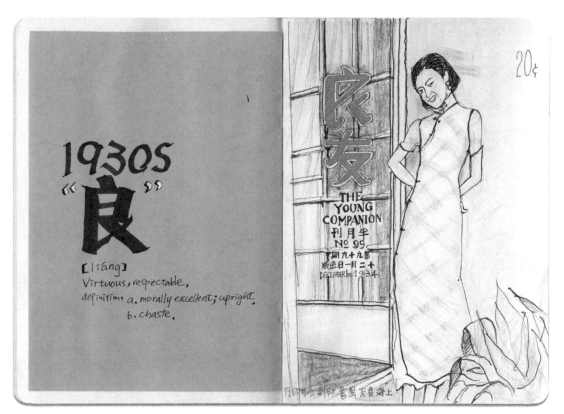

**Faye Chou** TAIPEI, TAIWAN

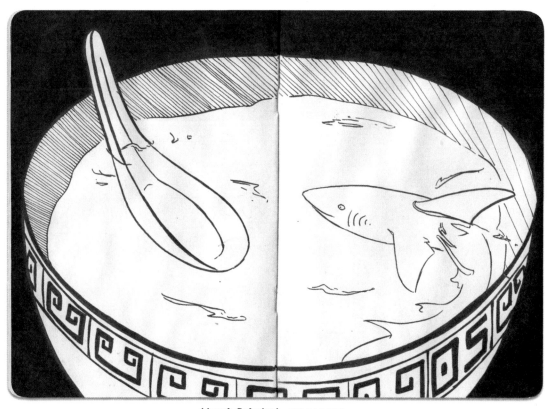

**Aisyah Suhaimi** SINGAPORE

**Dhiyanah Hassan**  KUALA LUMPUR, MALAYSIA

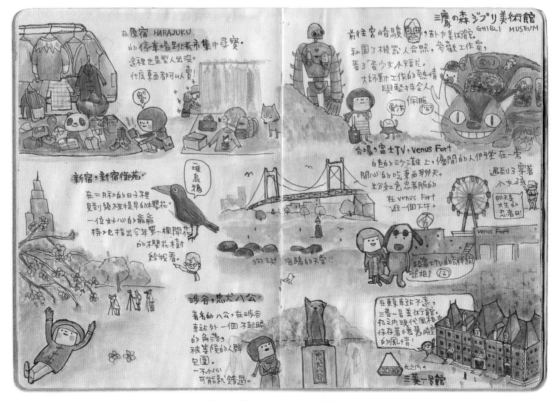

**Linyu Yen**  TAINAN, TAIWAN

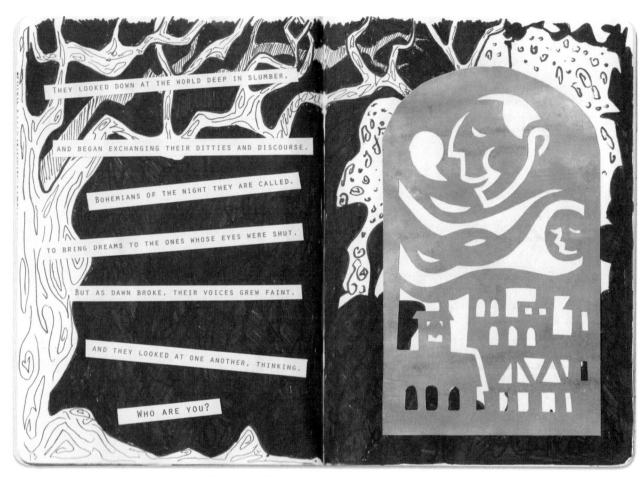

THEY LOOKED DOWN AT THE WORLD DEEP IN SLUMBER,

AND BEGAN EXCHANGING THEIR DITTIES AND DISCOURSE.

BOHEMIANS OF THE NIGHT THEY ARE CALLED,

TO BRING DREAMS TO THE ONES WHOSE EYES WERE SHUT,

BUT AS DAWN BROKE, THEIR VOICES GREW FAINT,

AND THEY LOOKED AT ONE ANOTHER, THINKING,

WHO ARE YOU?

**Celine Lau & Nur'Aishiqin Mohamed** SINGAPORE

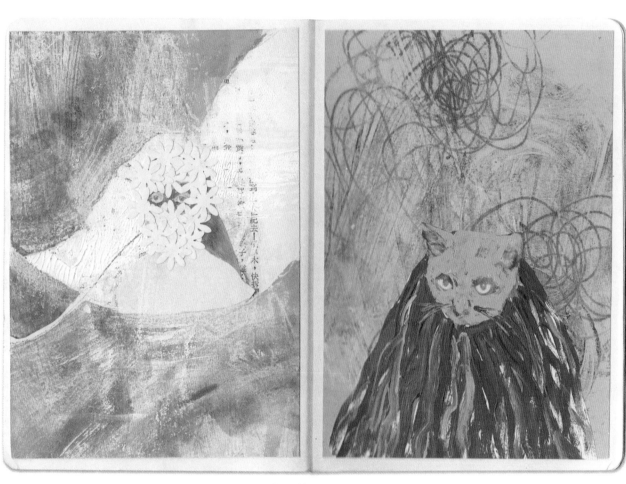

Marc Standing  HONG KONG

ASIA

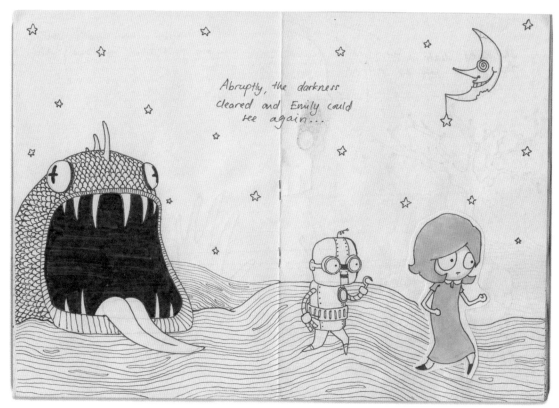

**Lam Kin Weng**  PETALING JAYA, MALAYSIA

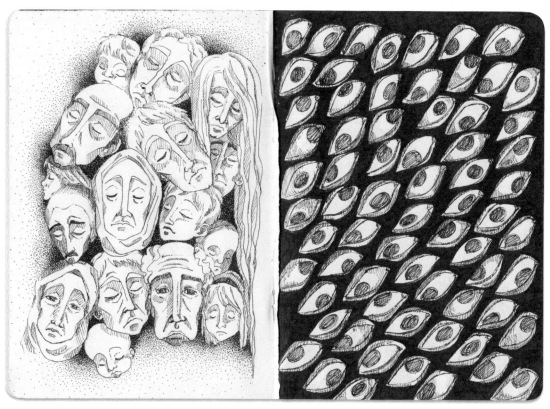

**Joumana Ismail**  DUBAI, UNITED ARAB EMIRATES

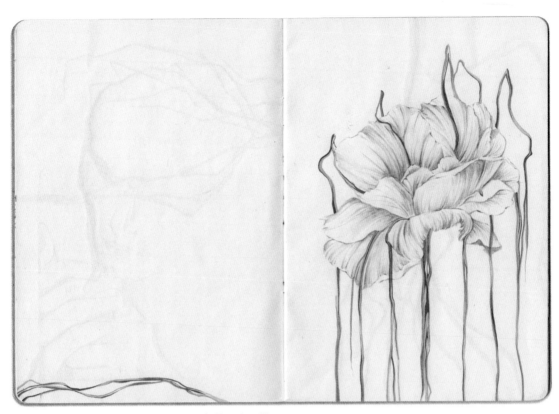

**Bernice Chua** SINGAPORE

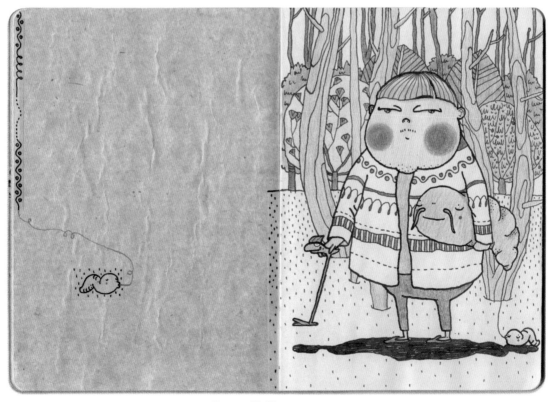

**Yvonne Y. Chan** HONG KONG

**Solomon T. Yu**

HONG KONG

**Devin Draudt**

HANGZHOU, CHINA

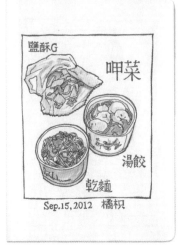

**Pei-Yi Lin**

TAIPEI, TAIWAN

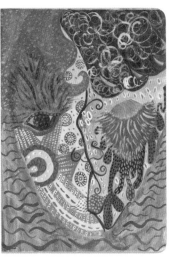

**Melissa Yong Li Sha**

SUBANG JAYA, MALAYSIA

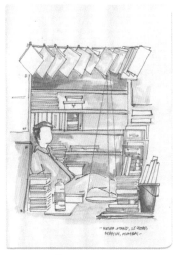

**Indu Mohan**

MUMBAI, INDIA

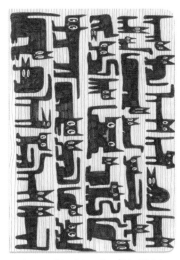

**Tamar Moshkovitz/GO-TAM**

TEL AVIV, ISRAEL

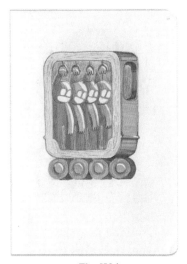

**The N2A**

TEL AVIV, ISRAEL

**Suren Hash**

ULAANBAATAR, MONGOLIA

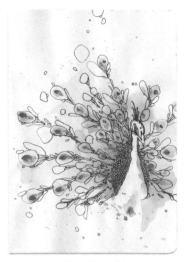

**Yen Chun Lin**

TAIPEI, TAIWAN

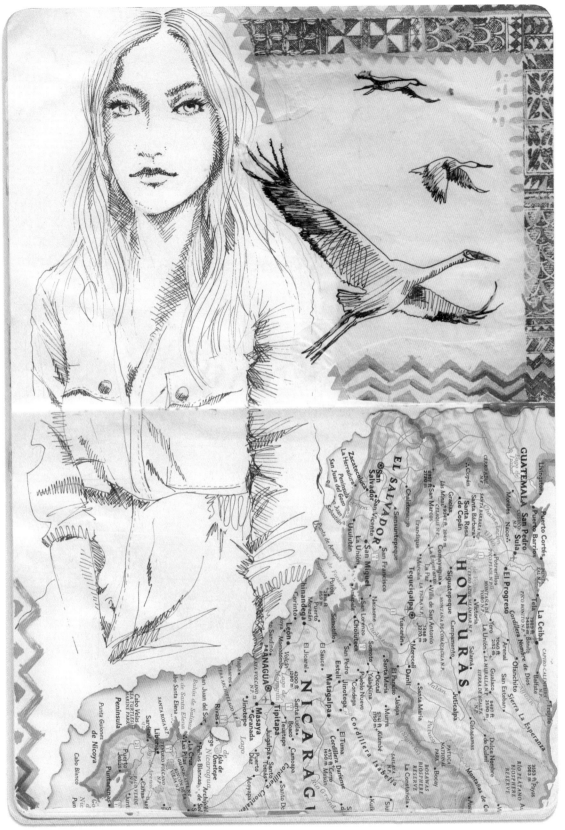

**Sharon Dev** MUMBAI, INDIA

**talktothesun** YAMAGUCHI, JAPAN

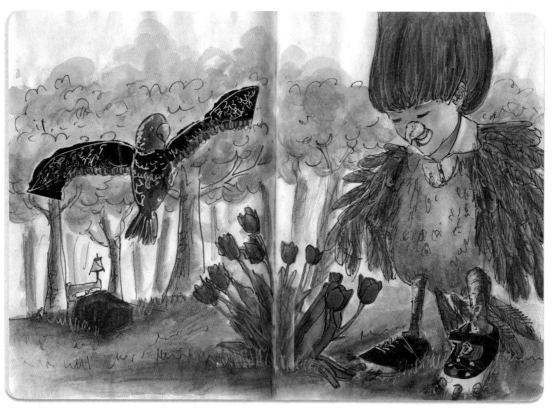

**MaryAnn Loo** SINGAPORE

194

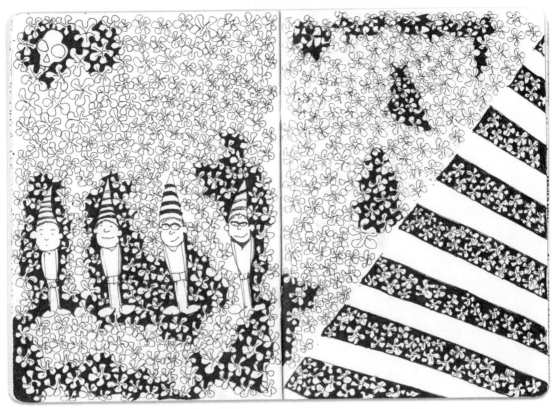

Pornchuen (Nong) Ngampromphan  BANGKOK, THAILAND

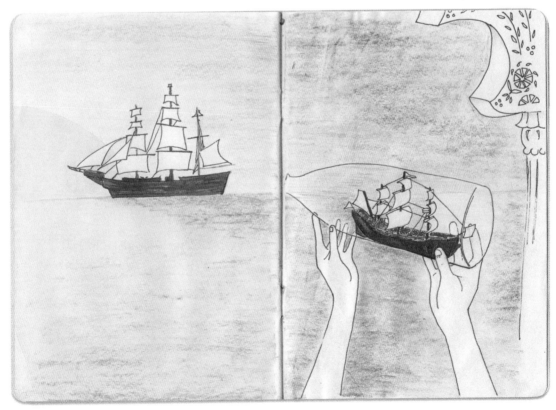

Pallavi Singh  NAVI MUMBAI, INDIA

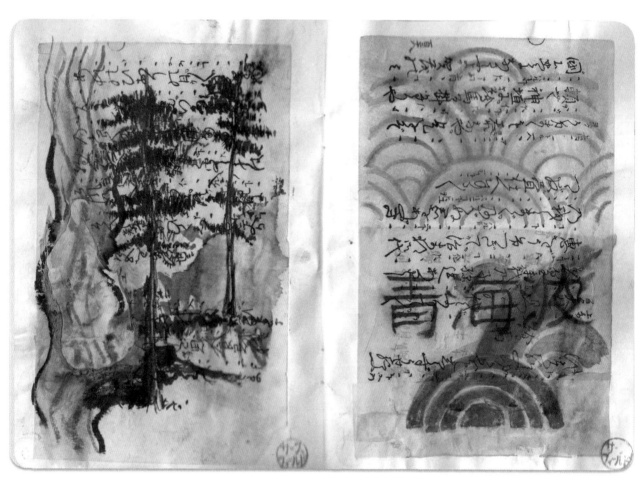

**Brendan Sarsfield** YOKOHAMA, JAPAN

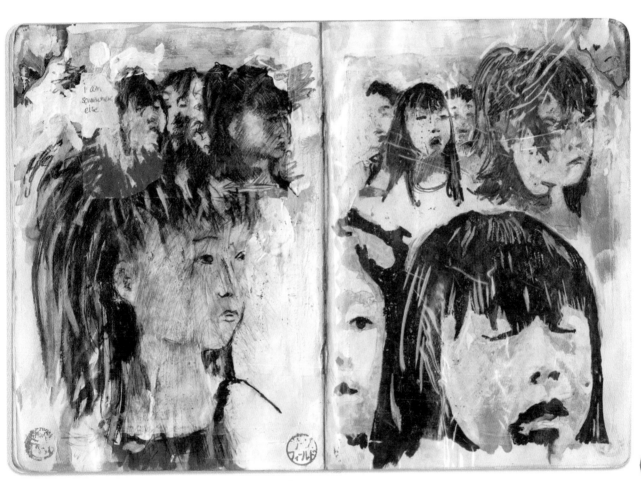

Brendan Sarsfield   YOKOHAMA, JAPAN

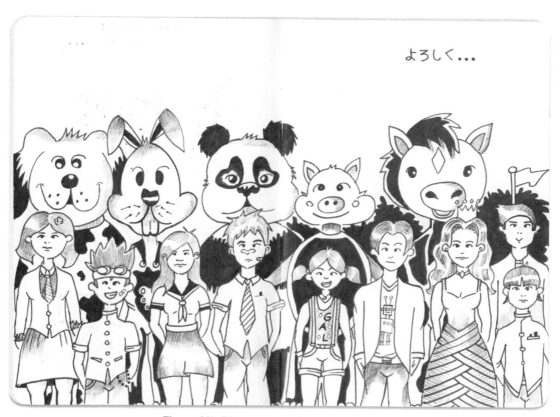

**Thessa Mia Rivera** LAS PIÑAS, PHILIPPINES

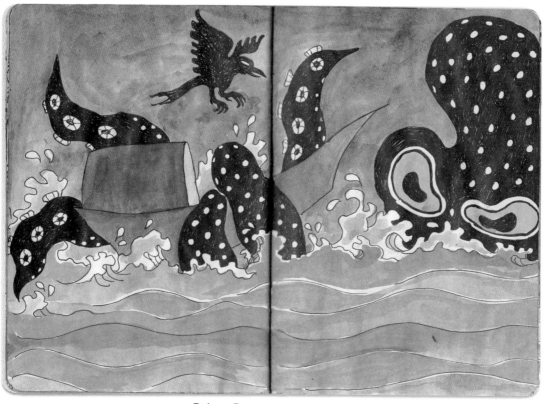

**Rajasee Ray** KOLKATA, INDIA

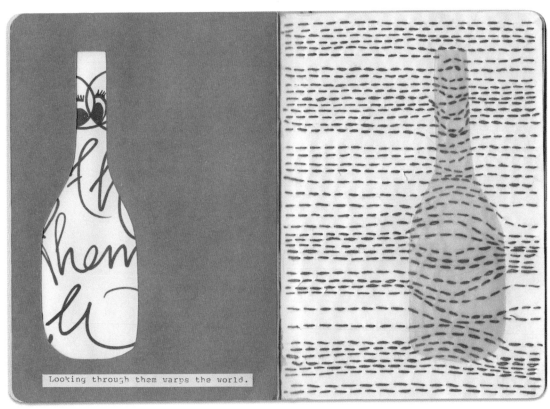

**Nishi Chauhan** BANGALORE, INDIA

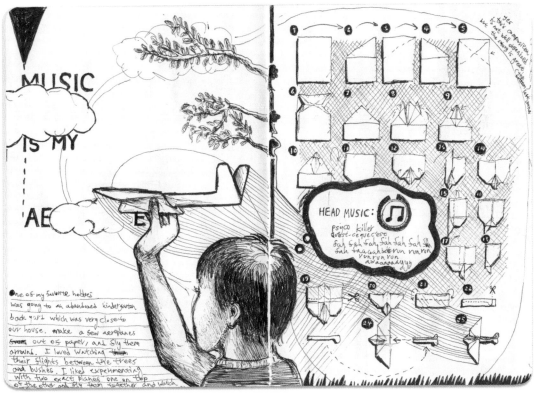

**Idan Shani** TEL AVIV, ISRAEL

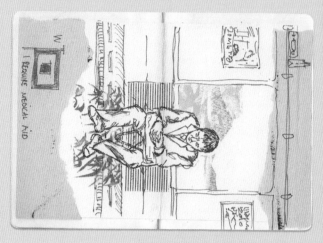

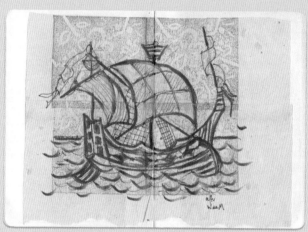

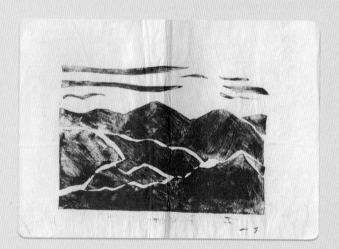

# Andrea E. Kobayashi

OIZUMI, JAPAN

**DO YOU HAVE ANY FORMAL ARTISTIC TRAINING? IF SO, WHERE?**

I was in the Art Students League at Victoria University, Australia, and Charles Sturt University, Australia.

**WHAT IS YOUR FAVORITE ARTISTIC TOOL?**

Anything that makes a good black line.

**HAVE YOU ALWAYS KEPT A SKETCHBOOK, OR WAS CREATING YOUR SKETCHBOOK A TOTALLY NEW ENDEAVOR FOR YOU? DID YOU ENTER THE SKETCHBOOK PROJECT WITH CERTAIN GOALS, OR WAS IT MORE OF AN EXPERIMENTAL EXPERIENCE?**

My goal was to keep my Sketchbook Project sketchbooks "sketchy," so to speak, to not edit them, to not plan the contents or preconceive a certain look. I wanted to contribute books that looked authentically like the sort of ad-hoc notes, drawings, and desultory scribbles, good, bad, or indifferent, that a real sketchbook contains. Projects that are documented online often end up being very self-conscious and careful not to look rough or incomplete and can be precious about "finish." I tried hard to avoid this: these are just notes and sketches.

**WHAT DOES YOUR ARTISTIC PROCESS ENTAIL? ARE THERE CERTAIN INSPIRATIONS YOU HOLD DEAR, OR MATERIALS YOU CAN'T LIVE WITHOUT?**

I like paper and experimenting with any kind of paper and line work, whether in ink, monotype, pen, paint sticks, or pencil. I'm always looking for materials that will give me the right kind of taut, tense, slightly scratchy line. I collect antique postcards and I get a great deal of inspiration from them.

**ARE THERE CERTAIN THEMES THAT RECUR THROUGHOUT YOUR WORK? DESCRIBE ANY VISUAL OR CONCEPTUAL ELEMENTS THAT YOU FIND CENTRAL TO YOUR PROCESS.**

I think and dream a great deal about ancient landscapes. I am interested in standing stones, symbolic topography, and the like. Probably none of that comes across in my sketchbooks. I think about landscapes and ways of finding places, ways of getting to and getting into places, connecting with places that are not based on traditional mapping.

**HOW DOES YOUR PERSONAL BACKGROUND OR GEOGRAPHIC LOCATION TIE INTO YOUR ARTISTIC PRACTICE?**

I live in a different country than the one I was raised in. I think about the landscapes and certain topographies in my native land, but not about the cities or urban areas, which don't interest or inspire me. It is easier to work as an artist in the country I live in now.

ASIA

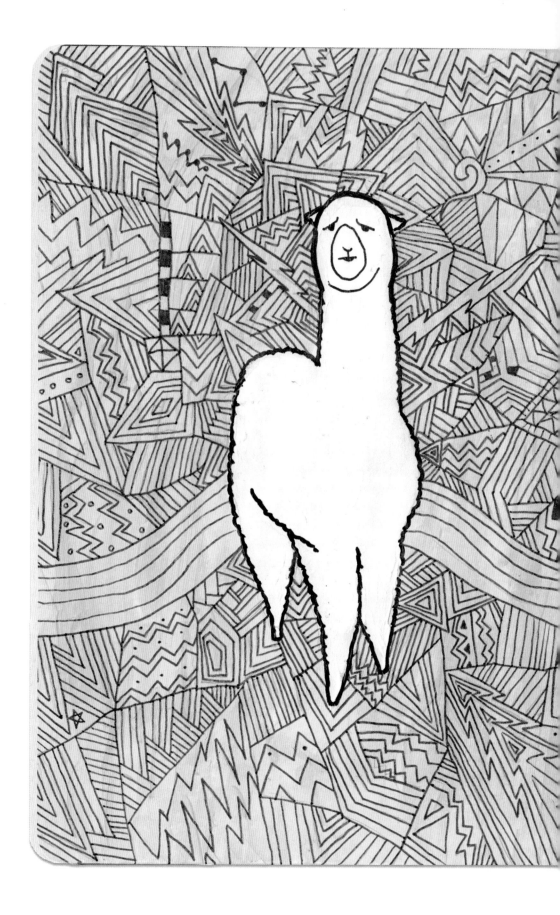

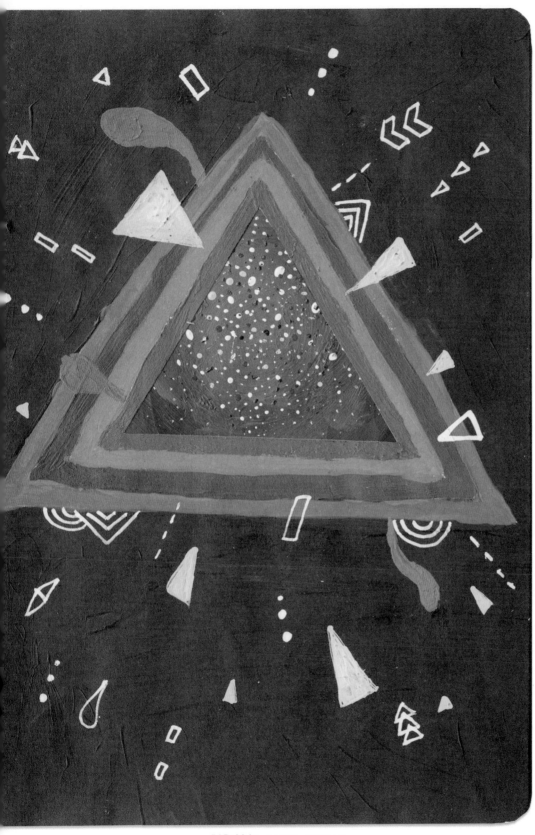

GODebbie  TAIPEI, TAIWAN

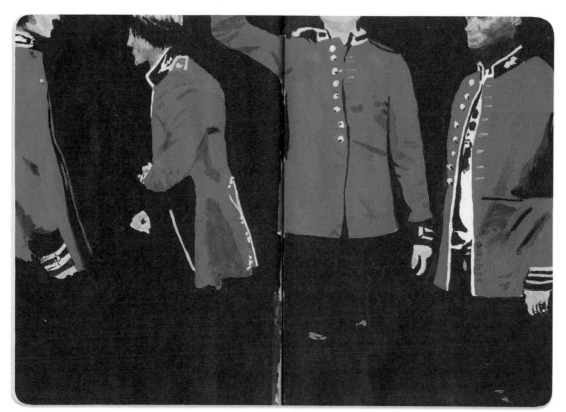

**Kitty Tang** HONG KONG

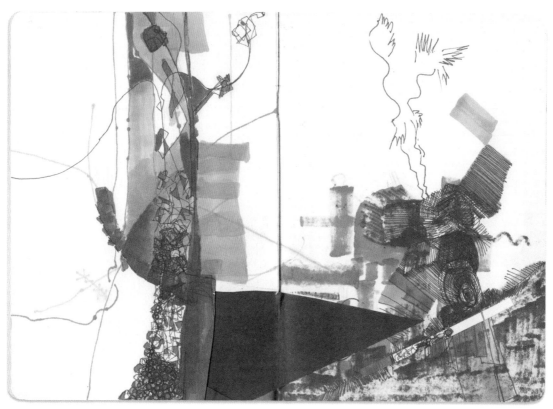

**Midori Ueda-Okahana** TOKYO, JAPAN

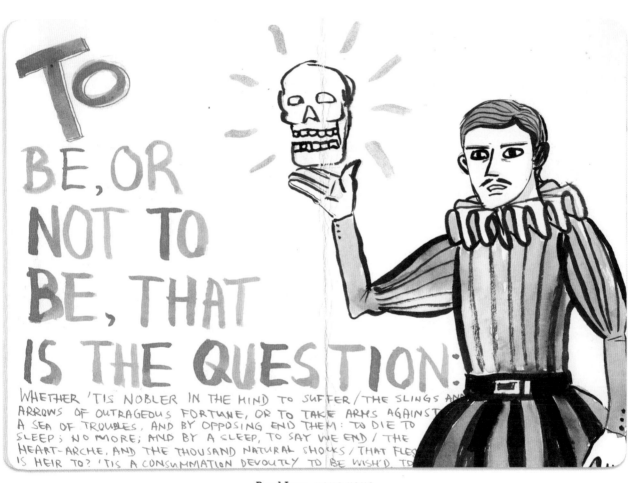

TO BE, OR NOT TO BE, THAT IS THE QUESTION: WHETHER 'TIS NOBLER IN THE MIND TO SUFFER / THE SLINGS AND ARROWS OF OUTRAGEOUS FORTUNE, OR TO TAKE ARMS AGAINST A SEA OF TROUBLES, AND BY OPPOSING END THEM: TO DIE TO SLEEP; NO MORE; AND BY A SLEEP, TO SAY WE END / THE HEART-ARCHE, AND THE THOUSAND NATURAL SHOCKS / THAT FLESH IS HEIR TO? 'TIS A CONSUMMATION DEVOUTLY TO BE WISH'D, TO

**Pearl Law** HONG KONG

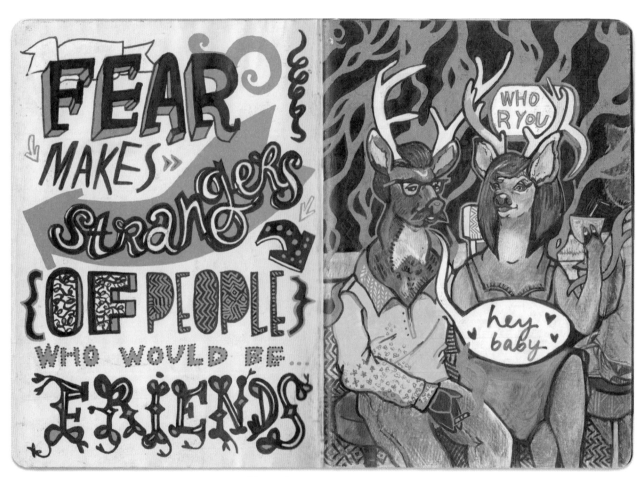

Diyou Wu HANGZHOU, CHINA

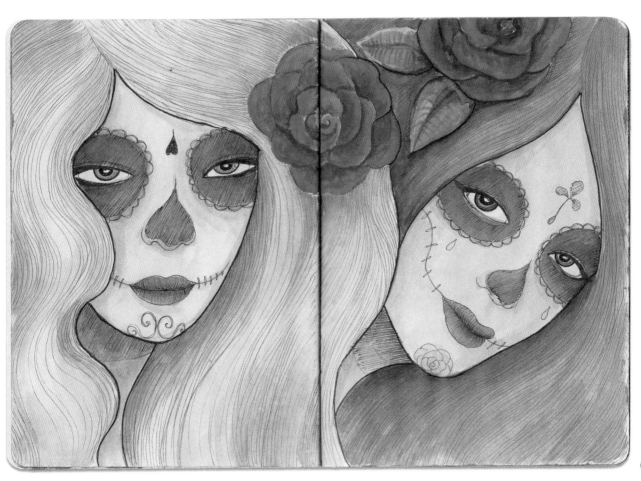

**Anna Hormiguera** TAGBILARAN, PHILIPPINES

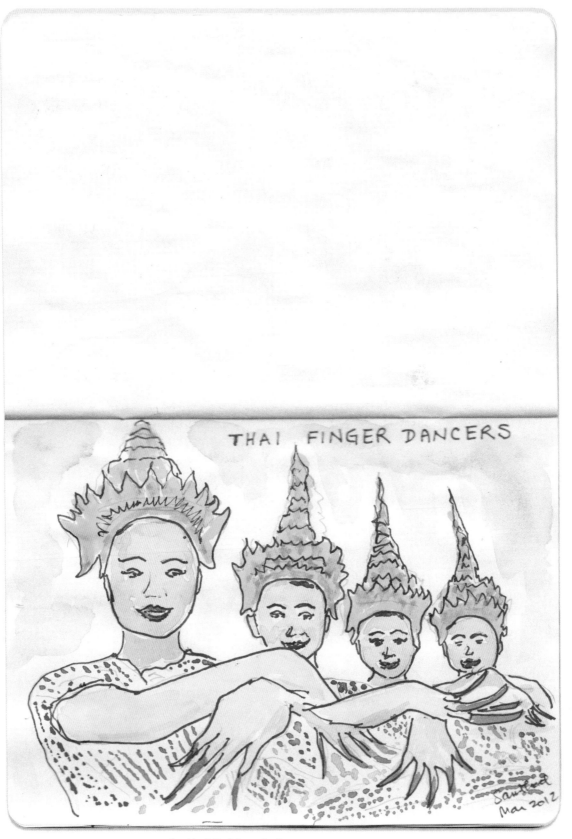

THAI FINGER DANCERS

**Santhad Prakkamakul** BANGKOK, THAILAND

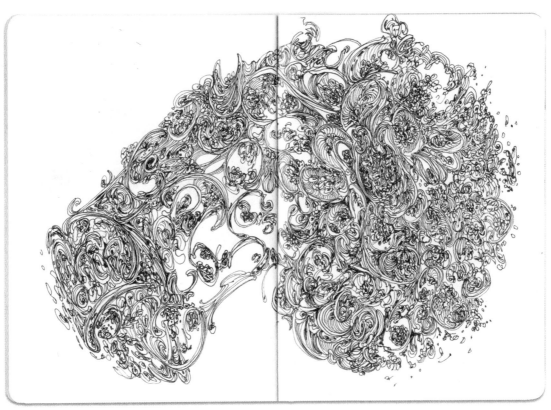

**Satomi Sugimoto** TOKYO, JAPAN

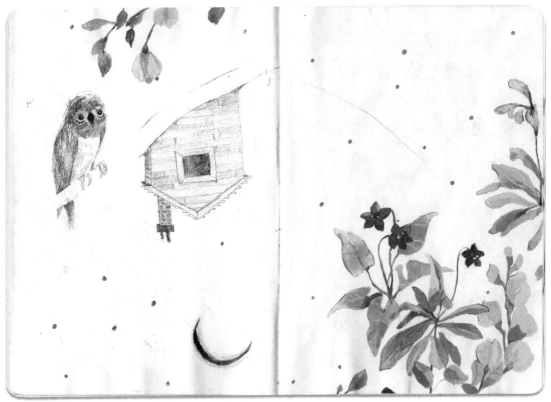

**Jenny Lumelsky** GIV'AT AVNI, ISRAEL

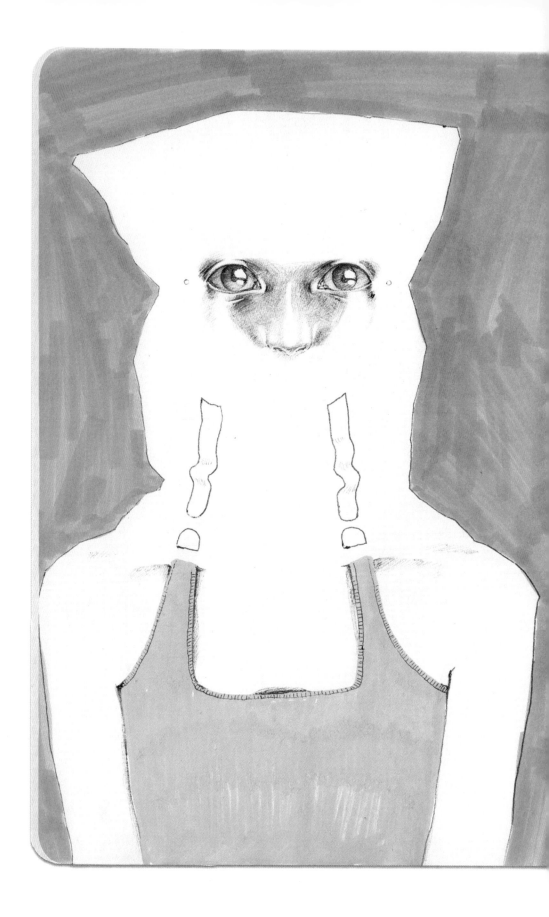

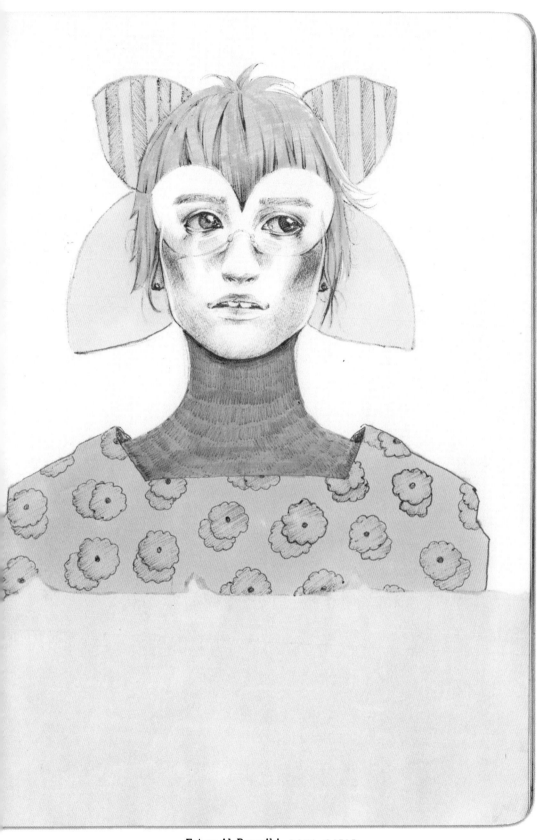

**Fatma Al-Remaihi** DOHA, QATAR

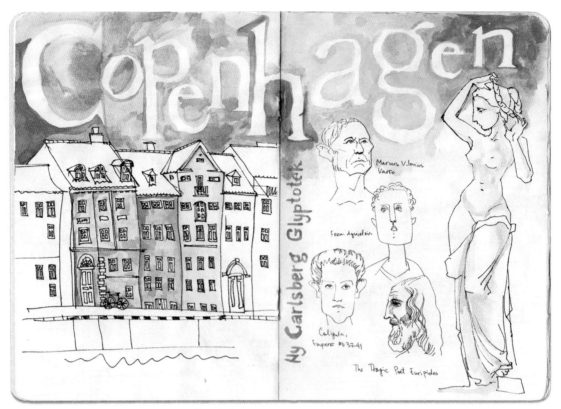

**Nastia Larkina** MOSCOW, RUSSIA

**Taarika Ravi John** KOCHI, INDIA

**Lawrence Chiam** SINGAPORE

**Nalani Rachel** QUEZON CITY, PHILIPPINES

**Jesvin Yeo** SINGAPORE

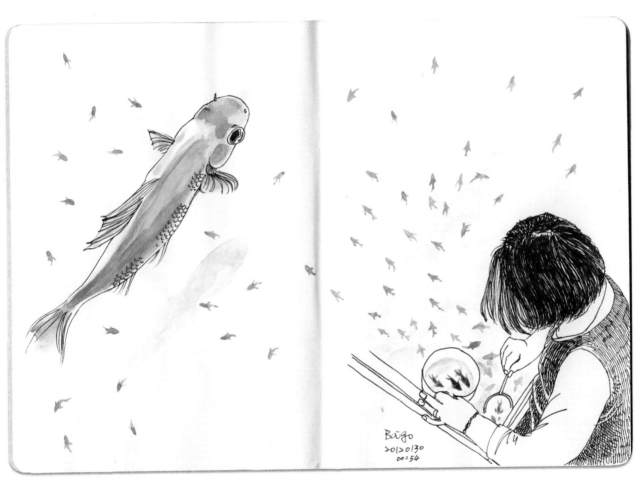

**Baigo Liao**  TOKYO, JAPAN

ASIA

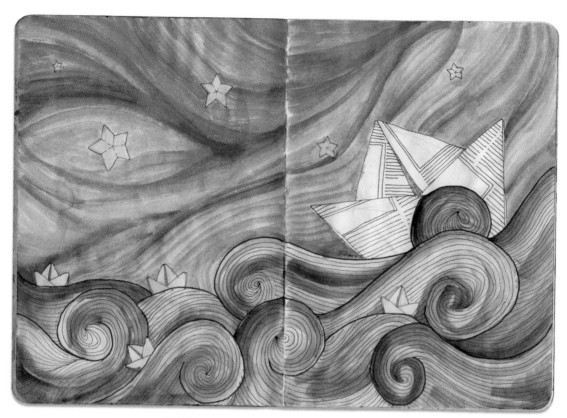

**Ella Mae Ladignon**  QUEZON CITY, PHILIPPINES

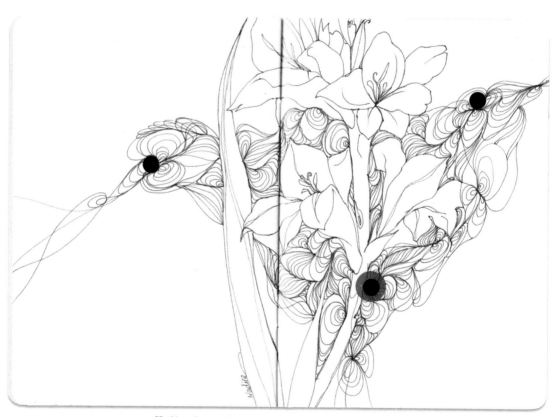

**Nadine Ruwaida**  DUBAI, UNITED ARAB EMIRATES

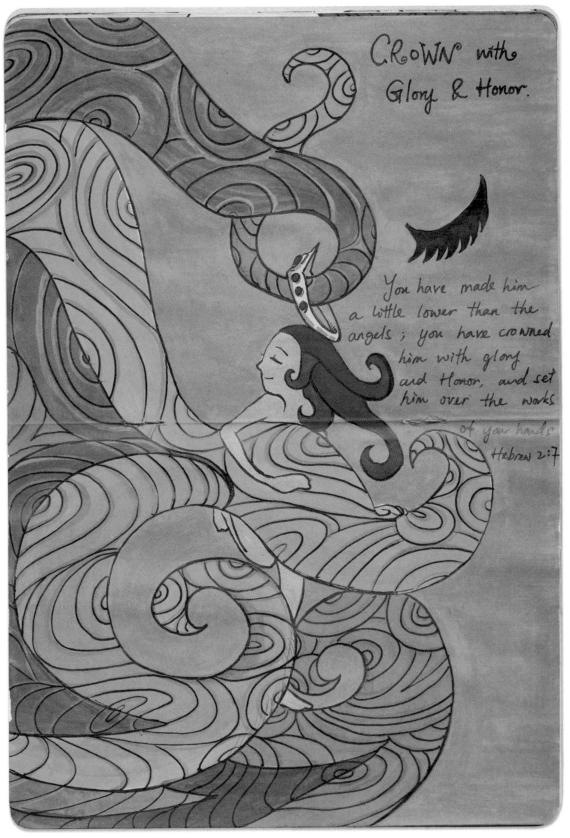

Chen Li Li KUCHING, MALAYSIA

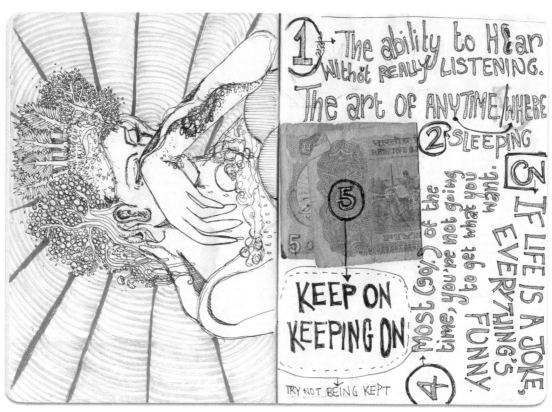

**Kavya Satyakumar** BANGALORE, INDIA

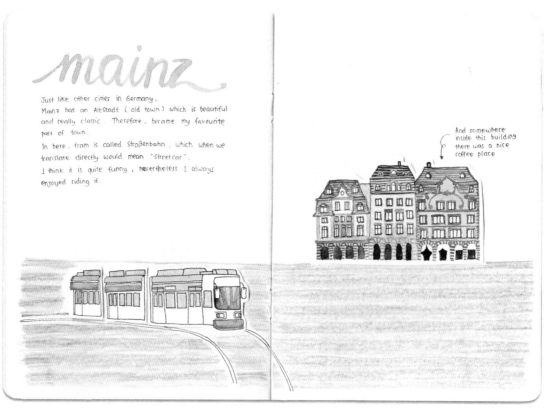

**Clara Oktarina** JAKARTA BARAT, INDONESIA

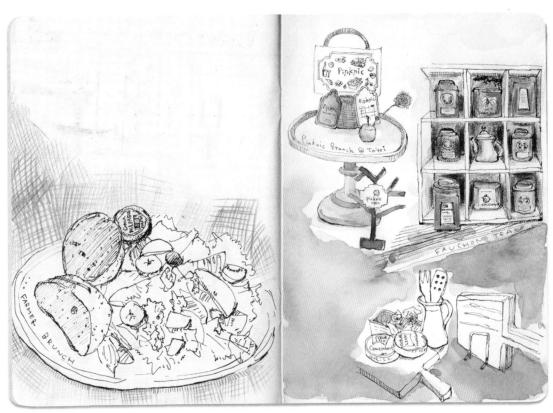

**Nicky Chang** YANGMEI CITY, TAIWAN

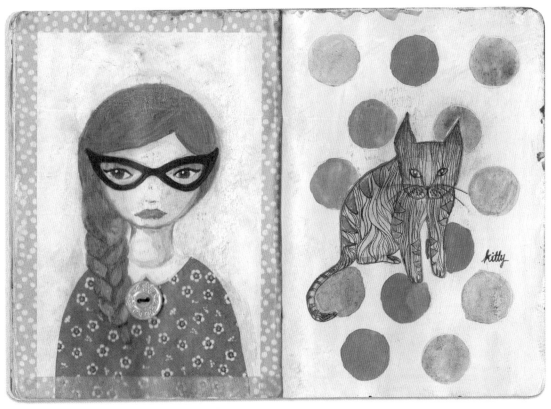

**Elfe Nur Reyany** SINGAPORE

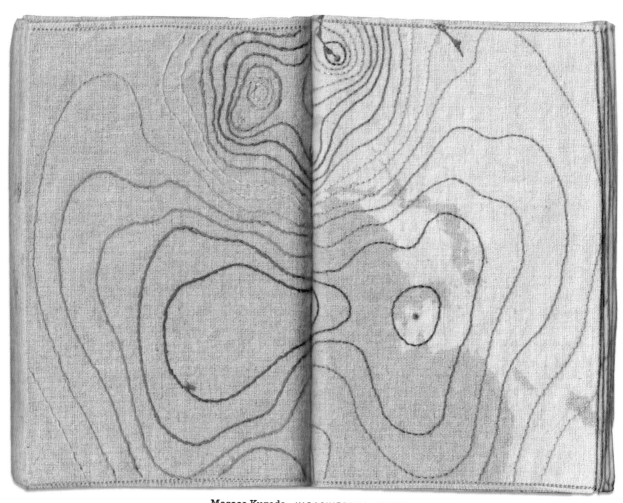

**Masaco Kuroda** HIGASHIŌSAKA, JAPAN

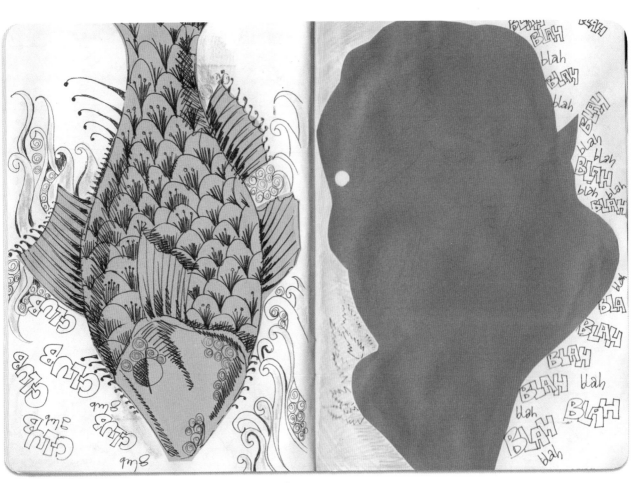

**Sharon Dev** MUMBAI, INDIA

# AUSTRALIA

With its variety of stunning landscapes, Australia is known for its unique cultures and climates and for its offbeat and original forms of expression. We see many bold and seemingly magical contributions to The Sketchbook Project from the Australian region.

The Australian artists appear completely unafraid to explore and fantasize. In the spread included here by Sydney-based artist Lobsterboy, we are encouraged to envision a sense of escape from the ordinary and mundane, the routine. We will soon be able to leave the suburbs behind and travel through time. Who doesn't dream of such a thing? Almost as a nod to Lobsterboy, Sydney-based artist Jillian McCrae brings us into a medieval world, masterfully dreamed up and detailed.

We see a lot of work in this region with a finger on the pulse of culture, exuding visual ideas that could easily translate to fashion or pop culture. Melbourne artist Alexandra Ethell's vibrant, dizzying pattern almost shifts across the page to take on its decorative role. Perhaps referencing the indigenous culture, Kate Dick, also from Melbourne, illustrates decorative wearable art in a very tangible way.

The environment is also a subject we encounter often in the work by artists from this part of the world. During an interview with artist Ro Bancroft, we learned how living in central Victoria affects her artistic practice. In Melbourne, artist Githa Postma's book shows a detailed pencil drawing of what looks like the outback, bringing us right there onto the rough land.

The exciting and imaginative work pouring out of Australia offers the sense that anything is possible. We can now imagine what tightrope walking elephants and barista cats might look like. And who knows, even time travel might be possible one day!

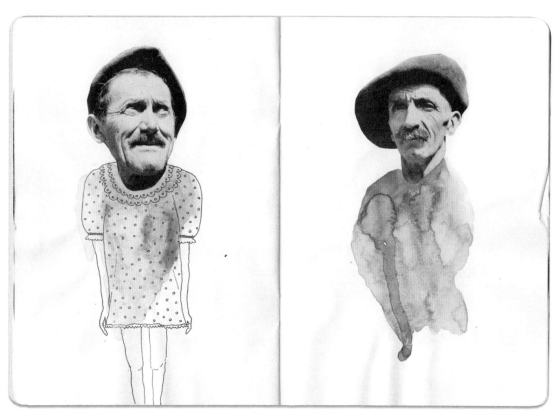

**Michelle Knowles**  BRISBANE, AUSTRALIA

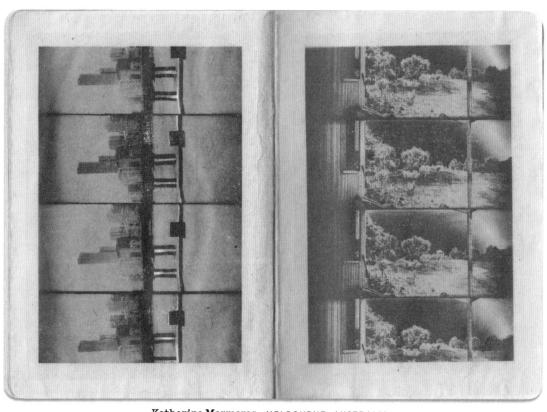

**Katherine Marmaras**  MELBOURNE, AUSTRALIA

**Tricia Brady** MELBOURNE, AUSTRALIA

**Amanda Brown** PERTH, AUSTRALIA

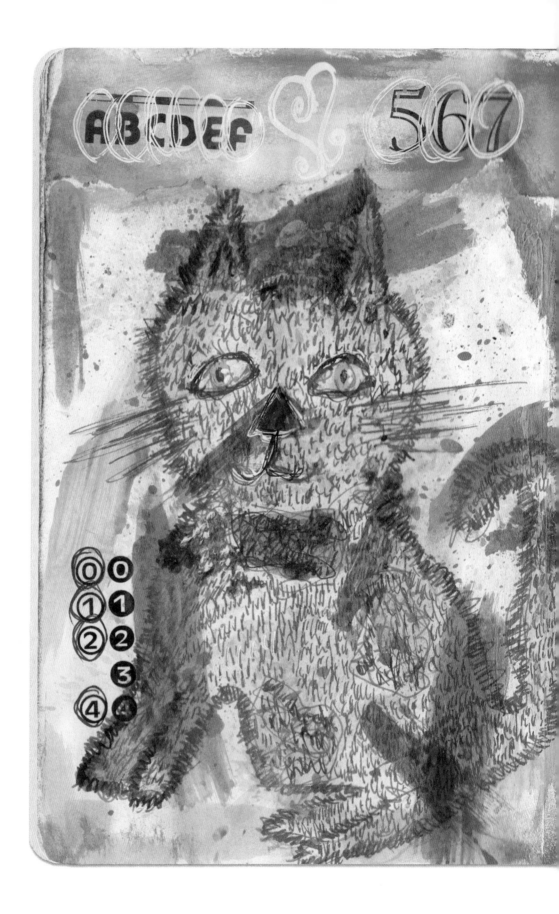

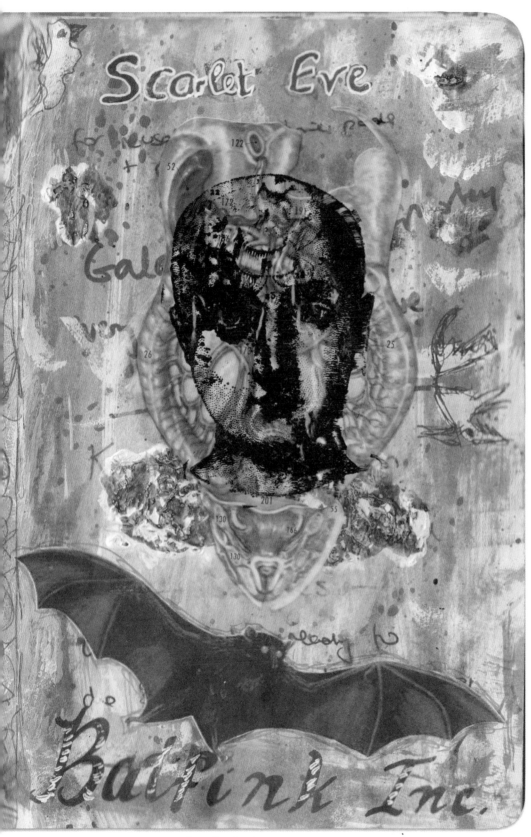

Joan Rowlands PERTH, AUSTRALIA

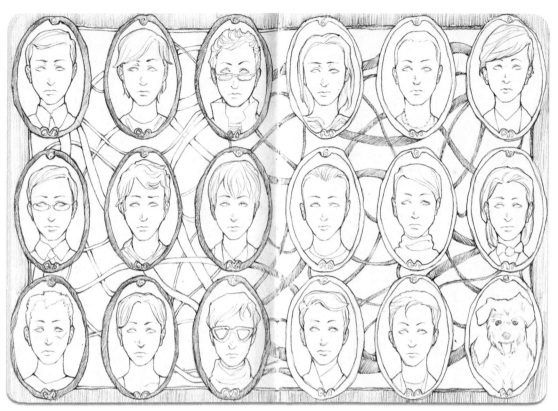

**Michelle Mun** MELBOURNE, AUSTRALIA

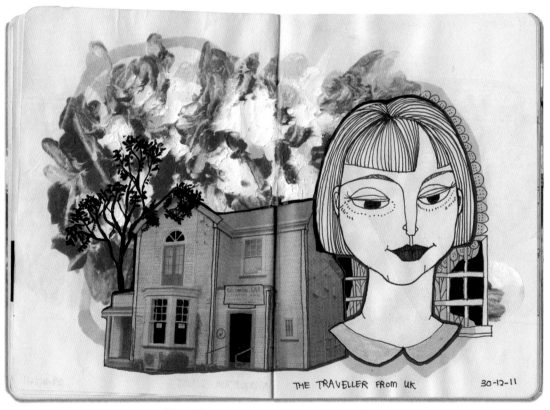

**Yiwen Seow** WELLINGTON, NEW ZEALAND

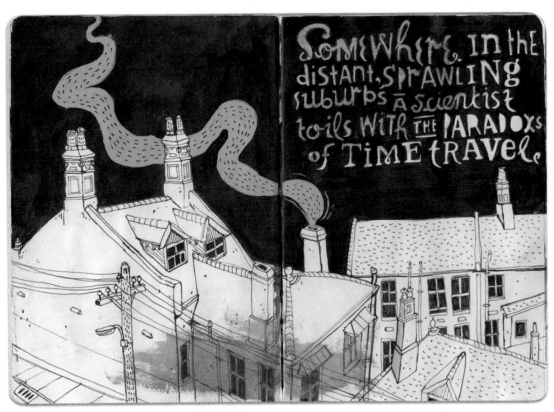

**Lobsterboy** SYDNEY, AUSTRALIA

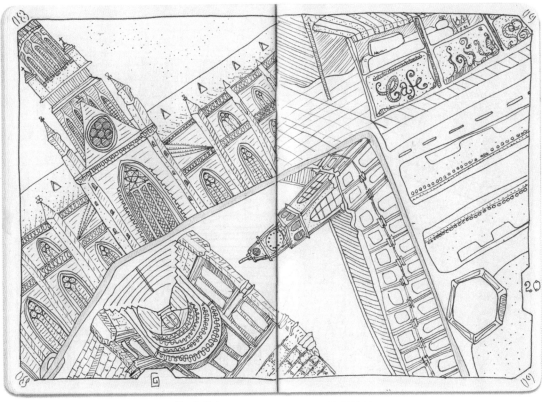

**Beck Feiner** ABBOTSFORD, AUSTRALIA

AUSTRALIA

**Sarah Louise Ricketts**  MELBOURNE, AUSTRALIA

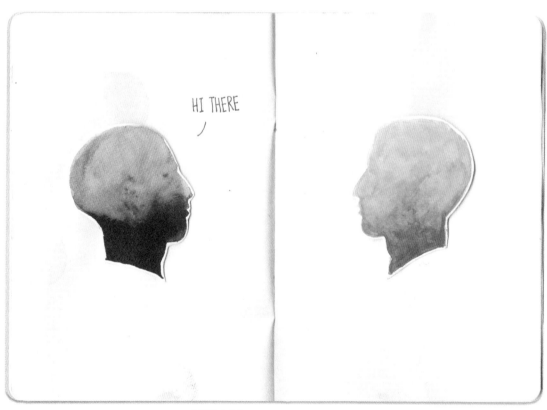

**Lillian Ling**  PERTH, AUSTRALIA

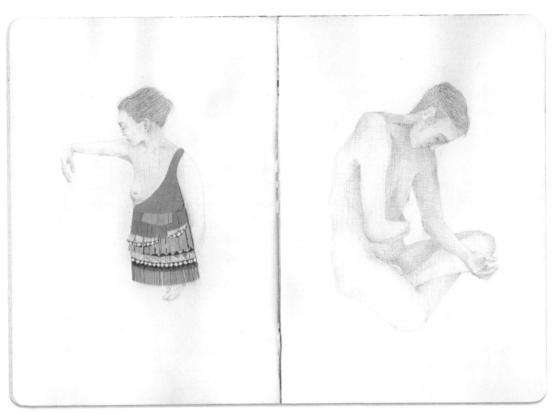

**Kate Dick** MELBOURNE, AUSTRALIA

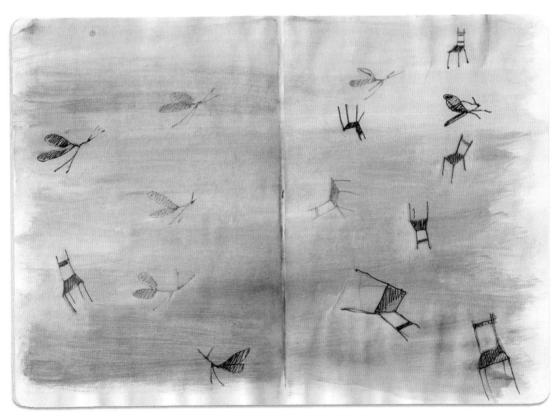

**Romy Dingle** MULLUMBIMBY, AUSTRALIA

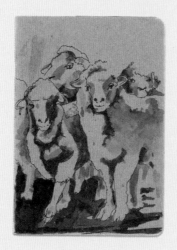

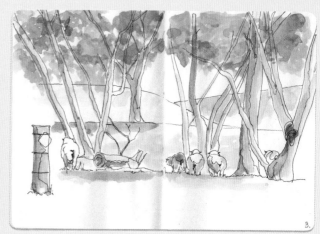

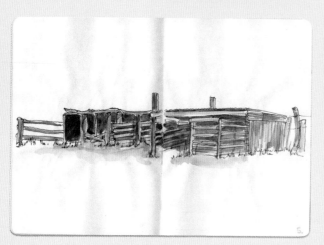

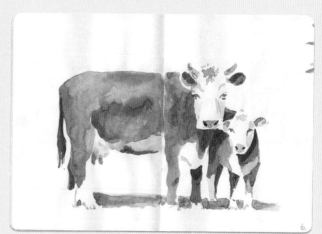

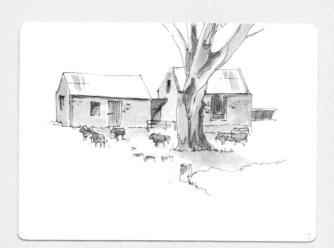

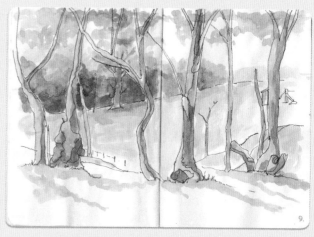

# Ro Bancroft

CASTLEMAINE, AUSTRALIA

**DO YOU HAVE ANY FORMAL ARTISTIC TRAINING? IF SO, WHERE?**

I studied graphic design at Victoria University, Australia.

**WHAT IS YOUR FAVORITE ARTISTIC TOOL?**

Watercolor brushes.

**HAVE YOU ALWAYS KEPT A SKETCHBOOK, OR WAS CREATING YOUR SKETCHBOOK A TOTALLY NEW ENDEAVOR FOR YOU? DID YOU ENTER THE SKETCHBOOK PROJECT WITH CERTAIN GOALS, OR WAS IT MORE OF AN EXPERIMENTAL EXPERIENCE?**

I have always kept a sketchbook and use it as often as possible, but usually the most on vacation.

**WHAT DOES YOUR ARTISTIC PROCESS ENTAIL? ARE THERE CERTAIN INSPIRATIONS YOU HOLD DEAR, OR MATERIALS YOU CAN'T LIVE WITHOUT?**

Sketching is a very freeing experience. The quicker the sketch, the better the outcome (usually).

**ARE THERE CERTAIN THEMES THAT RECUR THROUGHOUT YOUR WORK? DESCRIBE ANY VISUAL OR CONCEPTUAL ELEMENTS THAT YOU FIND CENTRAL TO YOUR PROCESS.**

The landscape inspires me, as it's ever changing. I find that trees seem to be central to my process.

**HOW DOES YOUR PERSONAL BACKGROUND OR GEOGRAPHIC LOCATION TIE INTO YOUR ARTISTIC PRACTICE?**

Living in central Victoria, Australia, the landscape is quite different from coastal areas, with gray trees, native bush forests, flat plains, and high mountains.

AUSTRALIA

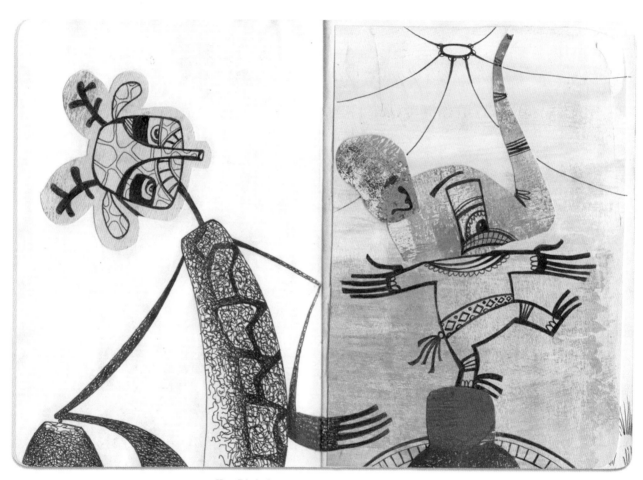

**Ken Rinkel** FRENCHS FOREST, AUSTRALIA

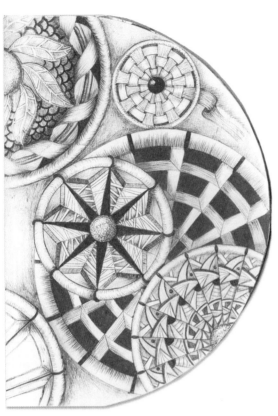

**Joanna Newsham** AUCKLAND, NEW ZEALAND

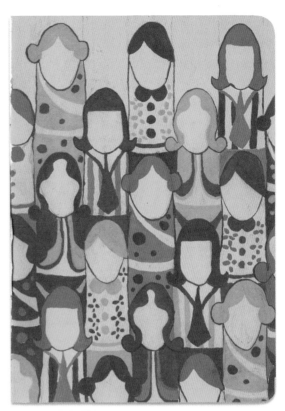

**Erin Ibbertson** SYDNEY, AUSTRALIA

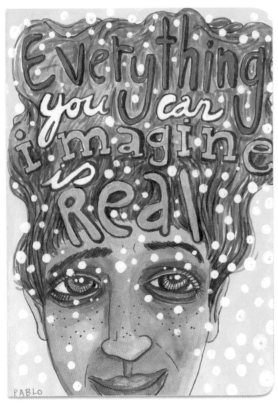

**Sarah Catherine Firth** MELBOURNE, AUSTRALIA

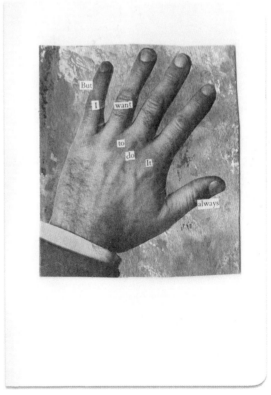

**Jessie Burrows** MELBOURNE, AUSTRALIA

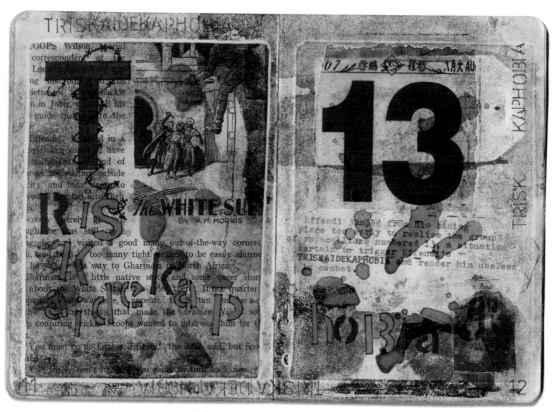

r0bf0s  REDLAND CITY, AUSTRALIA

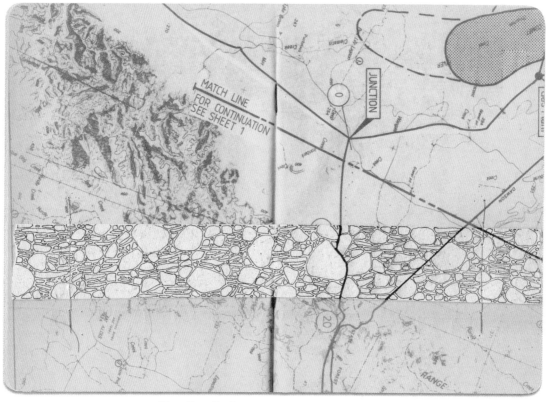

Clare Jean Ford  ROCKHAMPTON, AUSTRALIA

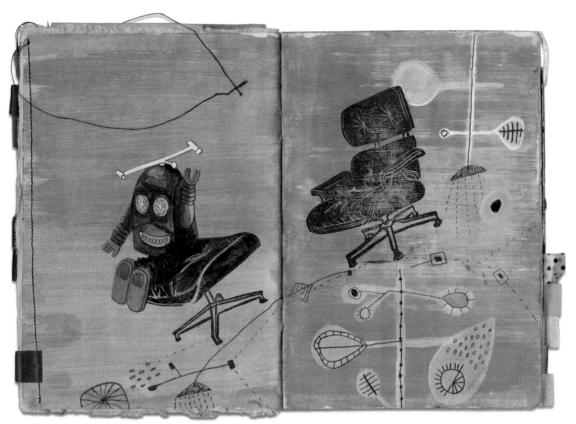

**Dudley Redhead** SYDNEY, AUSTRALIA

**Stephen Lovett** AUCKLAND, NEW ZEALAND

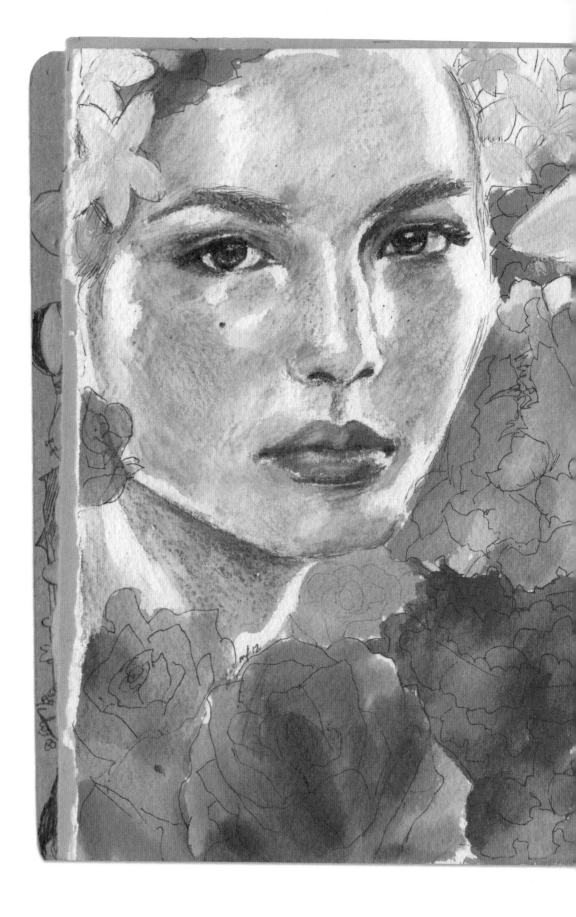

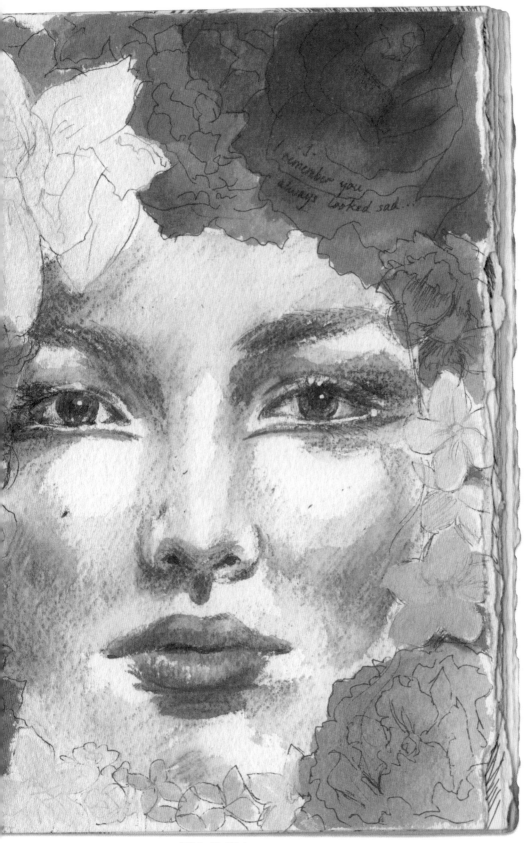

Within the artwork: *I remember you always looked sad...*

**Michelle Fisher** PERTH, AUSTRALIA

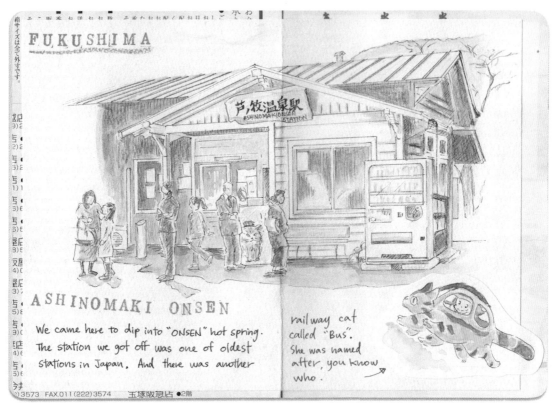

**Kimiko Fukube** CHRISTCHURCH, NEW ZEALAND

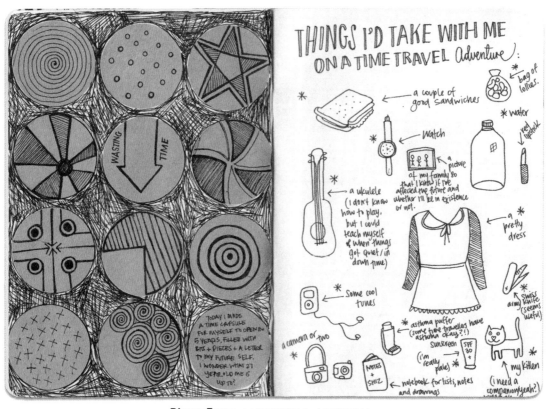

**Bianca Jagoe** LAUNCESTON, AUSTRALIA

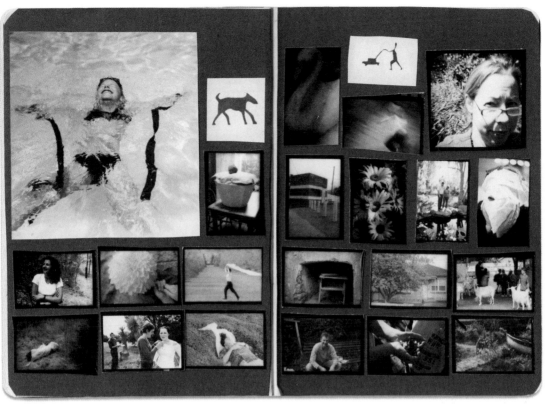

**Susan Michael** ADELAIDE, AUSTRALIA

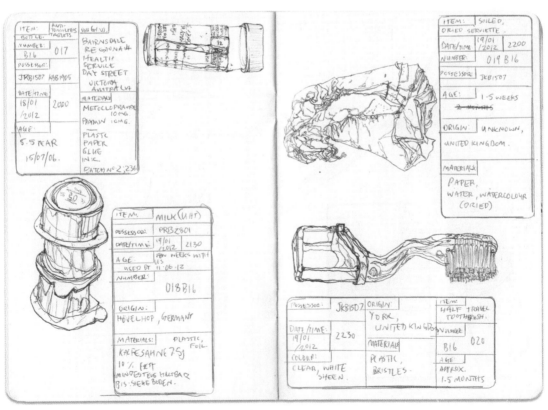

**Joanna Buckland** MELBOURNE, AUSTRALIA

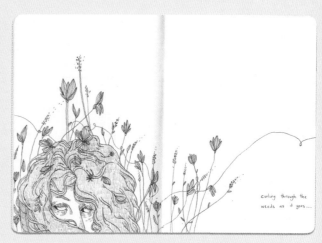

curling through the
weeds as it goes...

seawater

she sinks ships

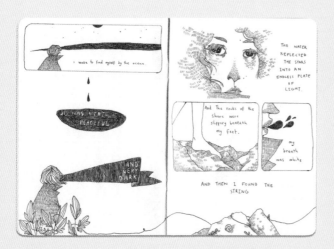

i woke to find myself by the ocean

IT WAS VERY
PEACEFUL

AND
VERY
DARK

THE WATER
REFLECTED
THE STARS
INTO AN
ENDLESS PLATE
OF
LIGHT.

And the rocks of the
shore were slipping beneath
my feet.

my breath
was white

AND THEN I FOUND THE
STRING

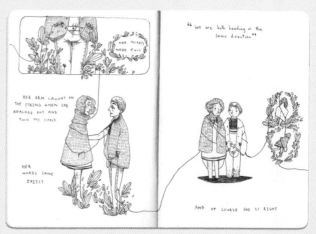

HER POCKETS
WERE FULL

" We are both heading in the
same direction "

HER ARM CAUGHT ON
THE STRING WHEN SHE
REACHED OUT AND
TOOK MY HAND

HER
WORDS CAME
EASILY

AND OF COURSE SHE IS RIGHT

# Nicola Gower Wallis

**BRISBANE, AUSTRALIA**

**DO YOU HAVE ANY FORMAL ARTISTIC TRAINING?**
No.

**WHAT IS YOUR FAVORITE ARTISTIC TOOL?**
Any old pencil will do.

**HAVE YOU ALWAYS KEPT A SKETCHBOOK, OR WAS CREATING YOUR SKETCHBOOK A TOTALLY NEW ENDEAVOR FOR YOU? DID YOU ENTER THE SKETCHBOOK PROJECT WITH CERTAIN GOALS, OR WAS IT MORE OF AN EXPERIMENTAL EXPERIENCE?**
Not so much a sketchbook but more a haphazard pile of papers. The Sketchbook Project was a challenge in that I wanted to create something that felt like a connected series of images. I suppose it was experimental in that I was still coming to grips with the ways I wanted to present my own work.

**WHAT DOES YOUR ARTISTIC PROCESS ENTAIL? ARE THERE CERTAIN INSPIRATIONS YOU HOLD DEAR, OR MATERIALS YOU CAN'T LIVE WITHOUT?**
Most of my thinking is done while walking back and forth to the supermarket and on my way to catch trains. I tend to script out an entire work in my head before I sit down and commit it to paper. As far as materials go, I am usually rather easily pleased. Ink or pencil does me just fine.

**ARE THERE CERTAIN THEMES THAT RECUR THROUGHOUT YOUR WORK? DESCRIBE ANY VISUAL OR CONCEPTUAL ELEMENTS THAT YOU FIND CENTRAL TO YOUR PROCESS.**
I suppose the connection between humans and nature is something I find myself returning to a lot in my works. Also, themes of vulnerability and rebirth. Honesty is something that appeals to me, but which is also a struggle, so there is something very appealing about the sensation of shouting out into the void.

**HOW DOES YOUR PERSONAL BACKGROUND OR GEOGRAPHIC LOCATION TIE INTO YOUR ARTISTIC PRACTICE?**
I think many Australian artists and writers are obsessed with the way we fit into the landscape, and there are certainly elements of that in my work. There is a kind of sense of isolation, of feeling terribly small and dirty against the vast space surrounding you. Trying to put that feeling into words or images is something that, I think, will always obsess me.

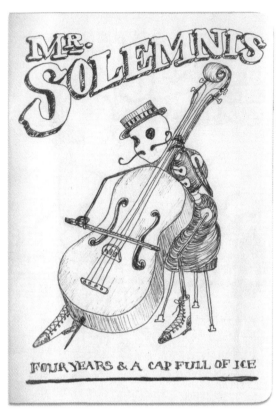

**Kate Logan** WELLINGTON, NEW ZEALAND

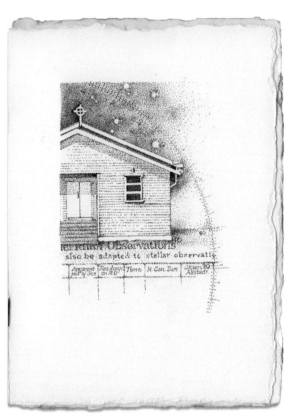

**Clare Jean Ford** ROCKHAMPTON, AUSTRALIA

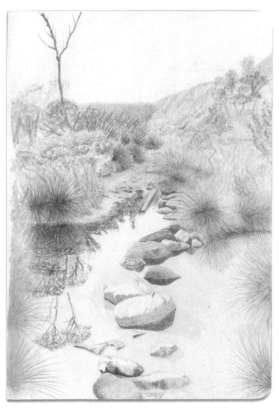

**Githa Postma** MELBOURNE, AUSTRALIA

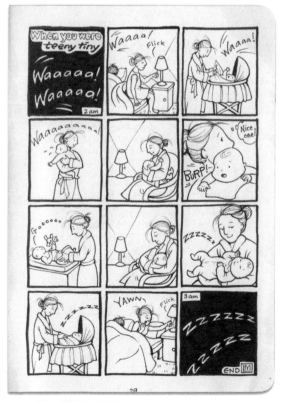

**Lisa McDonald** CANBERRA, AUSTRALIA

**Rhys Burnie**  MELBOURNE, AUSTRALIA

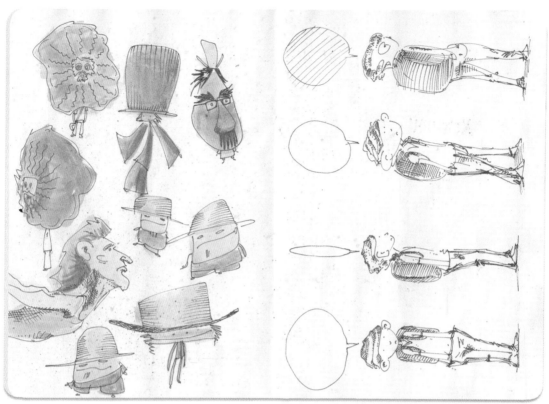

**Ahmad Habash**  WELLINGTON, NEW ZEALAND

**Margaret Swan**  CARLTON, AUSTRALIA

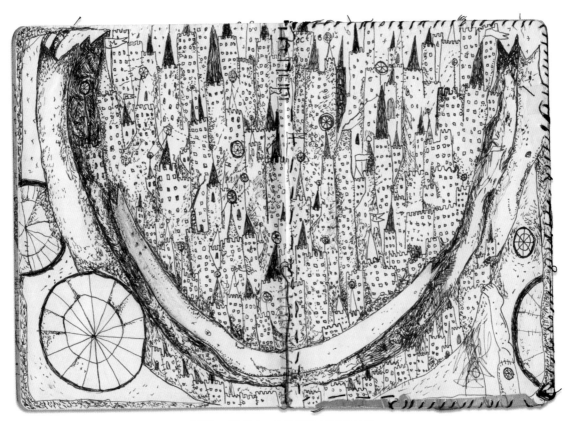

**Jillian McCrae**  SYDNEY, AUSTRALIA

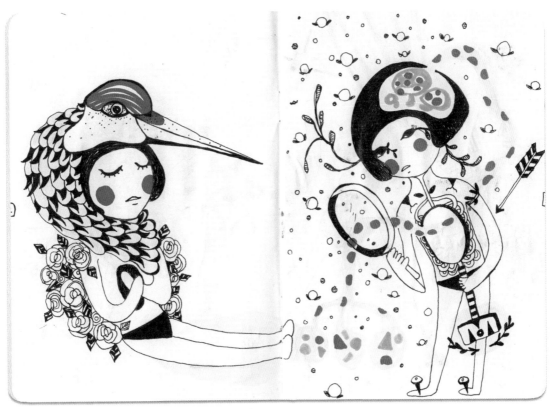

**Nani Puspasari**  MELBOURNE, AUSTRALIA

248

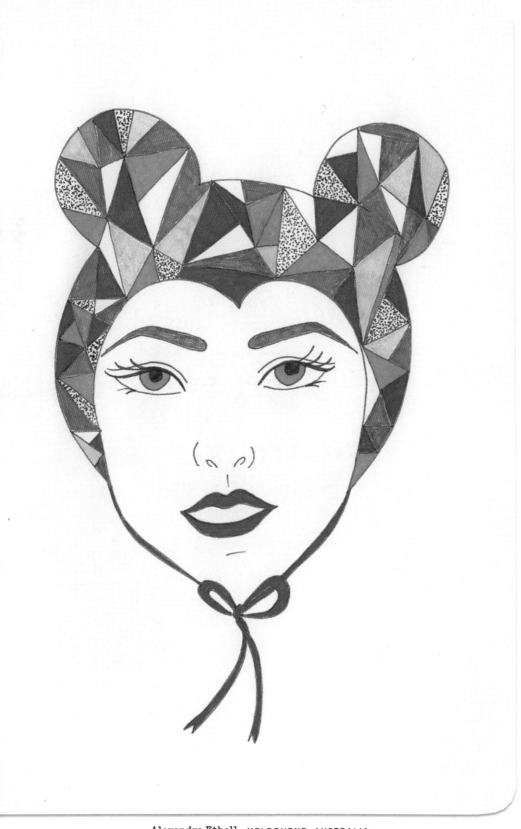

**Alexandra Ethell** MELBOURNE, AUSTRALIA

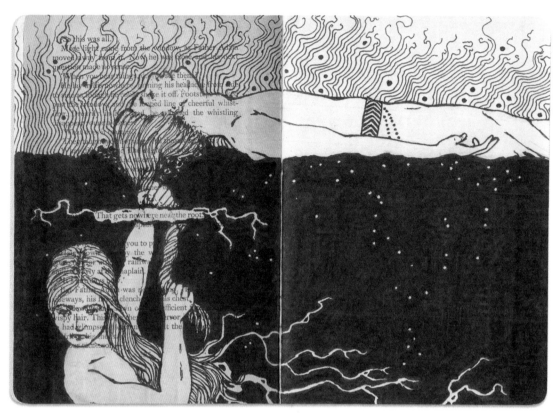

**Anna Disney** SYDNEY, AUSTRALIA

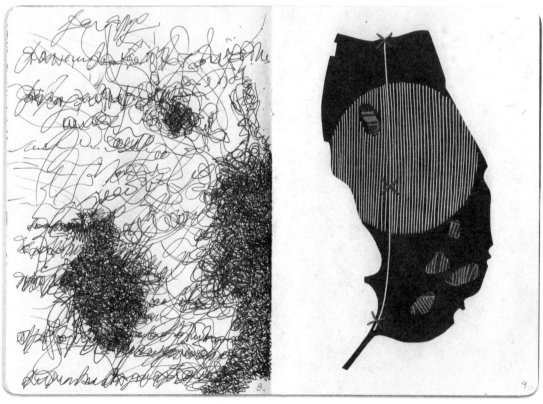

**Elizabeth Banfield** MELBOURNE, AUSTRALIA

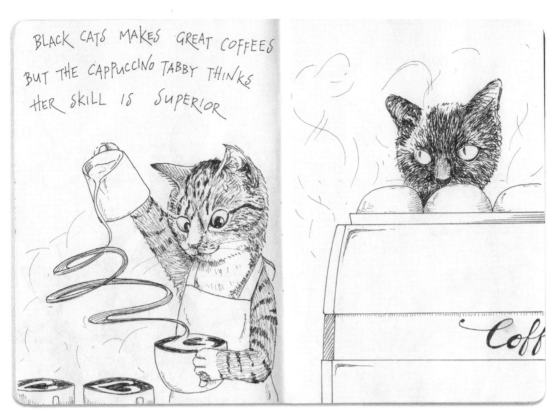

**Kimiko Fukube** CHRISTCHURCH, NEW ZEALAND

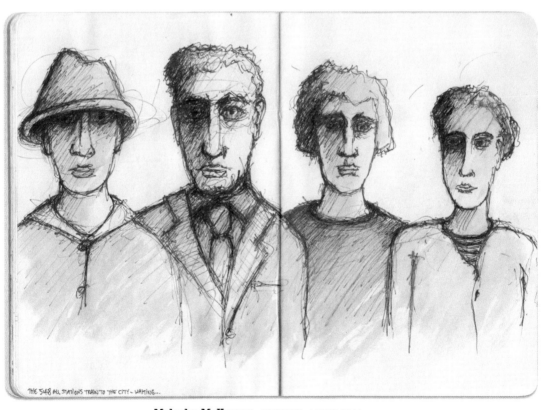

**Malcolm McKernan** SYDNEY, AUSTRALIA

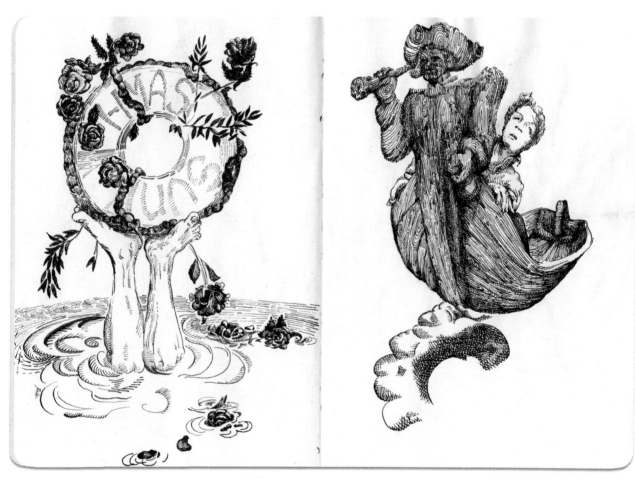

Dollo KINGSWOOD, AUSTRALIA

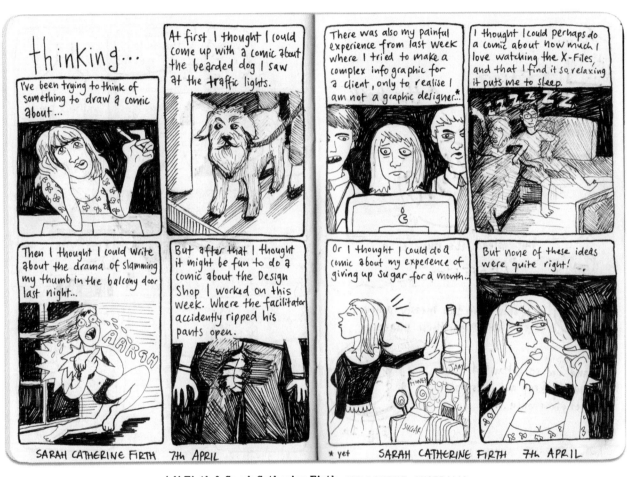

**Adi Firth & Sarah Catherine Firth**  MELBOURNE, AUSTRALIA

AUSTRALIA

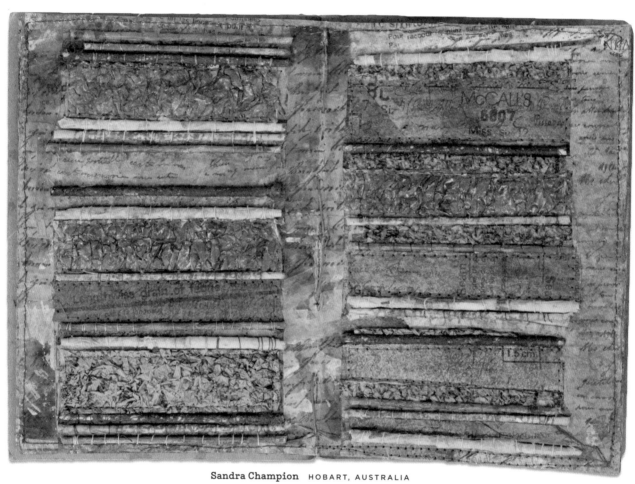

**Sandra Champion** HOBART, AUSTRALIA

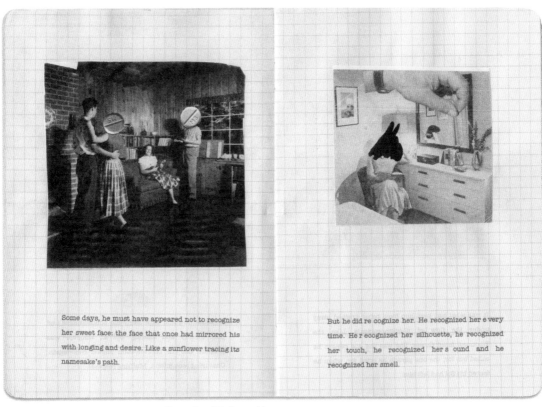

Some days, he must have appeared not to recognize her sweet face: the face that once had mirrored his with longing and desire. Like a sunflower tracing its namesake's path.

But he did re cognize her. He recognized her e very time. He r ecognized her silhouette, he recognized her touch, he recognized her s ound and he recognized her smell.

**Brendan McCumstie**  NUNDLE, AUSTRALIA

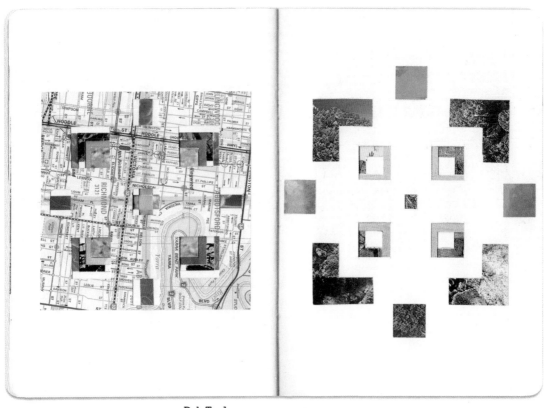

**Deb Taylor**  MELBOURNE, AUSTRALIA

## Acknowledgments

The Sketchbook Project is a team effort. The project would not be what it is today without the help and love of so many people. We have been amazed at the support we receive from not only our friends and family but from this growing global community.

Many thanks to Shane Zucker for being the other half to this amazing experience, and for helping create the platform that allows the project to exist. Wherever life takes you, you will always have a home at The Sketchbook Project.

Thank you Katie Shepherd for writing our continent introductions and for putting into words what we could not.

A huge thank you to our staff over the years for all the hard work and for always keeping a list of inspiring sketchbooks from the collection. And a special thanks to Jessica Sugerman and Richard Vergez. We have been so lucky to have you all!

Thank you to our community of creative people, who continue to inspire, support, and love this project.

And to S, our adventure is just beginning.

—S. P.

Published by
Princeton Architectural Press
37 East Seventh Street
New York, New York 10003

Visit our website at www.papress.com.

Art and text © 2015 Art House Projects, LLC
Foreword © 2015 Chris Jobson
All rights reserved
Printed and bound in China by C&C Offset Printing Co., Ltd.
18 17 16 15  4 3 2 1 First edition

Editor: Tom Cho
Designer: Mia Johnson

Special thanks to: Meredith Baber, Sara Bader, Nicola Bednarek Brower, Janet Behning, Erin Cain, Megan Carey, Carina Cha, Andrea Chlad, Barbara Darko, Benjamin English, Russell Fernandez, Jan Cigliano Hartman, Jan Haux, Diane Levinson, Jennifer Lippert, Katharine Myers, Jaime Nelson, Rob Shaeffer, Marielle Suba, Kaymar Thomas, Paul Wagner, Joseph Weston, and Janet Wong of Princeton Architectural Press
—Kevin C. Lippert, publisher

Cataloging-in-Publication Data available upon request